2 0 0 1 WORLD PRESS PHOTO

Thames & Hudson

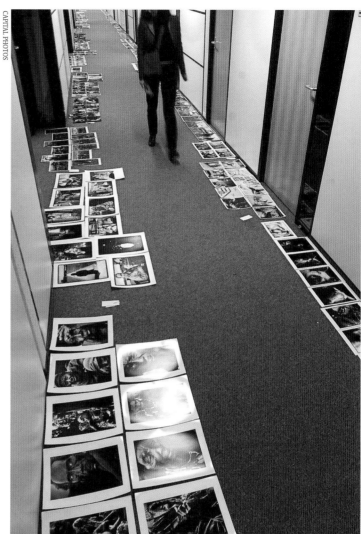

CAPITAL PHOTOS

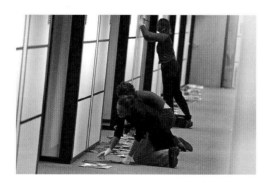

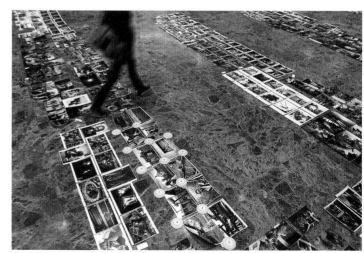

It took the jury of the 44th World Press Photo Contest two weeks of intensive deliberation to arrive at the results published in this book. They had to judge 42,321 entries submitted by 3,938 photographers from 121 countries.

World Press Photo

World Press Photo is an independent nonprofit organization, founded in the Netherlands in 1955. Its main aim is to support and promote internationally the work of professional press photographers. Over the years, World Press Photo has evolved into an independent platform for photojournalism and the free exchange of information. The organization operates under the patronage of H.R.H. Prince Bernhard of the Netherlands.

In order to realize its objectives, World Press Photo organizes the world's largest and most prestigious annual press photography contest. The prizewinning photographs are assembled into a traveling exhibition, which is visited by over a million people in 35 countries every year. This yearbook presenting all prizewinning entries is published annually in seven languages. Reflecting the best in the photojournalism of a particular year, the book is both a catalogue for the exhibition and an interesting document in its own right. A six-monthly World Press Photo newsletter deals with current issues in the field.

Besides managing the extensive exhibition program, the organization closely monitors developments in photojournalism. Educational projects play an increasing role in World Press Photo's annual calendar. Five times a year seminars open to individual photographers, photo agencies and picture editors are organized in developing countries. The annual Joop Swart Masterclass, held in the Netherlands, is aimed at talented photographers at the start of their careers. They receive practical instruction and are shown how they can enhance their professionalism by some of the most accomplished people in photojournalism.

World Press Photo is sponsored worldwide by Canon, KLM Royal Dutch Airlines and Kodak Professional, a division of Eastman Kodak Company.

World Press Photo of the Year

· Lara Jo Regan
USA, for Life

1ST PRIZE SINGLES DAILY LIFE

The mother of a Mexican immi-
grant family makes piñatas to
support herself and her children,
in Texas, USA. They number
among the millions of 'uncounted'
Americans, people who for one
reason or another have been
missed by the national census and
so don't exist in population
records. Children make up more
than half the uncounted. Census
records determine where new
schools, hospitals, firehouses and
basic social services are needed.
Areas like Las Colonias, where this
family lives, thus lack many
amenities and have high
illiteracy rates.

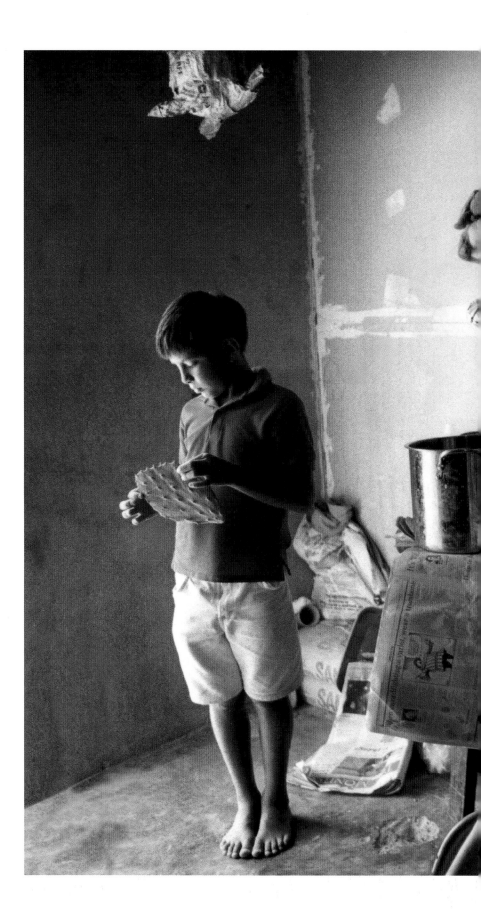

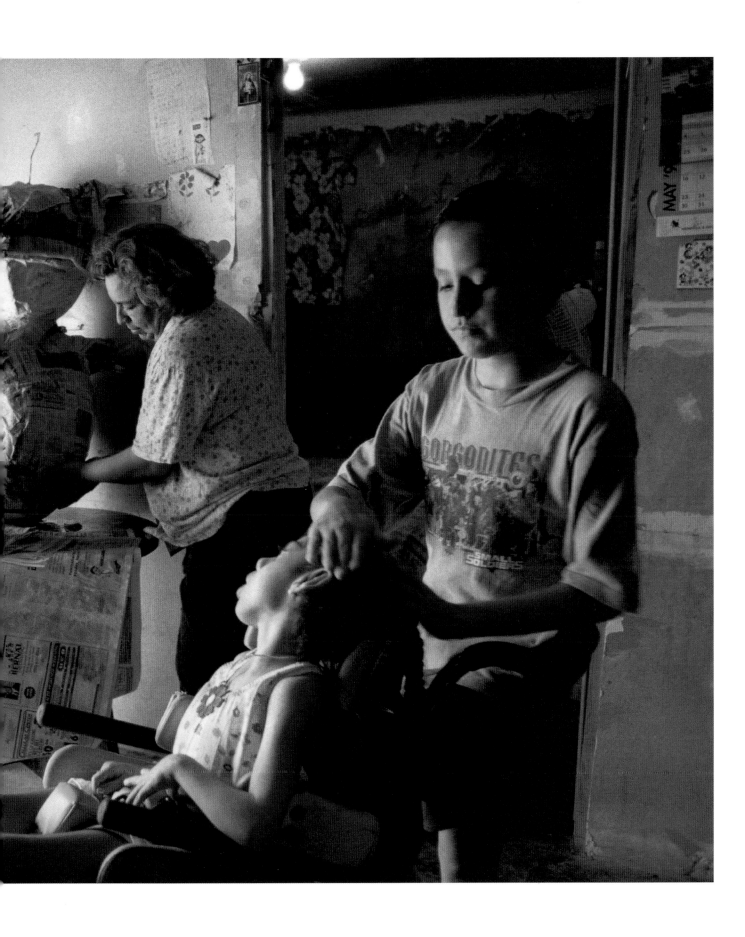

Lara Jo Regan lives in Los Angeles and has been a regular contributor to *Time*, *Newsweek*, *Life*, *Premiere* and numerous publications throughout the world for over ten years. She is best known for her visual commentary on segments of American culture, covering everything from homeless children to the Hollywood elite. With a background in anthropology and fine art, she aims in her work to combine painterly aesthetics with social commentary. She has had several one-woman shows of her work and is the recipient of many awards.

Lara Jo Regan

Lara Jo Regan, the author of the World Press Photo of the Year 2000, answered some questions about her work.

How did you start in photography?

I discovered photography by accident. I was 15, chaperoning my grandmother on an Hawaiian vacation. At the time, the tropical environment was very new and exotic to me, and I found myself not just snapping touristy shots, but putting an obsessive degree of effort climbing up fences and palm trees — trying to capture the surroundings in an interesting way. With my brother's teeny Instamatic! I was immediately hooked and started working at an ice cream shop to save up to buy a 35mm. I was an extremely shy child, and found the camera the perfect means of expression — I could say what I was thinking and feeling without having to talk.

What motivates you to take pictures?

Wanting to share my point of view about something, and also what I'm feeling about it. It's a translation of passion, in the most elemental sense. I get hired mainly to do visual commentary rather than traditional photojournalism. Capturing the spirit and soul of my subjects in a way that transcends the literal is what interests me. It's not less truthful, just a different dimension of truth. Illuminating truth, in all its manifestations, also really motivates me. Besides the personal satisfaction, I think it helps counter, in a small way, the advertising and entertainment industry's proliferation of hollow fantasy and seductive illusion which is steamrollering over our collective consciousness. This disconnection from reality distracts us from taking a healthy, active interest in the world around us, undermining our communities. Now more than ever, I think it is important that documentary photographers keep trying to show, in the most provocative, enlightening and moving way possible, the importance, beauty and wonder of the authentic world.

How do aesthetic considerations relate to the broader social issues in your work?

My background is in anthropology and fine art, and I try to combine painterly aesthetics with social observation. I've always been fascinated by the early Dutch painters — their work was sublimely beautiful, and also reveals so much about the day-to-day life of their contemporaries. The aesthetic element is an important part of photography for me, but I find pictures that are just pretty quite empty. On the other hand, some photography is very graphic, showing the horrors of the world in a very in-your-face kind of way with no aesthetic aspect. Those photos are important part of the journalistic record, but an image with a lyrical dimension is more likely to inspire people to explore it — which may increase the chance they will care. There is a lyrical quality that exists naturally in almost everything, even in the sadness and tragedy of war. Most of life, however, takes place in shades of gray. I've always been more drawn to celebrating the poetic quality of the everyday, and the holiness in the mundane.

What do you think makes a good photograph?

Photographs involve so many different dimensions — lighting, composition, content, tone, angle, the moment you're capturing. Really great photographs seem to be strong in all the dimensions and — beyond that — the dimensions interrelate in an intelligent and meaningful way. There's a rich resonance to these images, like playing a chord instead of a single note.

How do you organize the business aspect of your photography?

I represent myself, only using my agency for resale, which is an important service. I've been put off by the corporate takeover of many agencies. Rather than promoting and protecting photographers rights like any artist's agent should, the new bosses seem to be trying to do just the opposite. Many agencies seem to care less and less about promoting important photography and more and more about feeding the appetites of pop culture.

How did the winning photo come about?

It was part of an assignment for *Life* magazine on 'uncounted' Americans — people who 'don't exist' in the official U.S. census records. It was a vehicle to explore poverty, alienation, and also parts of America most of us don't even know exist. The writer had located a remote, desolate part of Texas populated by many uncounted Hispanic people. Most didn't want to be photographed. I ended up finding four families who let me in their homes, including the one in the winning picture whose living conditions were so far removed from what most people associate with American life. I spent the better part of the day with them as they went about their business, balancing on a shaky stool for hours in the main room of their dwelling until their self-consciousness dissolved. Then this sad but beautiful human ballet began unfolding before my eyes — kids running in and out of the room as the mother went through the haunting ritual of building piñata bodies. After many hours that moment occurred when everything came together — the composition, the light, the expressions, a subtle gesture and tilt of a head.

CAPITAL PHOTOS

THIS YEAR'S JURY.

FIRST ROUND JURY, FROM LEFT TO RIGHT:
Alexander Joe, Zimbabwe
Christiane Gehner, Germany
Robert Pledge, France (chairman)
Michele McNally, USA
Adriaan Monshouwer (secretary)

SECOND ROUND JURY, FROM LEFT TO RIGHT:
Henrik Saxgren, Denmark
Miguel Angel Larrea, Chile
Adriaan Monshouwer (secretary)
Guy Cooper, USA
Margot Klingsporn, Germany
Robert Pledge, France (chairman)
Brechtje Rood, The Netherlands
Yuri Kozyrev, Russia
Michael Young, Australia
Juda Ngwenya, South Africa

Foreword

A peaceful scene from everyday life: a mother, surrounded by three of her children, is preparing food in a rural kitchen. The oldest is brushing his little sister's hair. A barefoot boy in shorts stands immobile and pensive. An innocent domestic moment bathed in a chiaroscuro rusticity reminiscent of a 17th-century Dutch painting.

Yet we are in the year 2000. In the heart of Texas, the largest and richest state in the union, which has just produced the 43rd president of the most powerful country in the world, George W. Bush, in a controversial election. Technically speaking, the Sanchez family from Texas does not exist; along with millions of others, it escaped the last census, which determines the share of each state's federal subsidies for education, health and other social services.

If we look a little closer at Lara Jo Regan's photograph, we notice that the little girl in the foreground is sitting in a wheelchair. We remark the poverty of the place, the bare light-bulb, the glaring absence of home appliances that consumer society normally offers. We are bordering on destitution. That of people who have left everything to emigrate clandestinely in hope of a better life. Suddenly, we are no longer only in Texas, but in South Africa, which draws the jobless of neighboring countries; in Germany, where tens of thousands who fled the horror of the Balkans have ended up; in Guinea or in Ghana, which take in refugees fleeing the carnage of Sierra Leone and Liberia; in Calcutta, overflowing with poverty-stricken Bangladeshis; in France, in Great Britain, in Spain, where Africa and Asia send many of their children.

And so this scene captured by the American photographer takes on a universal, highly contemporary dimension, one not so Dutch, nor peaceful, nor innocent. It speaks to us of the most important human phenomenon on the planet, one which, given its scale, will epitomize the beginning of this new century.

These migratory movements are the fruit of confrontations and upheavals — local, regional or worldwide — of the century just ended. Wars of men and territory, famines and ecological disasters, ethnic and religious strife, oppression and repression, with their cortege of physical and psychological misery in tow: situations which, for the better part of the last five decades, produced the winning photograph of the World Press Photo.

The way in which a single little image manages to elbow its way to the top of a pyramid which exists only in the gaze, the thought, and the heart of the jury members, diverse in their origins and individual heritage, always intrigues and surprises. More so since the 2001 awards mark a clear step away from a long tradition of the harsh iconic news photograph. Through the jury's open and honest deliberation, a spontaneous and unmistakable consensus emerged.

For the first time in over ten years, the choice of World Press Photo of the Year was unanimous. A remarkable occurrence for a photograph selected from among the 42,321 submissions by 3938 photographers from 121 countries around the world — figures similar to last year's. This unanimity was also evident in many of the awards to the sixty-three prizewinners of twenty-four different nationalities across the eighteen categories of the contest.

The images and the subjects short-listed by this year's jury essentially deal with ordinary people and ordinary situations in circumstances which are not, leaving to television the high ground of pathos and the spectacle which emerges when the media en masse lays siege to an event. Neither do public figures or celebrities accustomed to the limelight find a place here.

The award-winners represent a diversity of styles, approaches and points of view which are often highly personal and removed from established formulae, in which color and black-and-white, film and digital, and a variety of formats blend irrespectively to cover the entire aesthetic range, from the most traditional to the most contemporary.

In response to difficulties and uncertainties born of sweeping technological and economic changes, non-stop TV news and the explosive spread of the web, press-oriented photography is demarking its difference, finding a new impetus. Imbued with a renewed maturity, it is expressing itself with greater freedom.

ROBERT PLEDGE
Chairman of the Jury
New York, February 2001

World Press Photo Children's Award

· **Stephan Vanfleteren**
Belgium, Lookat Photos, Switzerland for
Artsen Zonder Grenzen Nederland

A young landmine victim leaps a
stream near Bala Morghab in
Afghanistan. The country is locked
in a civil war between ruling
Taliban and opposition forces, and
is stricken by drought. The youth
became a soldier for the Taliban
and had lost his leg three months
previously after stepping on a
landmine. Of no further use as a
combatant, he was then sent
home.

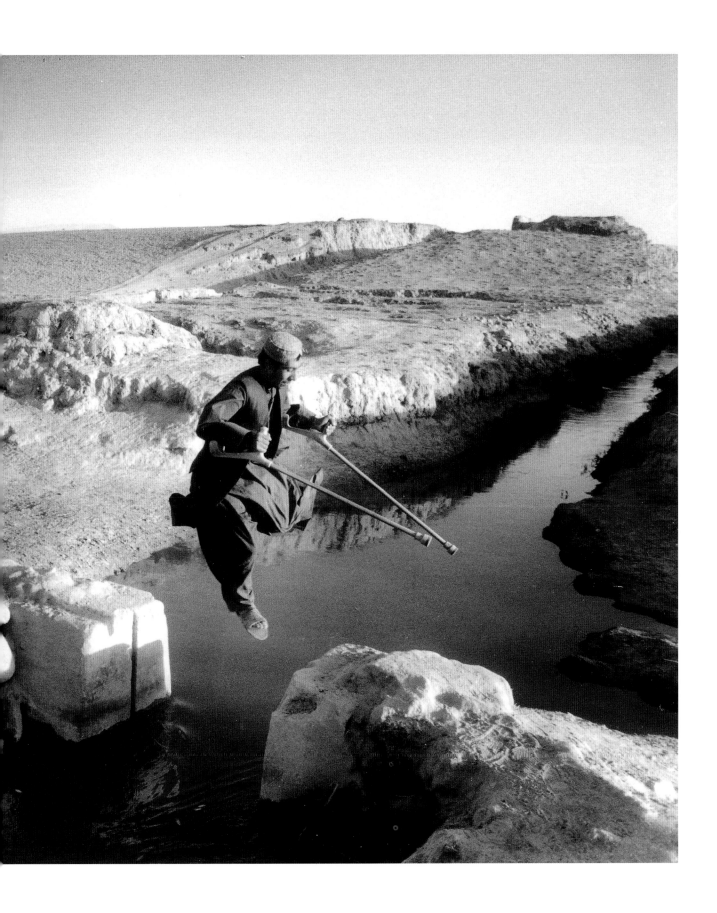

General News

· Reinhard Krause
Germany, Reuters

1ST PRIZE SINGLES

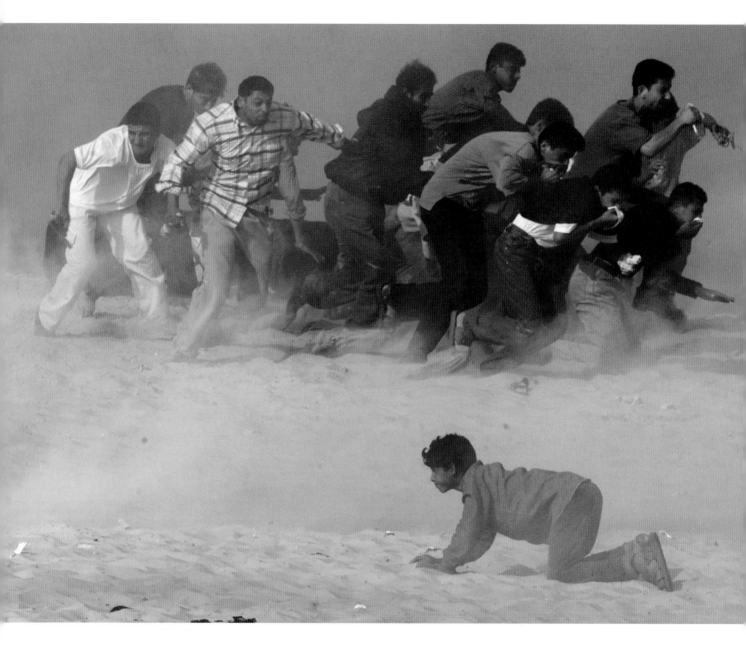

Palestinians attempt to escape Israeli tear gas during clashes in the south Gaza Strip
town of Khan Yunis in October. A month earlier, Likud Party leader Ariel Sharon had visited
Jerusalem holy sites, including Temple Mount, venerated by both Jews and Muslims. The
visit sparked off a spiral of violence in Gaza and the West Bank. Palestinian casualties as a
result of the intifada included large numbers of young men and boys. Palestinians accused
Israelis of deliberately targeting children, while Israel countered that children were being
sent to the front line to get international sympathy.

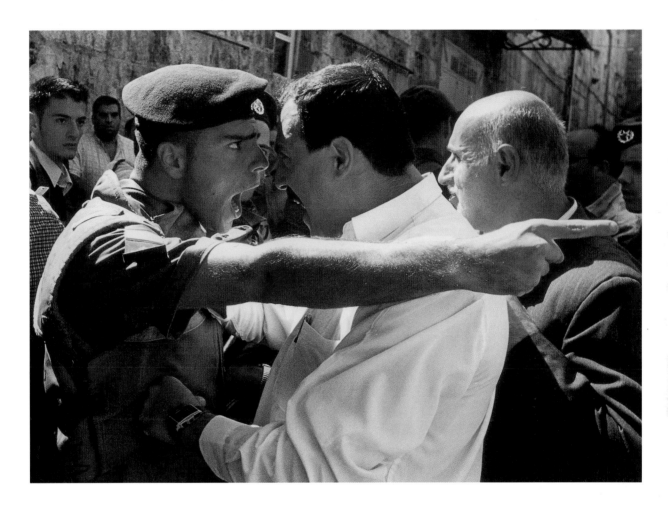

· Amit Shabi
Israel, for Reuters

2ND PRIZE SINGLES

An Israeli border policeman argues with a Palestinian in the Old City of Jerusalem in October. The man had been refused entry to the Al-Aqsa mosque for Friday prayers during Ramadan. Israeli security forces prevented Palestinian men under the age of 45 from attending prayers following unrest in the West Bank and Gaza Strip.

· Dudley M. Brooks
USA, The Washington Post

3RD PRIZE SINGLES

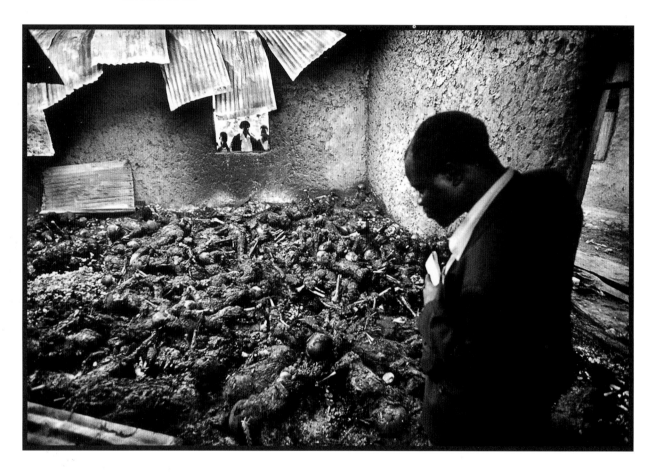

Hundreds of members of a religious cult died in an explosion
in a church in Kanungu, Uganda. The cult had predicted the
end of the world for midnight on December 31, 1999.
Members were told to sell their possessions and give the
proceeds to the movement. On March 17 a bell summoned
them to the church. Half an hour later an explosion was
heard and a fire broke out, killing everyone in the building.
Ugandan authorities issued arrest warrants for the cult
leaders on charges of murder. Evidence of further mass
deaths was found at other sites around the country. Officials
found it difficult to assess the total number of victims, the
final toll was given as between 500 and 1,000.

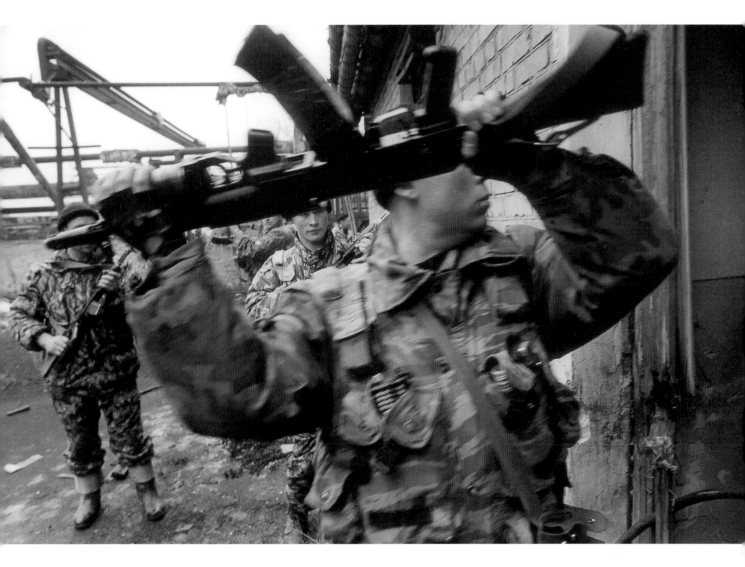

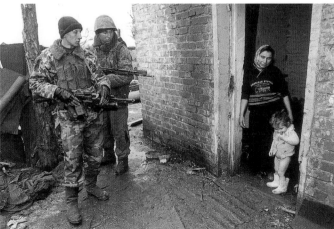

· Vladimir Velengurin
Russia, Komsomolskaya Pravda

1ST PRIZE STORIES

Russian troops round up suspected rebels in Chechnya in January and February. The Russian campaign against the breakaway republic had been renewed in the autumn of 1999, and early in the new year the capital Grozny was taken. The Russians began 'clean-up operations' known as *zachistka*. (story continues)

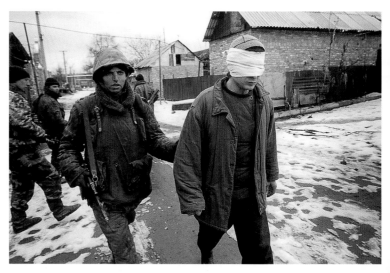
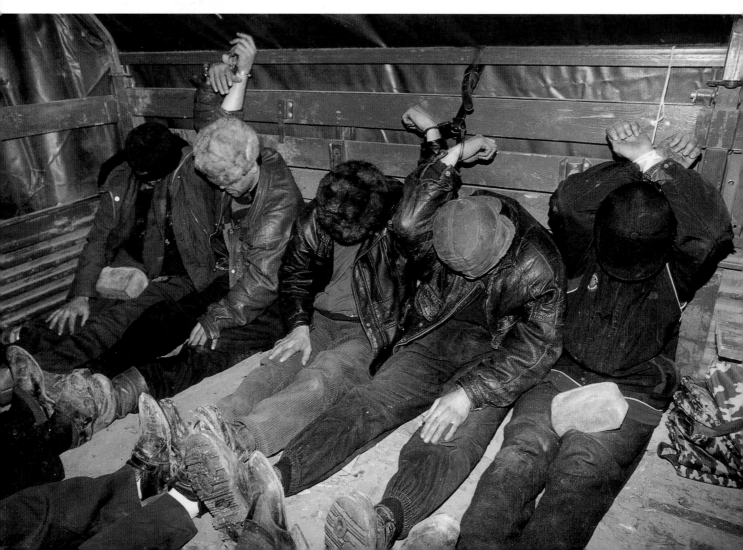

(continued) Moscow had previously vowed to get tough on Chechen men of fighting age in areas under its control. Suspects, especially men without documents or with marks of fighting on their bodies, were arrested and taken to 'filtration camps' outside the towns. Here it was decided whether or not they belonged to rebel forces. Below: A Russian soldier stands guard over Chechen men arrested in Grozny for not carrying ID documents.

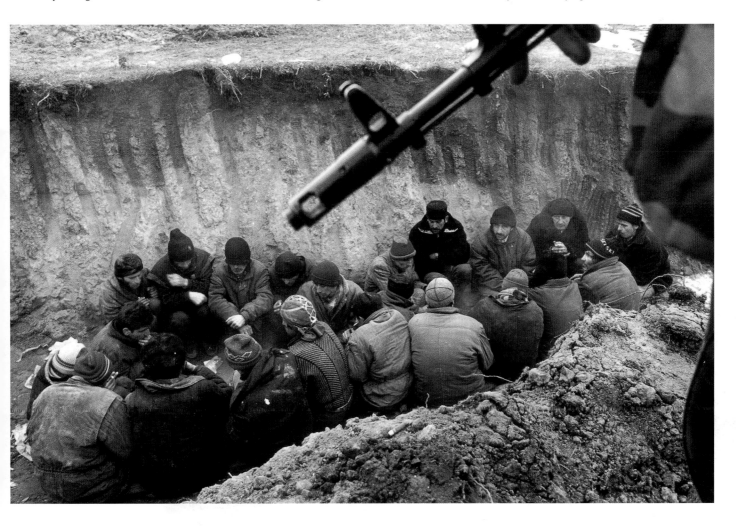

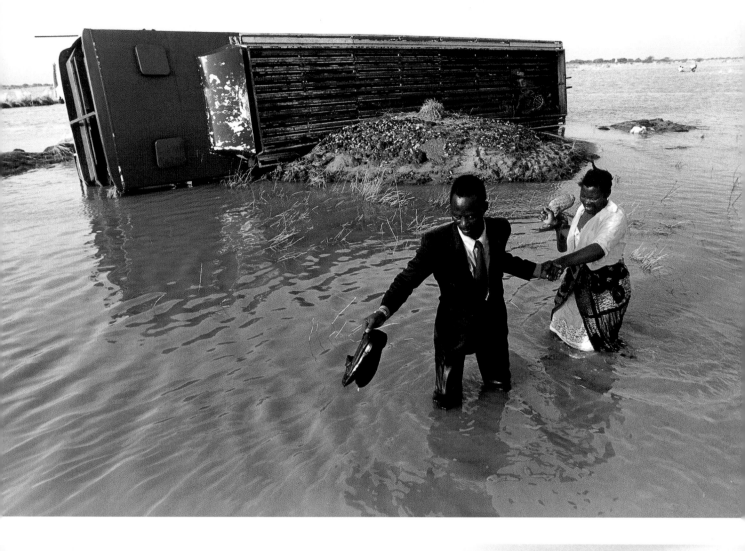
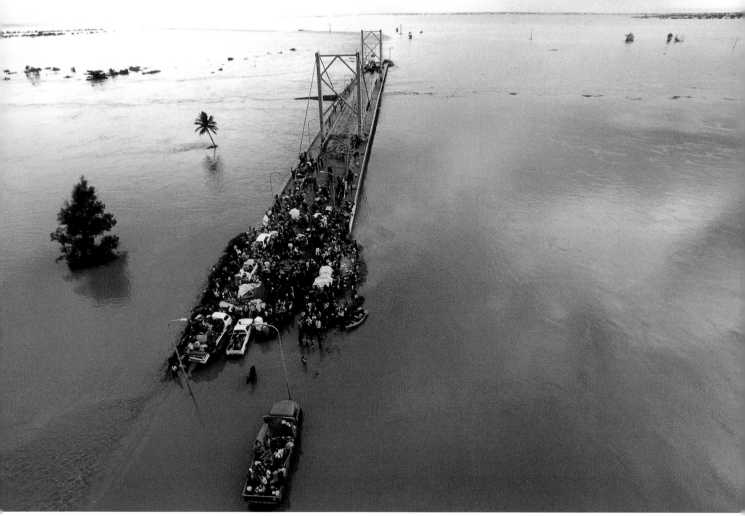

· Karel Prinsloo
*South Africa, Sunday
Times/Associated Press*

2ND PRIZE STORIES

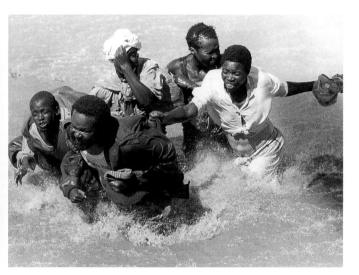

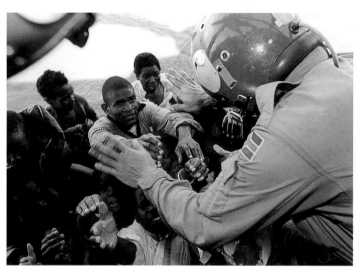

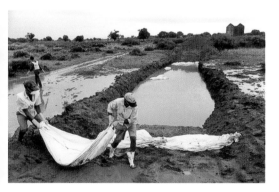

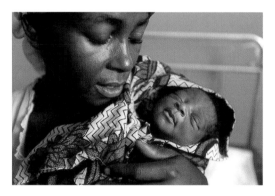

In January a cyclone hit Mozambique, causing water levels to rise six meters in 24 hours. Continuing rains led to a flood that was the worst to hit the area in thirty years. A quarter of arable land was lost, and damage was estimated at US$ 100 million. Facing page, top: A man helps his wife across a river near Xai-Xai, north of the capital Maputo, past a bus that was swept away when a bridge collapsed. Below: Hundreds of people who had taken refuge on a high bridge near Xai-Xai were stranded when waters rose overnight. This page, top: People run as a South African Airforce rescue helicopter approaches. An airforce member explains that the helicopter is full. Below: Sophia Pedro with her baby Rositha, who was born while Sophia was trapped up a tree.

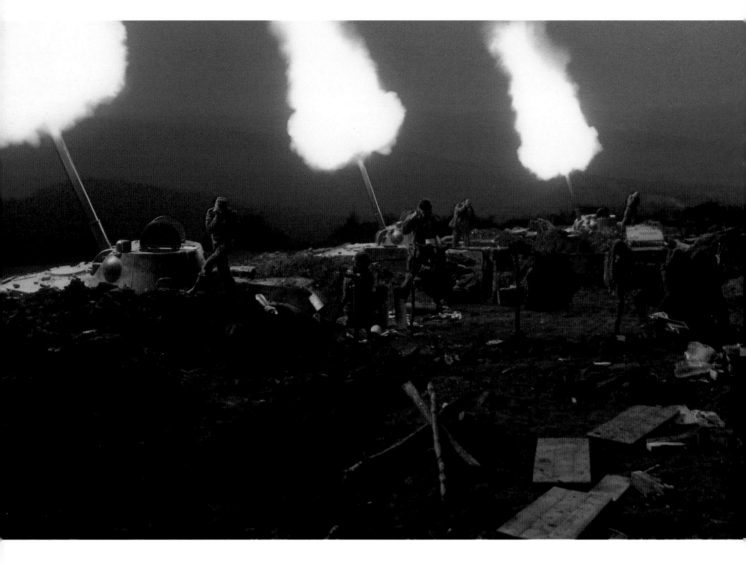

· Vladimir Vyatkin
Russia, Ria Novosti for Ogonyok

3RD PRIZE STORIES

By March the Russians were established in Chechnya, though groups of rebel fighters had consolidated position, mainly in mountain districts. Above: The Russian artillery opens night fire on rebel positions in the mountains. Facing page: A Russian engineer searches for mines laid by militants in the river Bass, near Lenin-Kort mountain. (story continues)

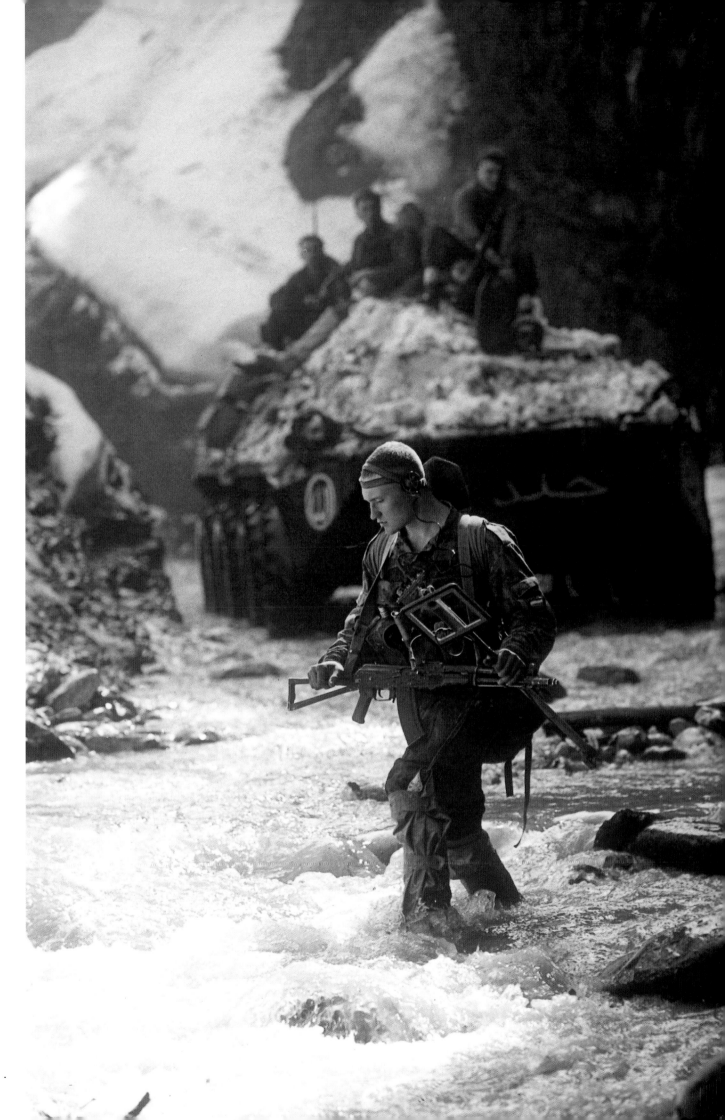

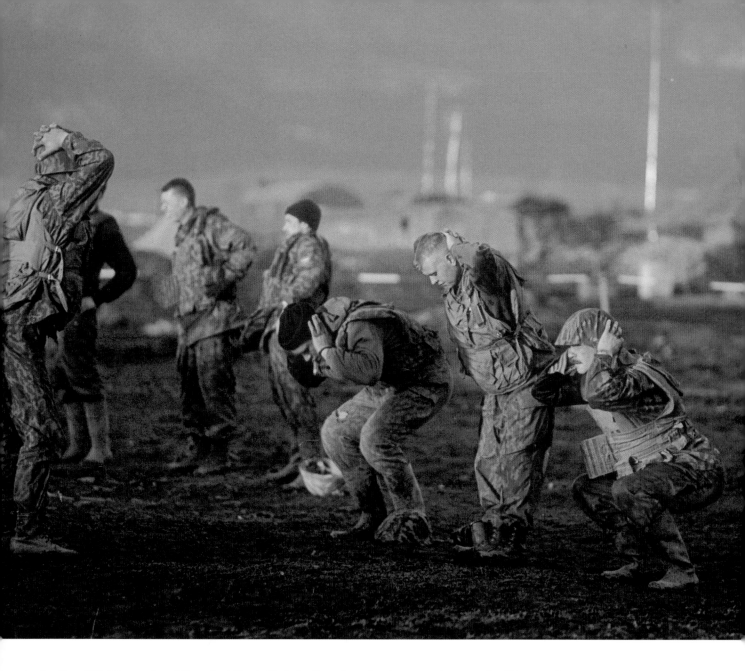

(continued) Fighting continued throughout March. Clockwise from above: Russian reconnaissance-unit soldiers exercise before a maneuver. Russian tanks head off on a combat operation in the Chechen mountains. Reconnaissance officers take a rest. The dead and wounded are evacuated after a clash in the Bass river gorge.

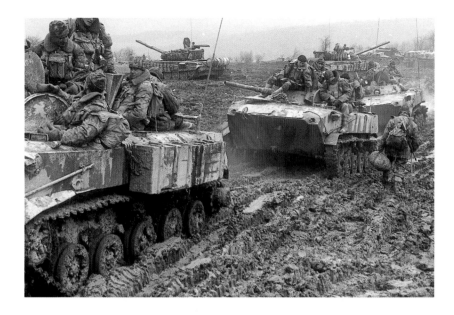

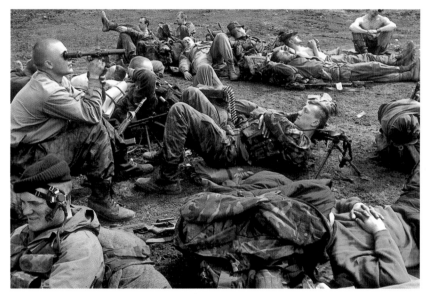

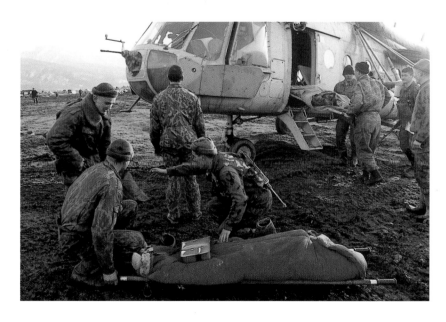

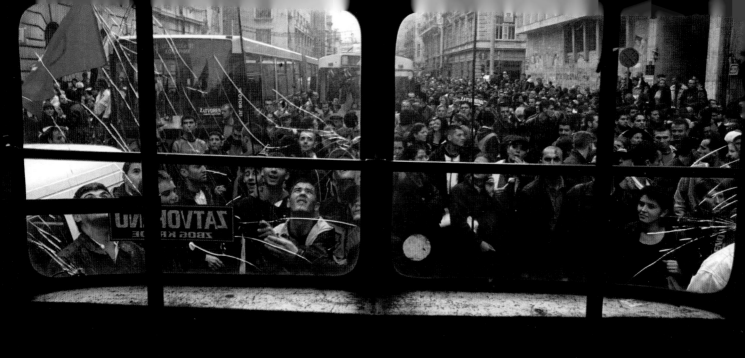

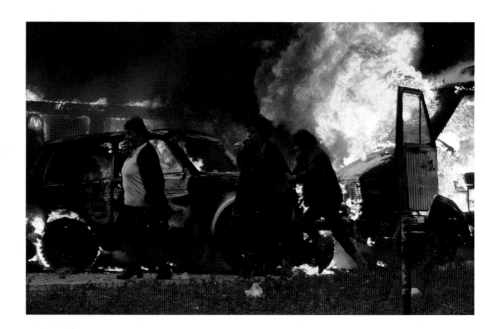

· Noël Quidu

France, Gamma for Newsweek, USA

HONORABLE MENTION STORIES

In October, a revolution in Serbia toppled President Slobodan Milosevic. The opposition had claimed victory in the September elections, but a Federal Election Commission called for a second ballot, claiming neither side had an outright majority. A general strike and mass protests followed. On October 4, Yugoslavia's constitutional court annulled the election; by dawn on October 5 people were converging on Belgrade. Top: Students demonstrate in Belgrade. Below: State media workers flee the television station, which had been set alight by demonstrators. Facing page, top: Opposition supporters battle through tear gas set off by police. Below: Demonstrators launch tear gas into the parliament building. (story continues)

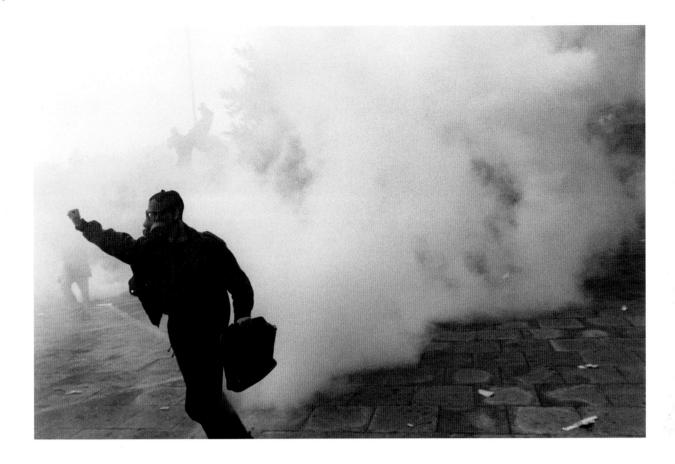

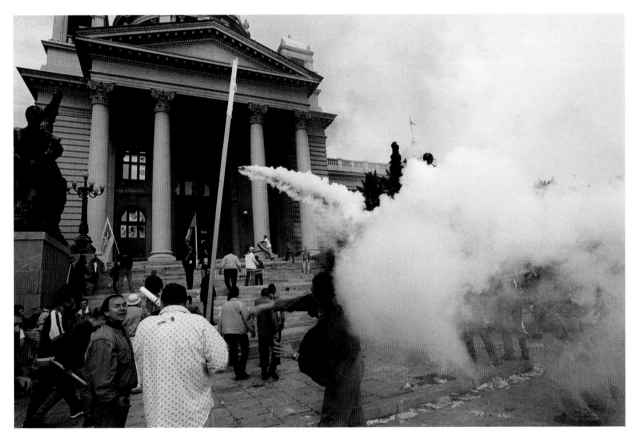

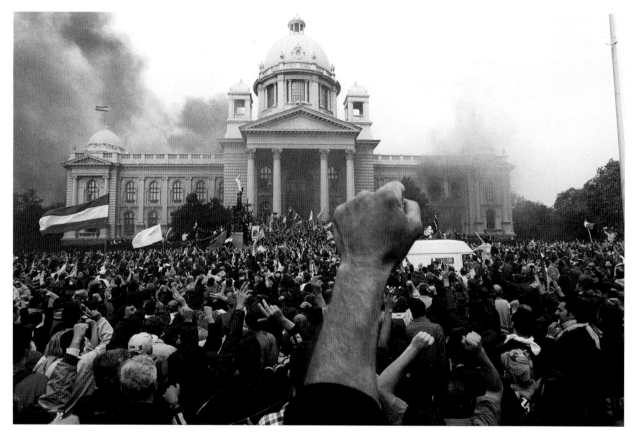

(continued) By 16h00 protestors had captured the parliament building. At 18h30 opposition leader
Vojislav Kostunica addressed a rally of some half a million people and declared himself president.
Top: Opposition members leave the parliament building with a chair they said symbolized the
throne of Milosevic.

People in the News

· Antonio Zazueta Olmos
Mexico, for The Observer

1ST PRIZE SINGLES

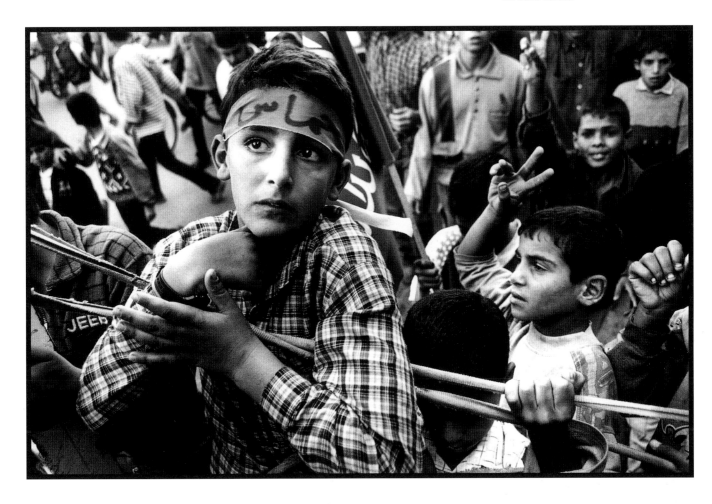

A young boy hangs on the back of a truck during a funeral procession through the streets of Rafah in the Gaza Strip. The funeral was for Zyad Khalil Abu Jazr, aged 22, who had been killed the day before during clashes with the Israeli army.

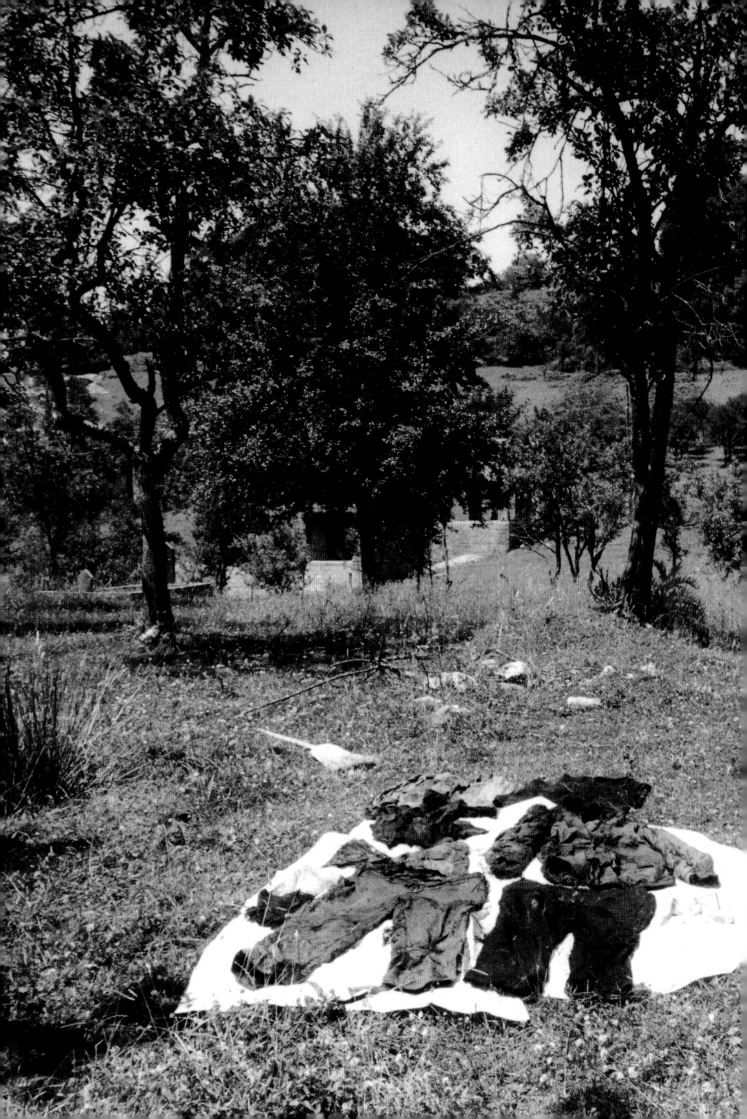

· Paul Lowe
UK, Magnum Photos

2ND **P**RIZE **S**INGLES

Clothes from an exhumed grave are laid out in a village in Bosnia. Later, the garments
would be shown to friends and family for clues as to the identity of the owner, a victim
of ethnic cleansing. Eighteen people from this village were killed during a Serb raid in
1992. This year survivors began to return. The Bosnian commission for missing
persons is carrying out many such investigations to identify remains, but there are
still thousands of missing persons following the years of conflict.

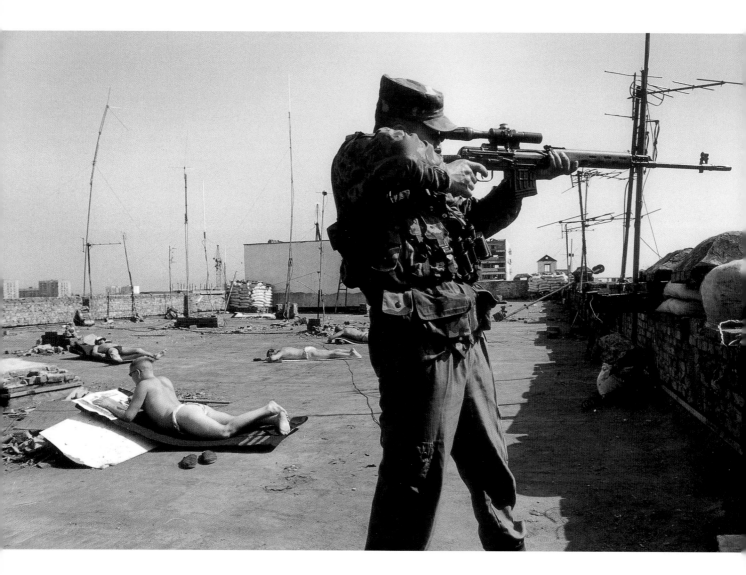

· Vladimir Velengurin
Russia, Komsomolskay Pravda

3RD **P**RIZE **S**INGLES

Russian soldiers sunbathe on a rooftop in Grozny in May, while a sniper stands guard.
Street fighting during the final stages of the capture of the city from Chechen rebels had
taken its toll, but by the spring Russian troops had established themselves. Although
the Chechen capital was razed and most citizens had fled, the rebels consolidated in the
surrounding hills and still posed a threat.

· Claus Bjørn Larsen
Denmark, Berlingske Tidende

HONORABLE MENTION SINGLES

A woman waits in the rain for food on the main road in Chókwé, Mozambique in March. The floods that ravaged
the country at the beginning of the year had practically destroyed the town. At one time the main road was the
only dry point, but by now the waters had begun to subside. Although South African army helicopters had helped
with rescue operations and delivering medical supplies in February, it wasn't until March that international
aid arrived.

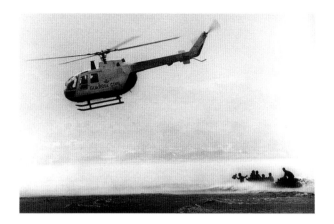

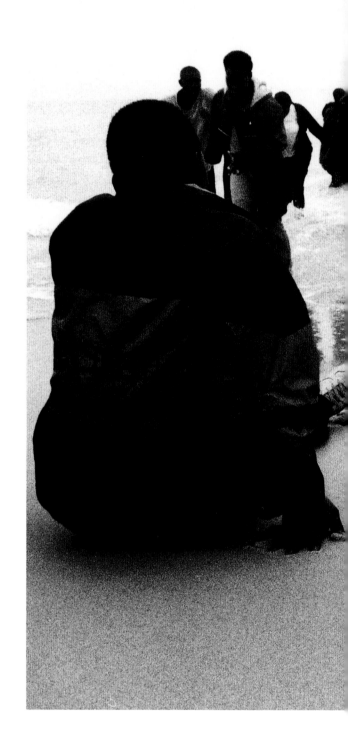

· Matias Costa
Spain, Agence Vu, France

1ST PRIZE STORIES

An estimated 500,000 foreigners entered the
European Union illegally in 2000. The short
passage from Morocco across the Strait of
Gibraltar to the Spanish coast was a frequently
used route. Small, overladen open boats often
sunk during the crossing; hundreds of people
drowned in this way. Immigrants who relied
on illicit traffickers had to pay up to US$ 3,000
to be smuggled in to Spain, often crowded
into the backs of trucks. Top and right: Police
intercept immigrants near the town of Tarifa.
(story continues)

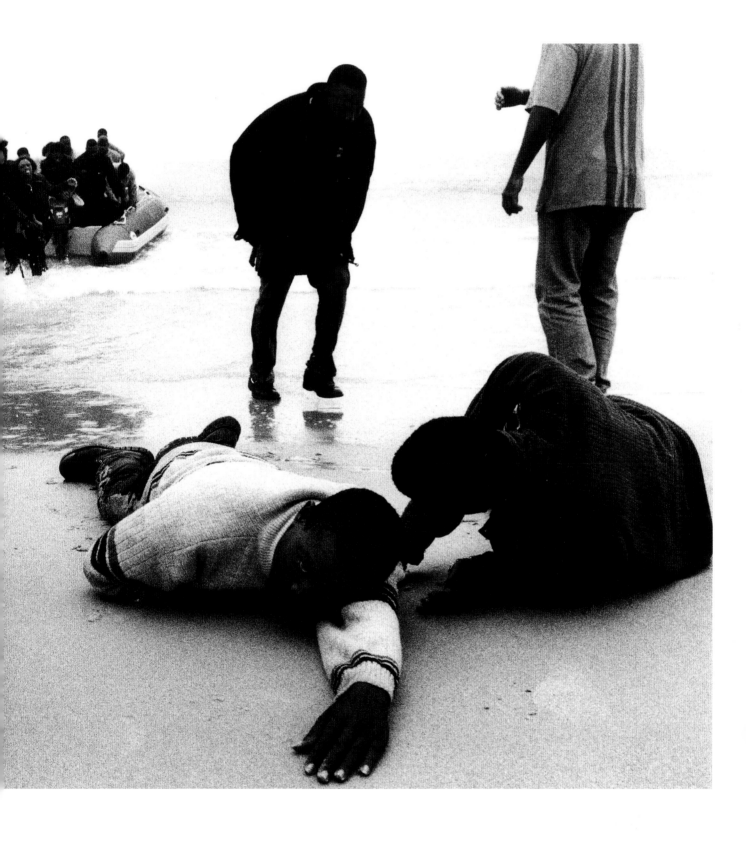

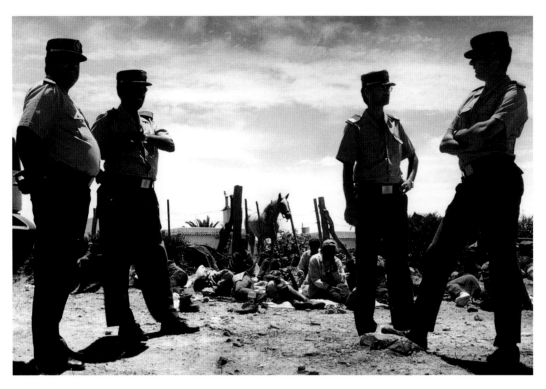

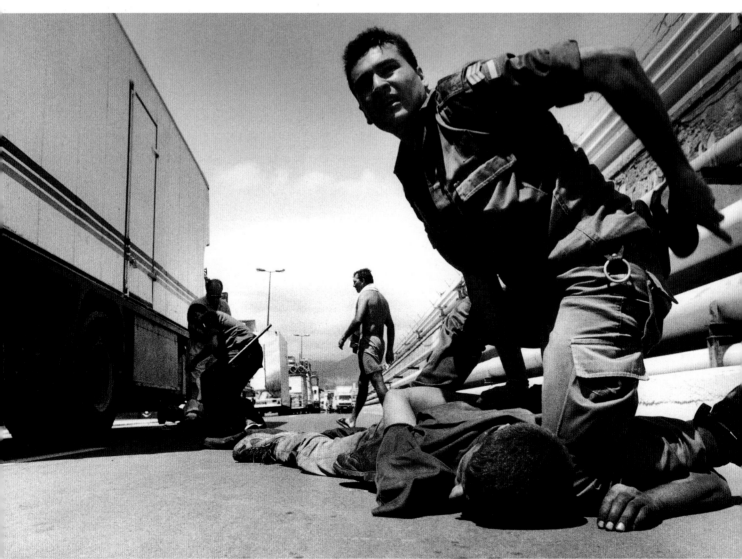

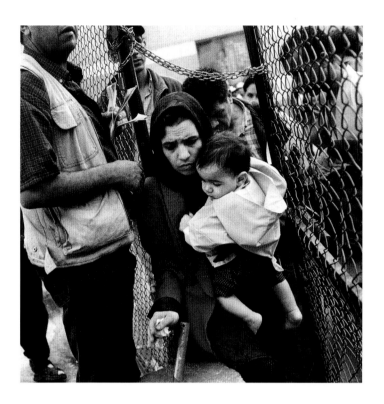

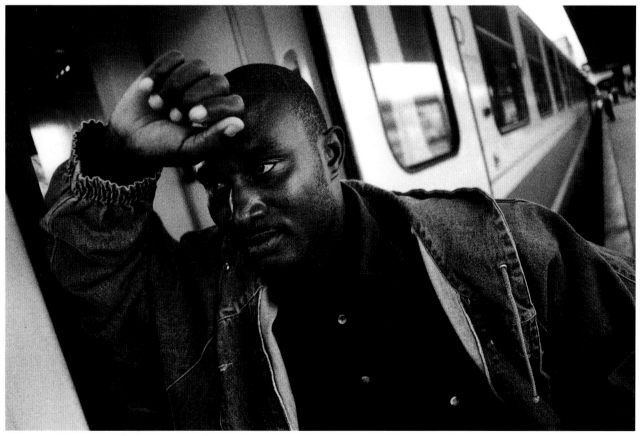

(continued) Spain tightened its immigration laws during the year. The authorities revealed that in two years they had arrested 70,000 illegal foreigners, but some estimates are that three quarters of the people who reach Spain are not detained. This page, below: From Spain many immigrants travel elsewhere in Europe. A man waits to board a train in the Spanish town of Algeciras.

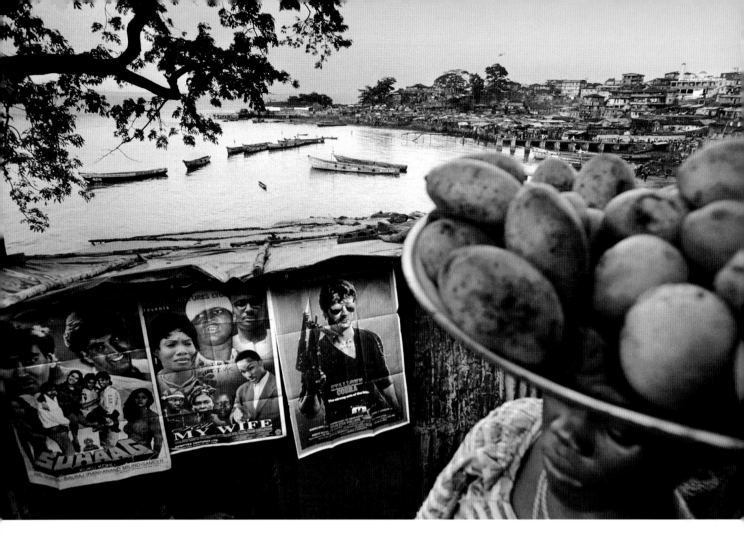
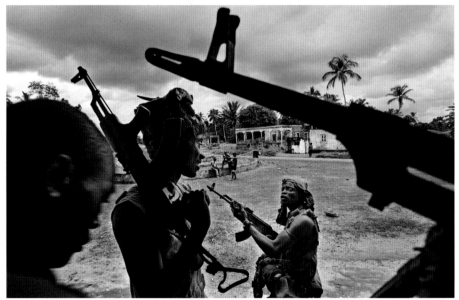

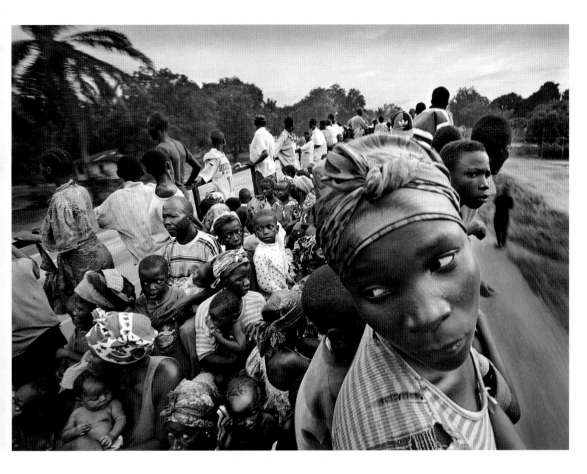

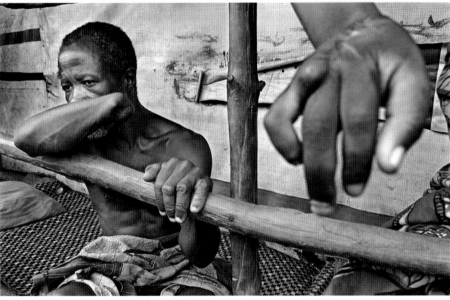

· Jan Dago
Denmark

2ND **P**RIZE **S**TORIES

The civil war between government and rebel forces in Sierra Leone continued to disrupt the country's economy, and led to internal displacement of the population. As rebels looted and burned down country villages, many people fled to the capital Freetown. Facing page, top: A view of Freetown. Below: Kamajor soldiers, who fight in support of government forces, control the Songo region north of Freetown. They wear amulets that they believe offer protection from bullets. This page, top: Displaced villagers head to Freetown. Below: Gibrilla Kamara had his hand amputated by rebels. He was told to sacrifice the hand with which he had voted for former president Kabbah.

· Jodi Bieber
*South Africa, Network Photographers
for The New York Times
Magazine, USA*

3RD PRIZE STORIES

In November there was an
outbreak of the Ebola virus in
Uganda. The virus causes massive
hemorrhaging, and is highly
contagious. There is no cure, and
it kills around half the people
infected. This page, top:
Ambulance workers have to wear
protective clothing and dare not
touch victims. Their job is to
transport the sick and bury the
dead. Below: Ebola patients and
suspected sufferers are housed in
isolated wards. Facing page:
Lilly is eight years old, and probably
caught the virus from her grand-
mother, who died of Ebola.
(story continues)

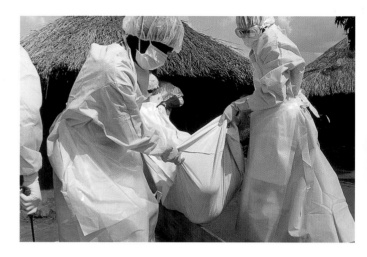

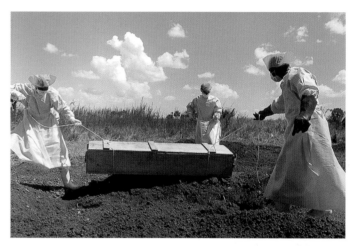

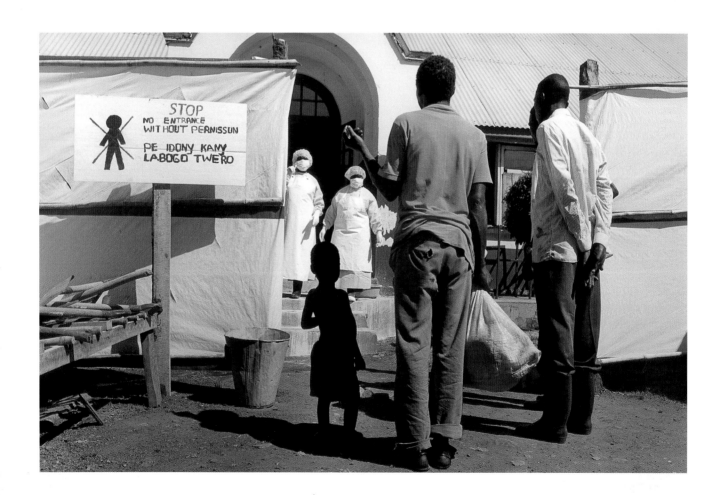

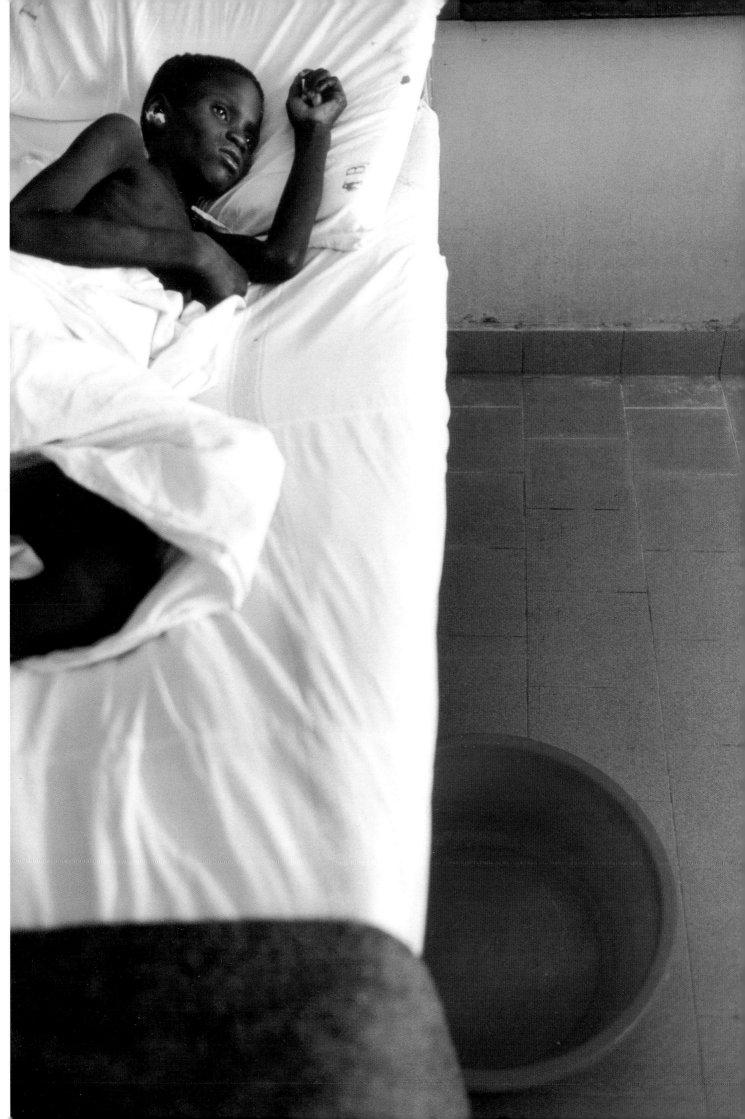

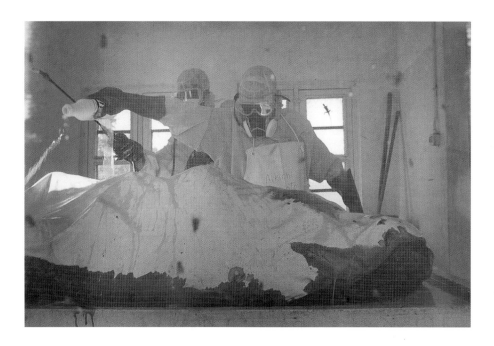

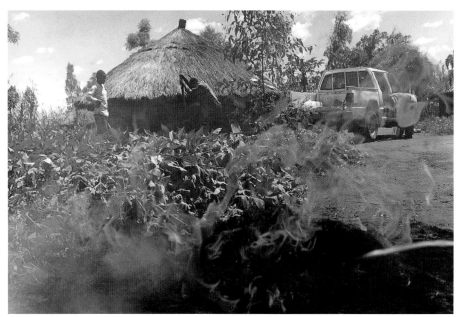

(continued) Traditional funeral ceremonies cannot be allowed for fear of the corpse infecting other family members. Top: Ambulance workers disinfect a body with bleach before burial. Below: Families may request a home burial and prepare a grave, but may not handle the body. Clothes and bedding of the deceased are burned.

Portraits

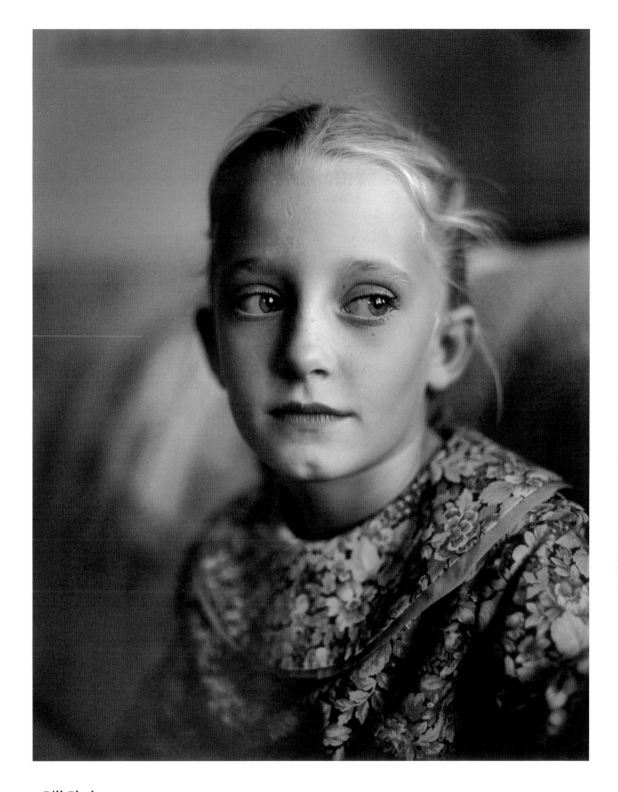

· Bill Phelps
USA, *for Fortune*

1ST PRIZE SINGLES

Eight-year-old Amy Martin suffers from Crigler-Najjar Syndrome, a rare inherited disease in which the liver lacks a key enzyme. The effects are toxic and often fatal. Phototherapy, especially with light in the blue spectrum, has proved effective in managing the disorder. Amy has to spend eight to 14 hours a day under special lamps, usually as she sleeps. She is soon to be given a newly developed gene therapy.

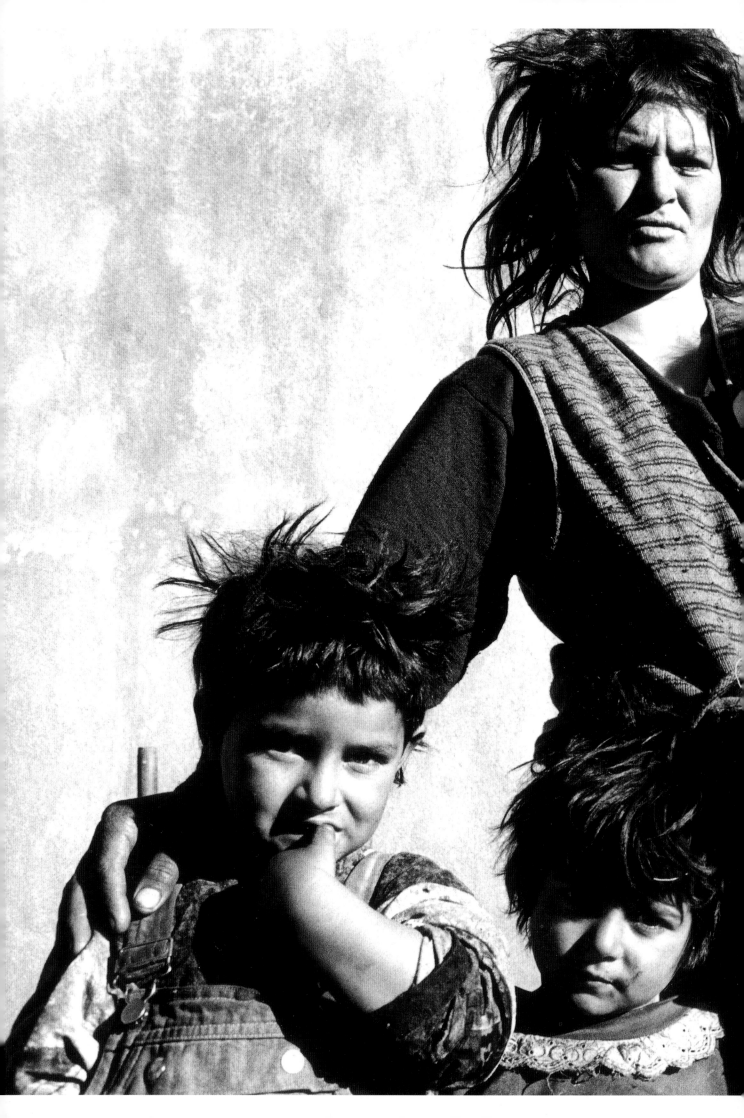

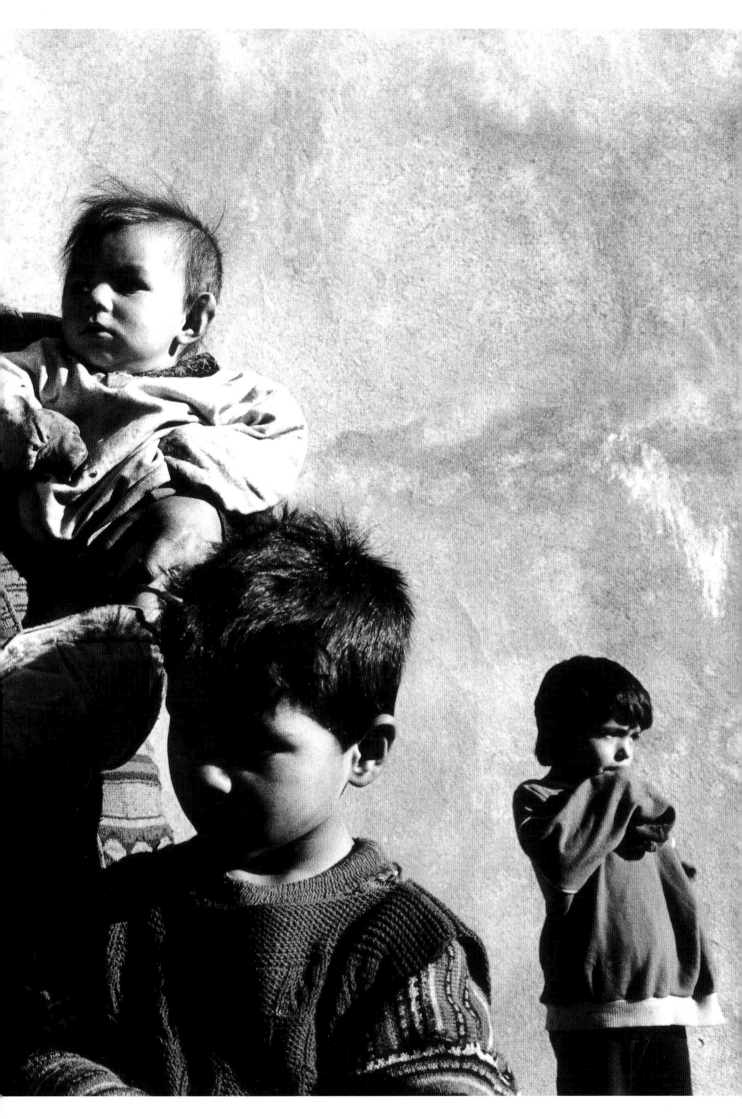

· Tim Georgeson
Australia, Cosmos, France for World Vision Australia

2ND PRIZE SINGLES

(previous page) The Shola family stand outside their temporary home in the Konik refugee camp, near Podgorica, Montenegro. Together with most other Roma, the family were forced out of Kosovo in mid 1999, when ethnic Albanians were returning. The Kosovo Roma had been accused of siding with the Serbs. The wave of anti-gypsy violence in Kosovo was the most severe since the holocaust of the Second World War, and thousands were displaced. By March there were around 8,000 Roma estimated to be living in Montenegro. Western European countries generally gave them only temporary protection rather than full refugee status.

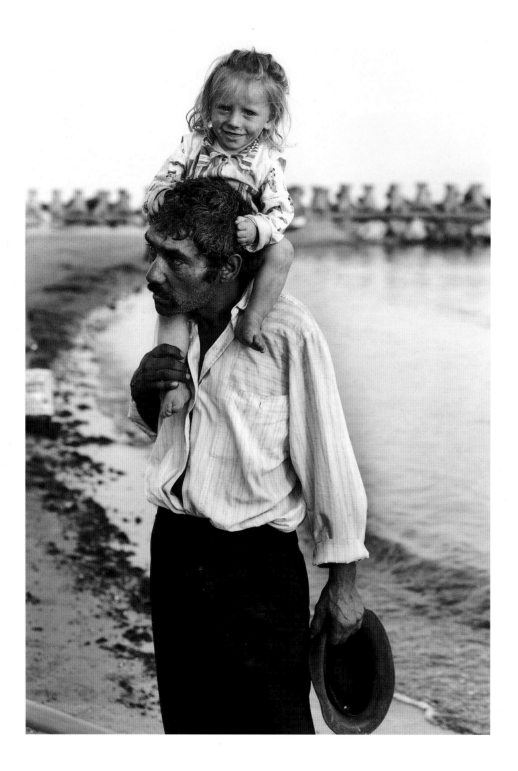

· Alessandro Albert &
Paolo Verzone
Italy, Agenzia Grazia Neri

3RD PRIZE SINGLES

Roma beachcombers on Venus Beach on the Black Sea, Romania. Just before sunset, when the beach empties of bathers, Roma families arrive to pick up what they can for recycling. The photographers are spending three summers making a series of portraits of people on beaches around Europe.

· Hien Lam-Duc
France, Agence Vu

1ST PRIZE STORIES

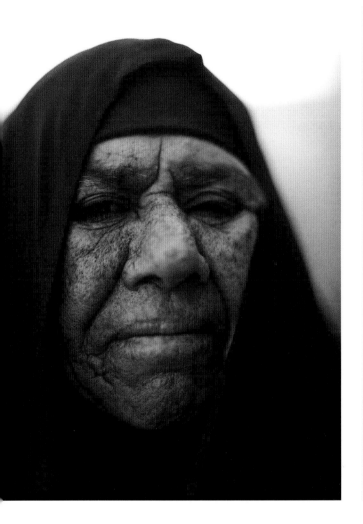 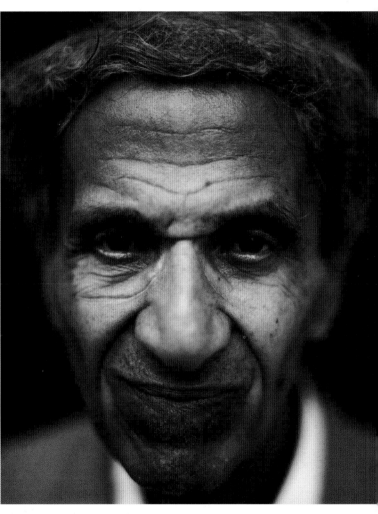

Walking the streets in and around Baghdad for hours on end, the photographer came face to face with a wide range of Iraq's inhabitants. Left: A woman in the market place of Sadam City, northeast of Baghdad. Right: Saleh Al Karagoli, a sculptor. Following pages: Oum Khfider in the Khadamya quarter; 52-year-old Khadhum Judes; a young girl.

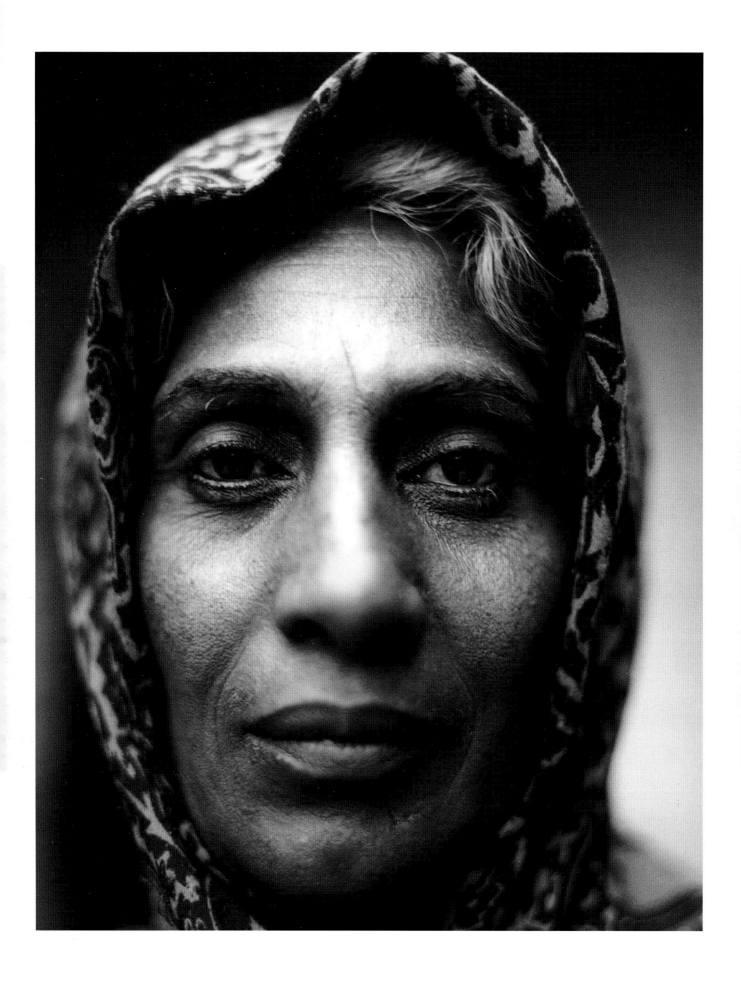

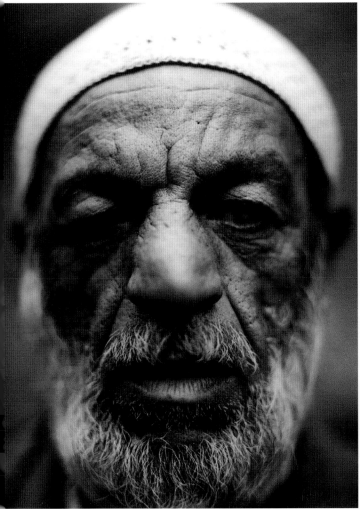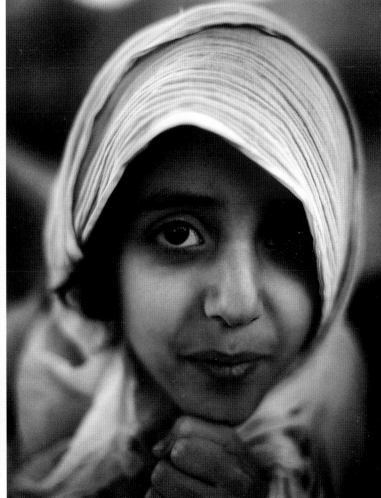

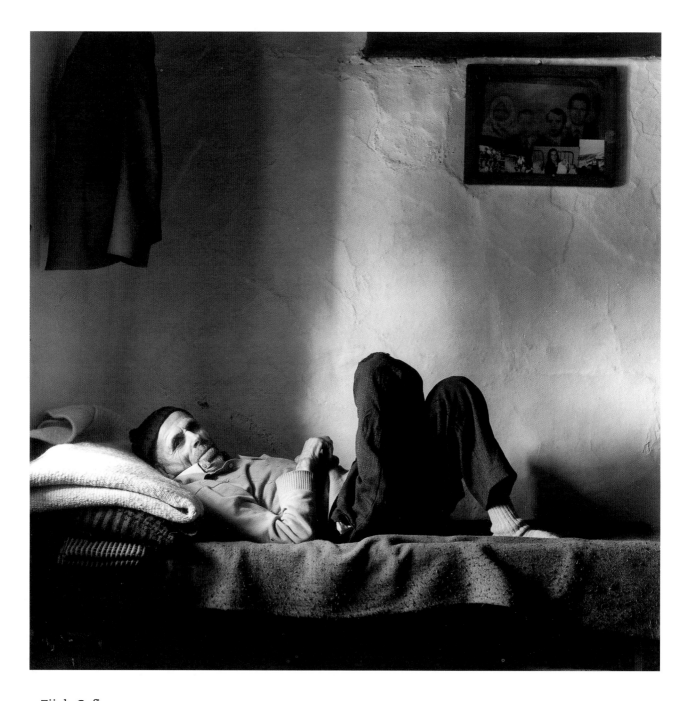

· Zijah Gafic
Bosnia Herzegovina

2ND PRIZE STORIES

Residents of Lukomir, a remote village in Bosnia. High on the Bjelasnica mountain, at the edge of a
ravine, the hamlet has been untouched by any of the wars of the 20th century. There is no electricity
or running water, and the 16 inhabitants live on what they can produce. The village is often under
heavy snow and is isolated for much of the year. Most of the young people have left. Nearly everyone
is over 60.

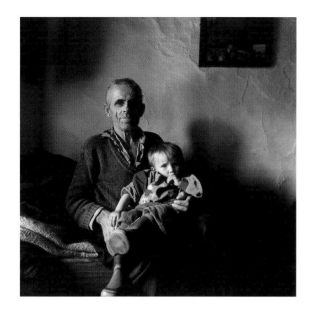

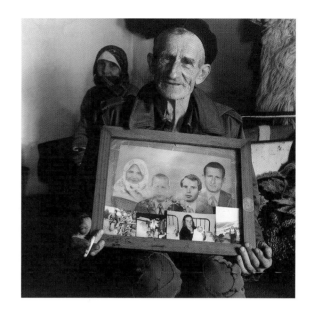

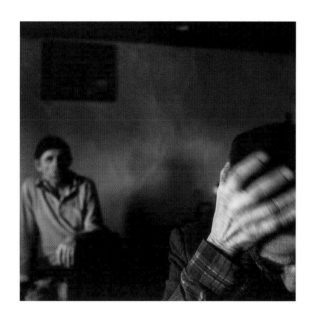

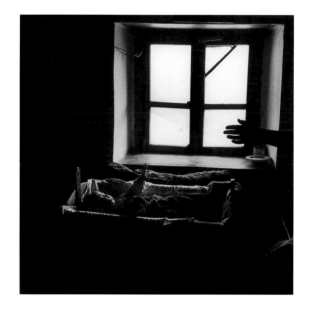

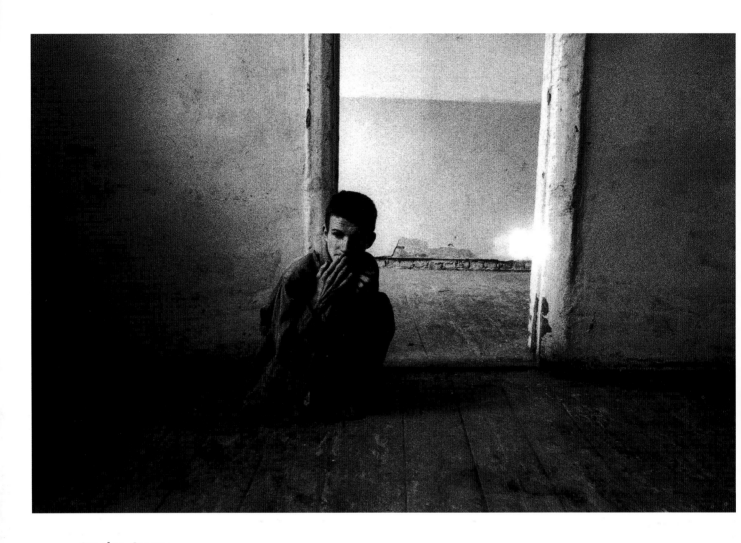

· Stanley Greene
USA, Agence Vu, France

3RD PRIZE STORIES

Forgotten refugees from
Chechnya. Following the Russian
bombardment of Chechnya, many
people fled to neighboring
Ingushetia. The 80 old or mentally
ill residents of Katayama House in
Grozny were left behind.
Journalists and Chechen separa-
tists made two buses available for
their escape, but the buses were
fired on and three people died.
(story continues)

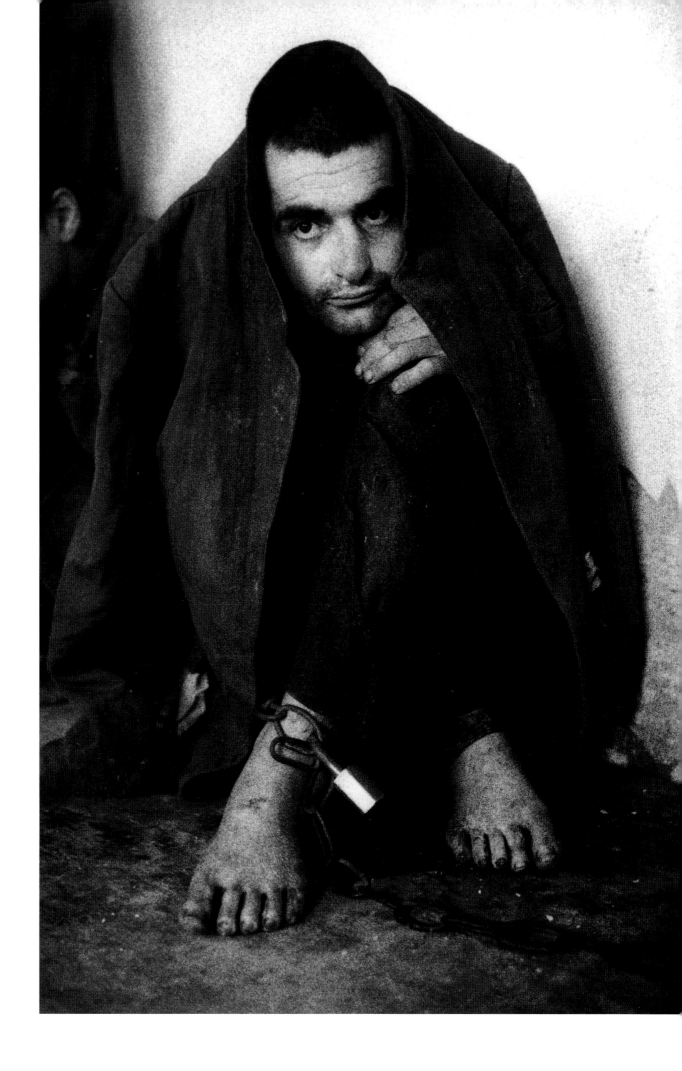

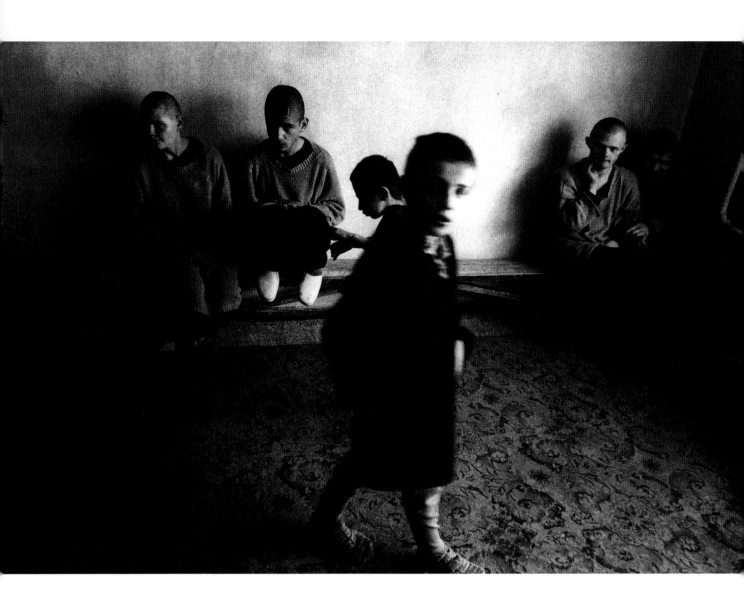

(continued) Once in Ingushetia
the refugees were housed in an
asylum for mentally ill children.
Some were chained to the walls,
and those who were Russian were
sent to Russia. Many of the others
have now returned to Grozny.

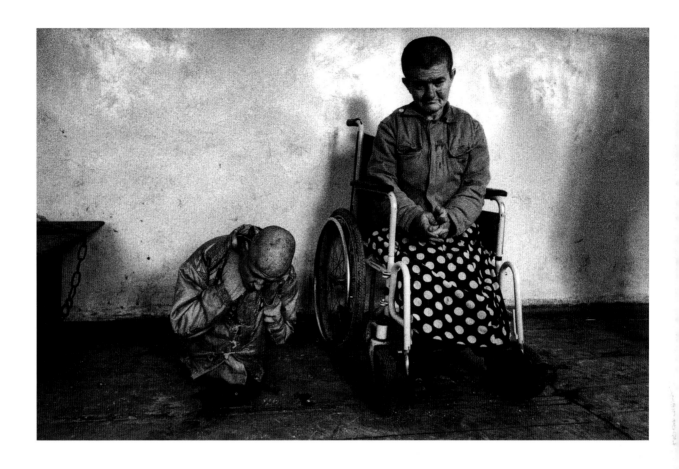

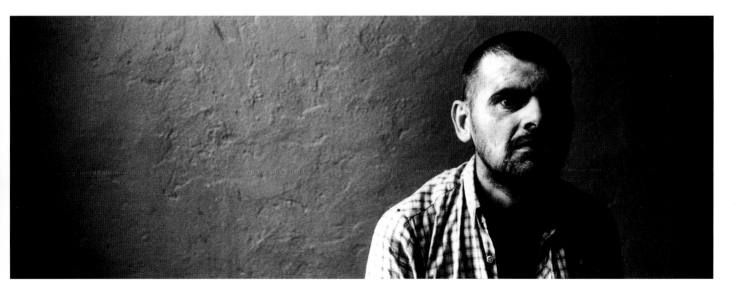

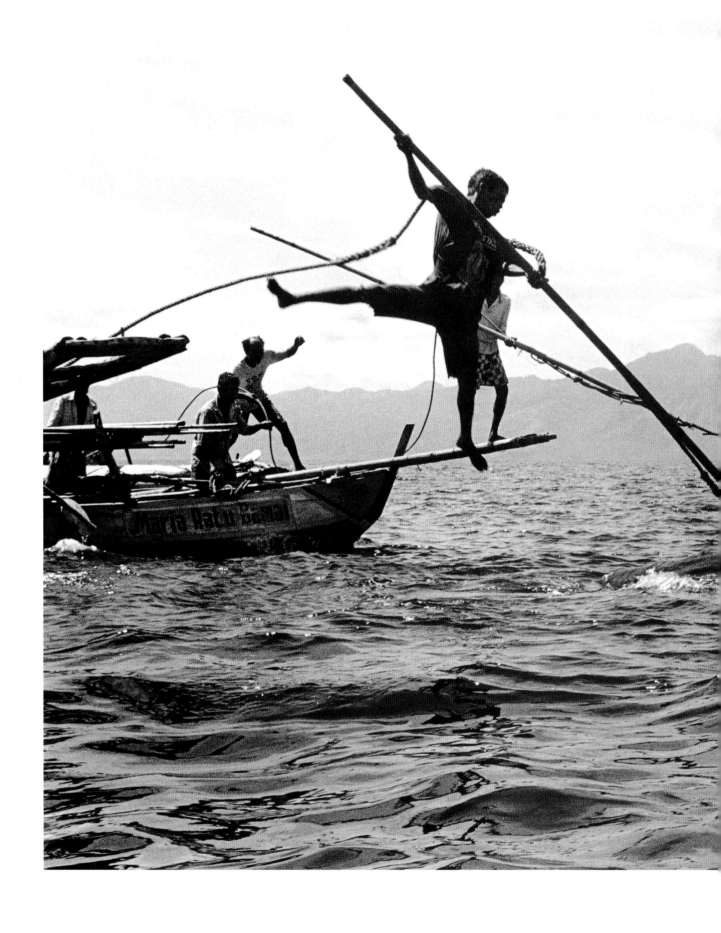

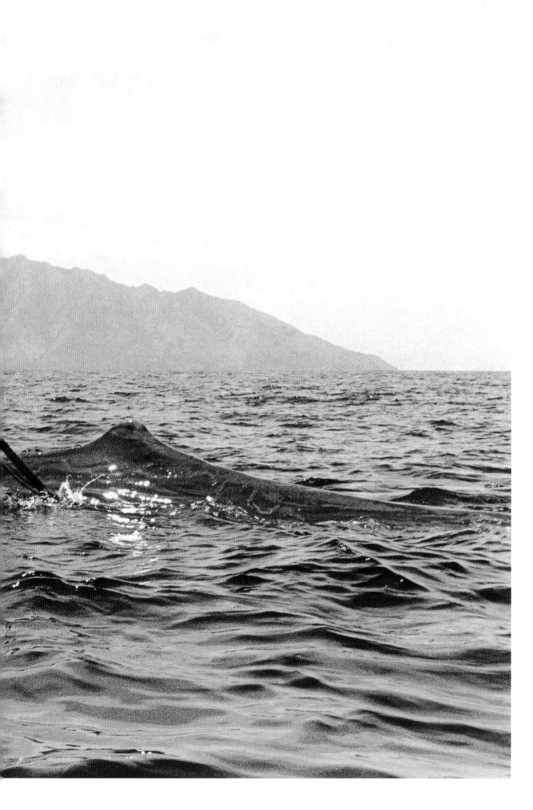

· Bo Thomassen
Denmark

1ST PRIZE SINGLES

A traditional whaler harpoons a sperm whale in waters off the village of Lanalera on Lembata Island, Indonesia. The men hunt using wooden boats and hand-held harpoons. They put their entire weight behind the harpoon, jumping on to the whale's back to spear it. This does not kill the whale. Instead, a number of boats harpoon the animal, and it swims around dragging the boats behind it until it is tired out. Then the men pull it alongside and kill it with knives. Whaling is not only a means of subsistence, but is part of the local belief and ceremonial system. The villagers are exempt from the international ban on whaling under clause that allows similar aboriginal communities to follow traditional practices.

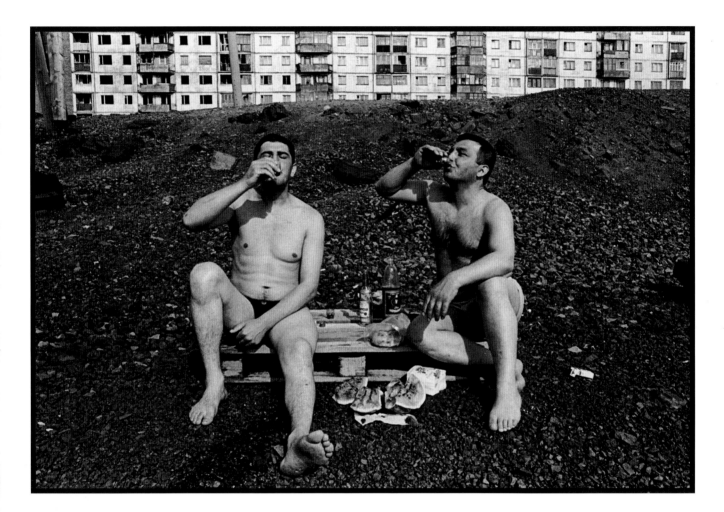

· Jacqueline Mia Foster
USA

2ND PRIZE STORIES

Workers sun themselves on a slag heap in the Russian industrial town of Noril'sk, north
of the Arctic Circle. Built in the 1930s, Noril'sk has little vegetation, and toxic gases from
its industries pollute the countryside for miles around. The workers are from Dagestan, a
republic far south on the Caspian Sea. Here their beach comprises waste products from
the smelting of copper, nickel and cobalt.

· Andrés Salinero
Argentina

3RD PRIZE SINGLES

A boy walks through a public bathing area in the seaside town of Mar del Plata, on the Atlantic coast of Argentina. The town is a popular resort, attracting millions of visitors throughout the summer.

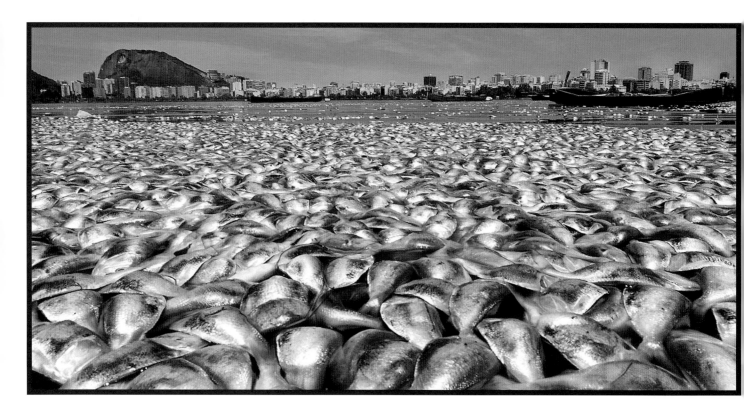

· Antonio Scorza
Brazil, Agence France Presse

HONORABLE MENTION SINGLES

Thousands of dead fish lie on the shores of the Rodrigo de Freitas lagoon in southern Rio de Janeiro, during carnival time in early March. Waste leaking from a sewerage pipe that ruptured when the system became overloaded had contaminated the lake. The pollution promotes growth of weeds and algae, which consume oxygen in the water. Warm temperatures made the situation worse. The incident provoked a demonstration by 10,000 local residents.

· Trent Parke &
Narelle Autio
Australia, Oculi Photos for
Sydney Morning Herald

1ST PRIZE STORIES

Thousands of Australia's
native animals are killed
annually on the expanding
network of roads crossing
the outback. Right: The
venomous Australian brown
snake is drawn to the warm
road to raise its body
temperature. (story continues)

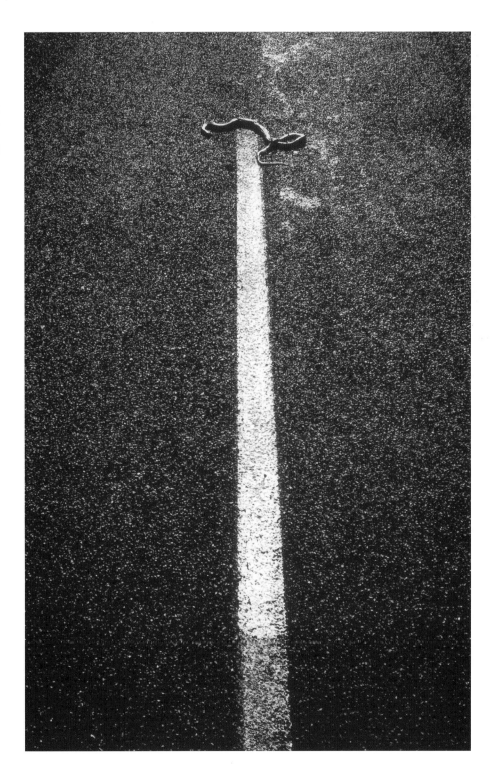

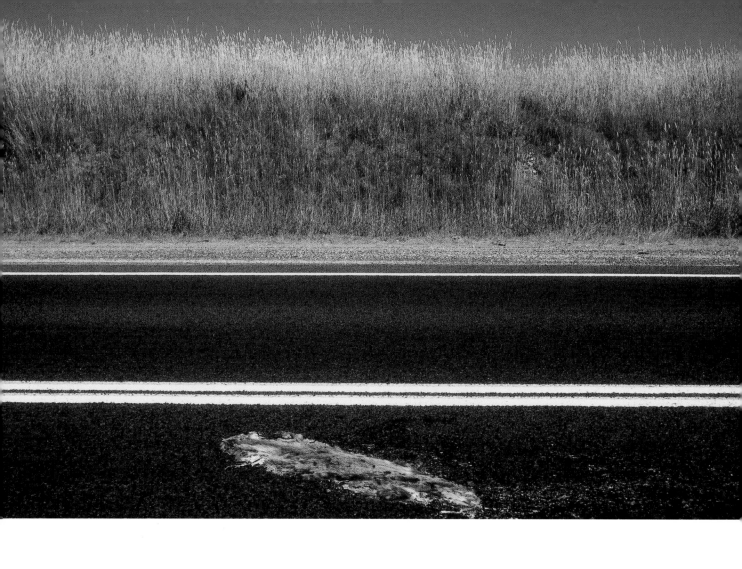

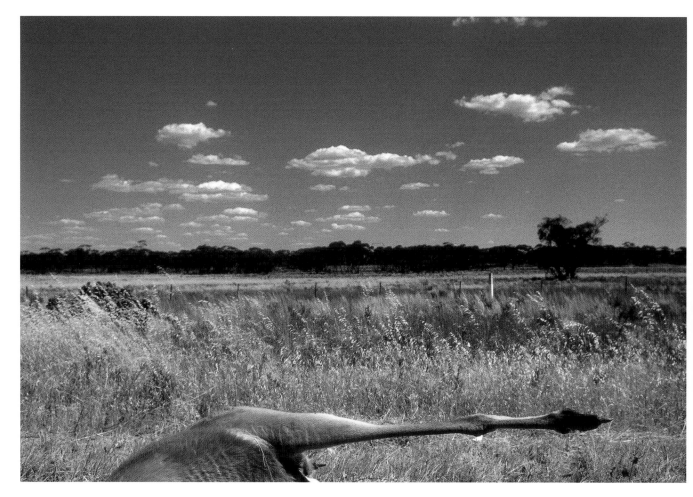

(continued) Housing developments and deforestation have already reduced natural habitats, and roads add a further hazard for local fauna. Facing page, top: Some animals are thrown to the roadside, others are run over again and again by cars traveling too fast to stop. Below: Kangaroos are common victims. This page, clockwise from top: A bearded dragon lizard; a sulfur-crested cockatoo, and a galah, which feeds on seed along the roadside.

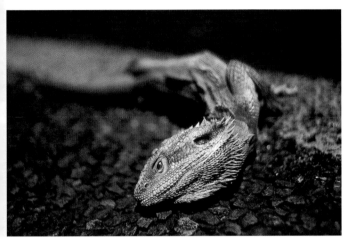

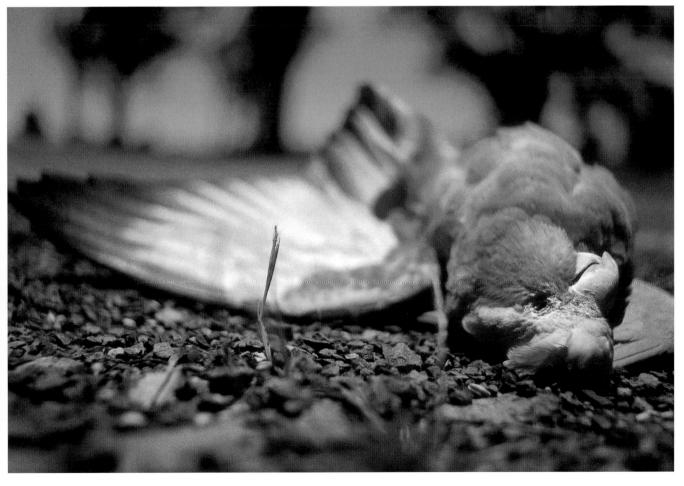

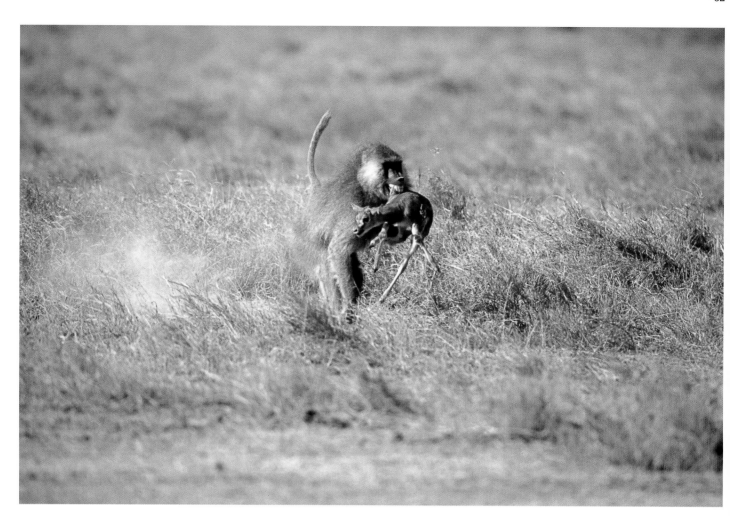

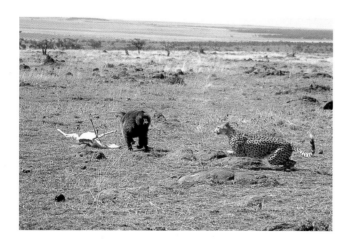

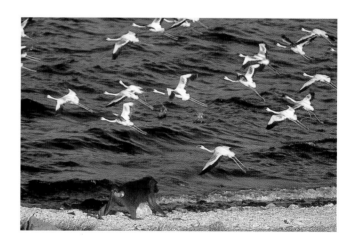

· Michel Denis-Huot
France

2ND PRIZE STORIES

Over the past decade it has become increasingly apparent to
zoologists that not all primates are purely herbivorous. Baboons
are skilled animal hunters, but are mainly opportunists, attacking
vulnerable younger animals and stealing the prey of other predators.
Whether or not a baboon eats meat appears to depend on the
troop it is with. This page, below left: A baboon steals a gazelle
from a cheetah, at Masai Mara in Kenya. Facing page, top: A troop
of baboons at Lake Bogoria in Kenya have developed a taste for
dwarf flamingos. Below: Baboons have highly developed
canine teeth.

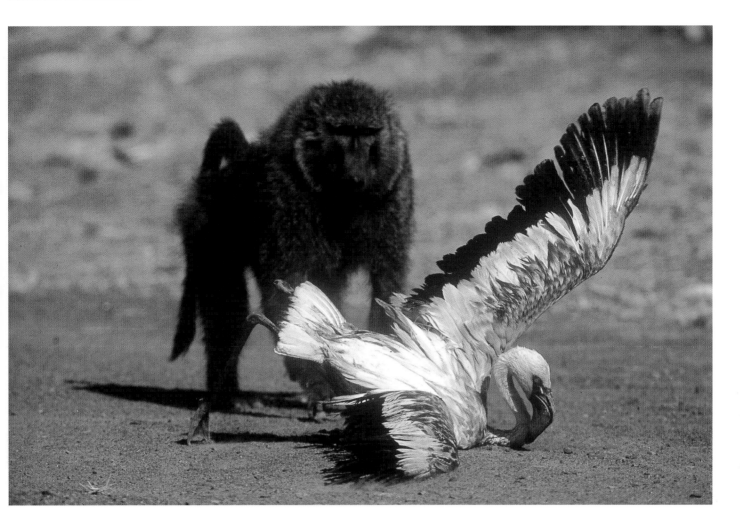

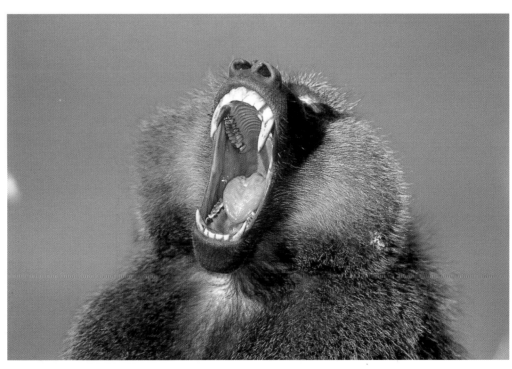

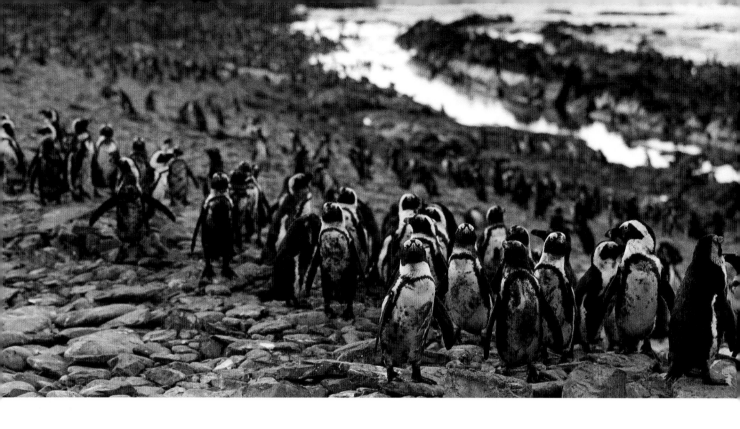

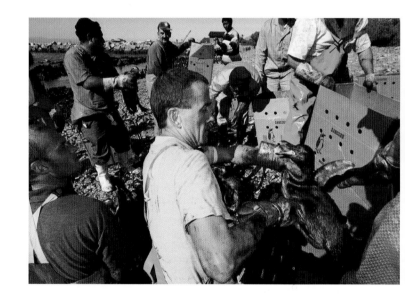

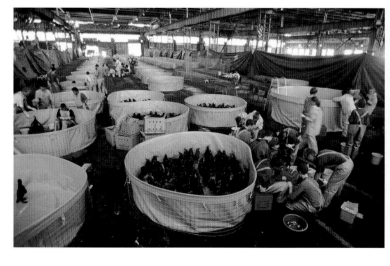

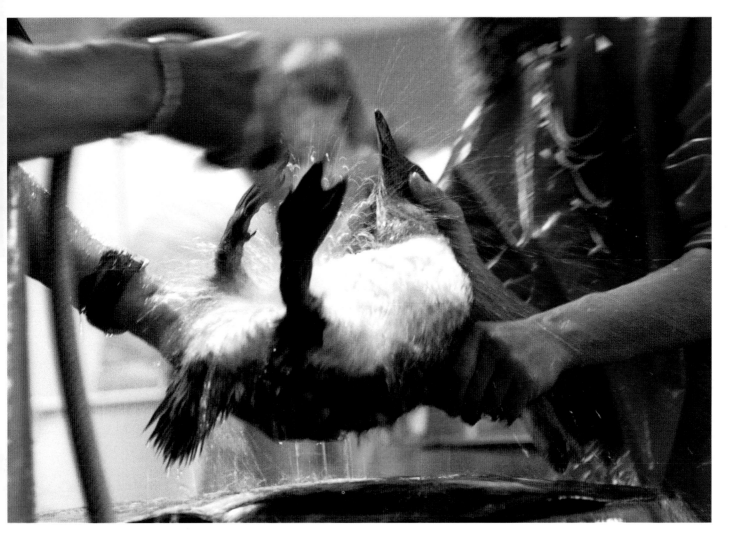

· Jon Hrusa
South Africa, for The International Fund for
Animal Welfare

3RD PRIZE STORIES

An oil spill following the sinking of the *MV Treasure* off Cape Town in June threatened colonies of African penguins, an endangered species. Over 40 per cent of the African penguin population live on nearby Robben and Dassen islands. Around 12,000 volunteers from across the world joined in a rescue mission. Facing page, top: Robben Island is home to some 18,000 penguins. Middle: Distressed penguins are loaded into boats for transport from the island. Below: Portable swimming pools were constructed in a disused railway warehouse to accommodate the oil-covered birds. (story continues)

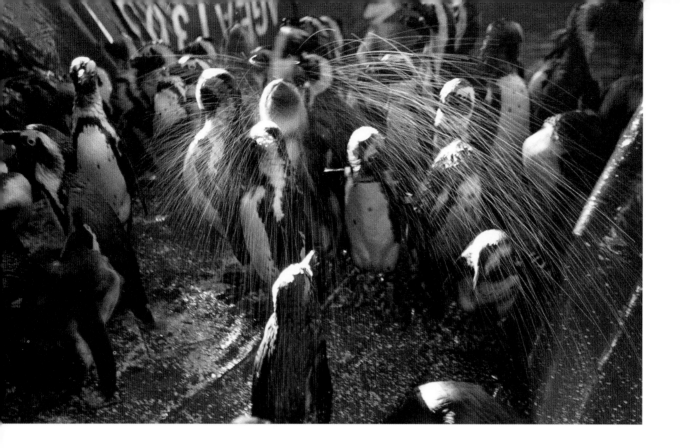

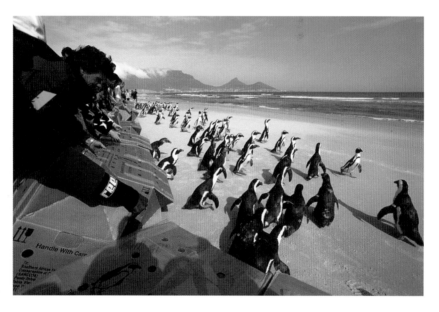

(continued) By the end of the operation, nearly all the affected birds had been returned to the wild. Top: Penguins shake off water after a swim, which completes the rinsing process and helps re-waterproof their plumage. Below: Penguins are released bearing pink dye marks that enable researchers to monitor their progress.

The Arts

· **Angelo Turetta**
Italy, Agenzia Contrasto

1ST PRIZE SINGLES

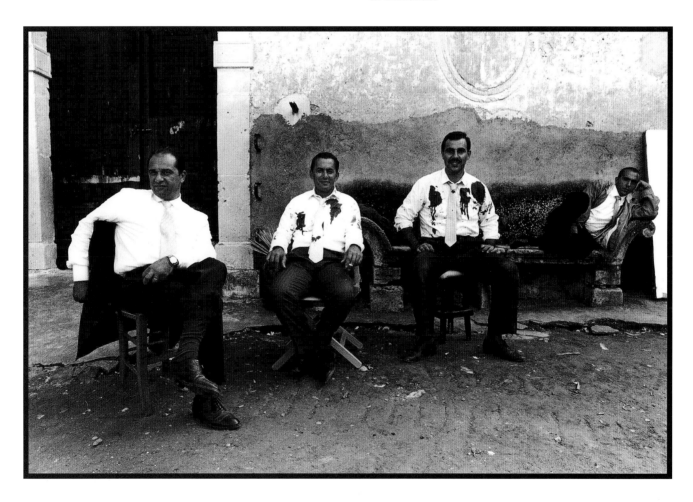

Actors from the Italian television series *La Piovra* (The Octopus) take a break after a Mafia assassination scene. *La Piovra* attracts millions of viewers across the country. Its focus on the relationship between organized crime and politics has in the past brought fiction close to reality, with some episodes uncannily foreshadowing the future. Both Church and Government have previously expressed displeasure with the series.

· Jordis Antonia Schlösser
Germany, Ostkreuz for Merian

2ND PRIZE SINGLES

A girl prepares to have her portrait
taken in celebration of her 15th
birthday, in Mayarí, eastern Cuba.
'La fiesta del quince' traditionally
marks a girl's initiation into
womanhood. Her family will go to
great lengths to ensure that she
has a glamorous and memorable
day.

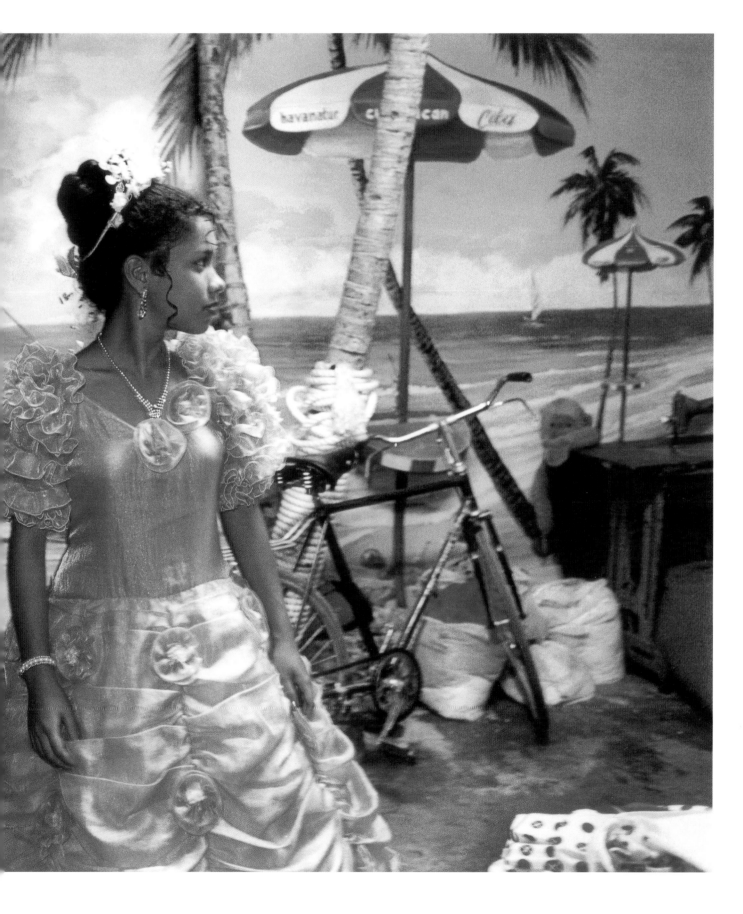

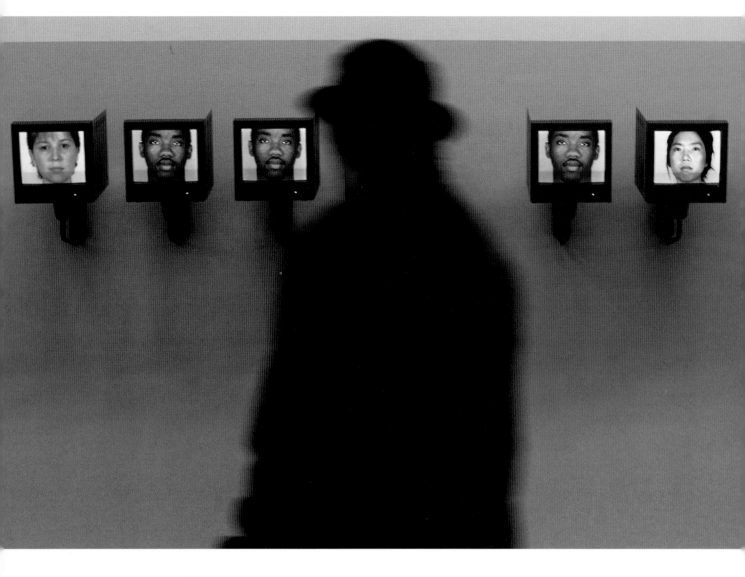

· Fred Squillante
USA, The Columbus Dispatch

3RD PRIZE SINGLES

A video installation at the Wexner Center for the
Arts in Columbus, Ohio. The installation, *Clock* by
Iñigo Manglo-Ovalle, took the form of a countdown
clock running from January 1 2000 to the start of
the millennium in 2001. Human portraits were
substituted for digits on 16 monitors, representing
year, month, day, hour, minute, second and fractions
of a second.

· T.J. Lemon
South Africa, Sunday Independent Newspaper

1ST PRIZE STORIES

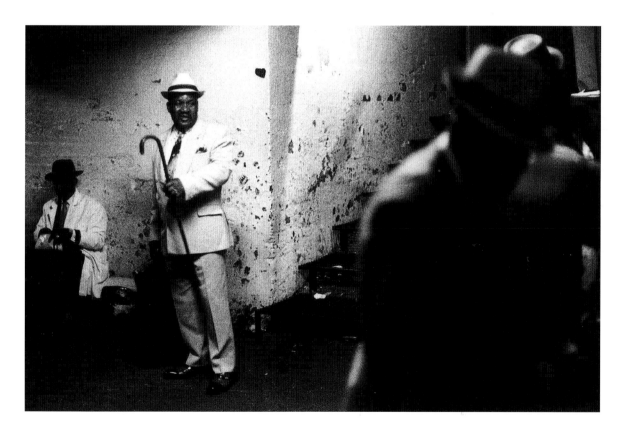

Every Saturday night, 'swankas' gather at Jeppe Hostel in downtown Johannesburg. They compete in a style contest for a prize that is a portion of pooled entrance fees. Smart suits, hats, and handkerchiefs in breast pockets are very much part of the image. Competitors are also judged on the moves and turns of their performance. Above: A snappy American style was popular among black South Africans when the competitions began in the 1950s, and still characterizes swanka culture. (story continues)

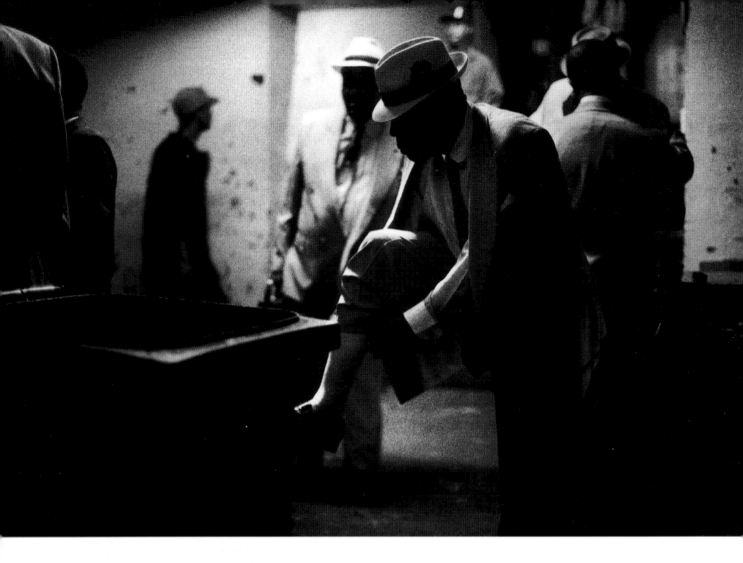

(continued) The event takes place in the hostel basement, which also serves as a storeroom. Although they are poorly paid workers, swankas may invest in a number of expensive suits and shoes. Accessories, such as lapel brooches and tiepins, are important, as are things that match: tie, socks and handkerchief, perhaps. After the show, swankas don dustcoats and leave for the next venue.

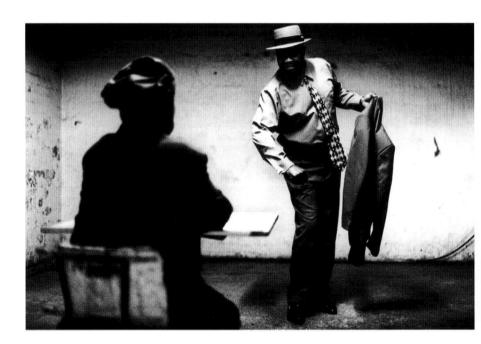

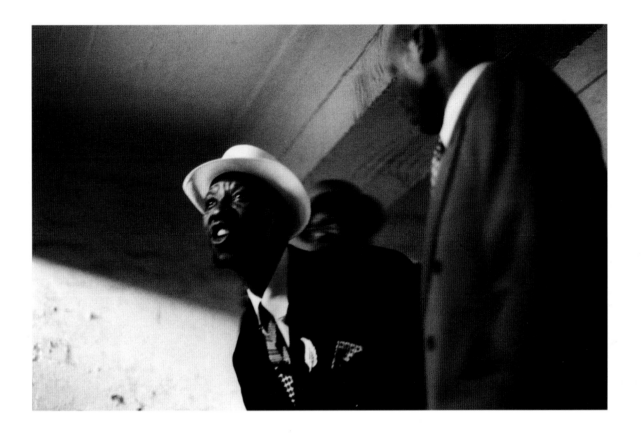

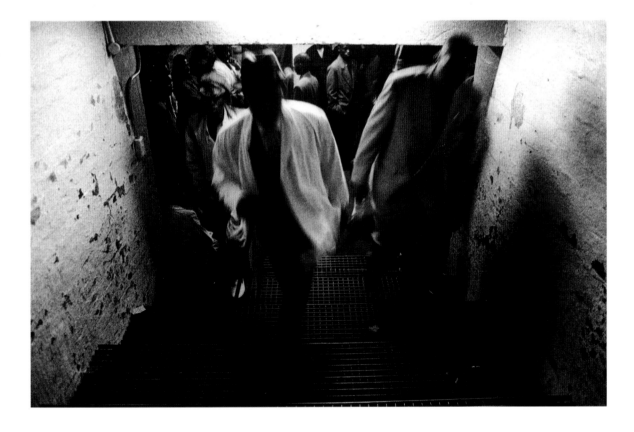

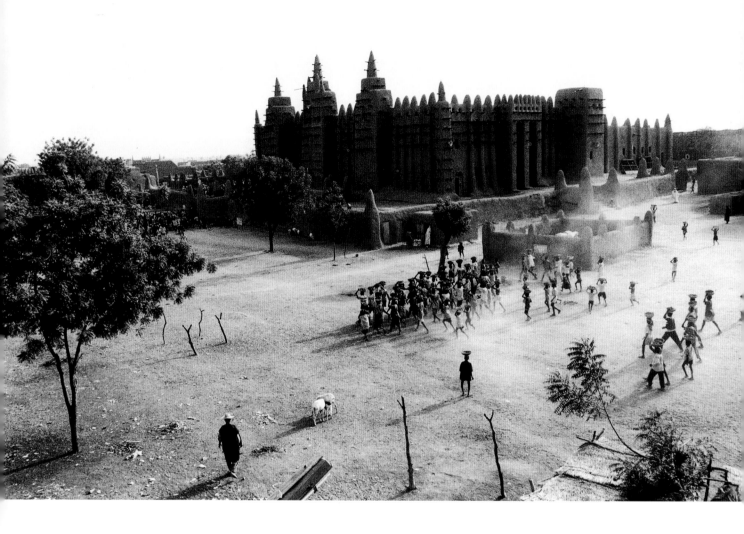

· Christien Jaspars
The Netherlands, Panos Pictures, UK

2ND PRIZE STORIES

The great mosque of Djenné in Mali, West
Africa is considered a masterpiece of traditional
adobe architecture. Djenné itself is one of the
oldest towns in Africa, and has been on
UNESCO's World Heritage list since 1988. The
re-plastering of the mosque is an annual event.
Each year during the rainy season the thin
outer layer of plaster is washed away, and has
to be replaced to protect the building from
deterioration. Right: Men hold heavy ladders
enabling others to climb the walls. Facing
page, top: Boys bring mud on donkey carts to
the foot of the mosque. Below: Hungry helpers
are fed throughout the day. Next page:
Decorative boxwood protuberances also provide
footing for climbing the walls.

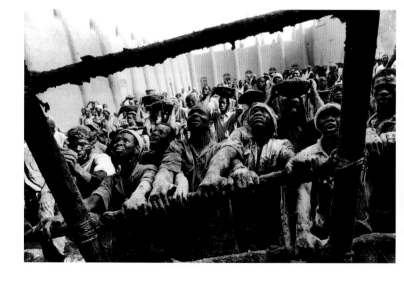

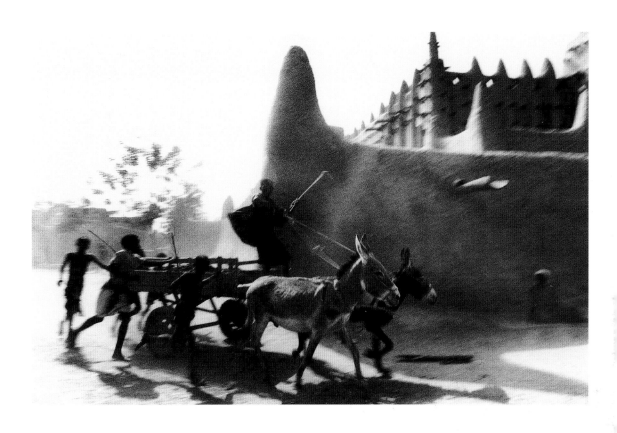

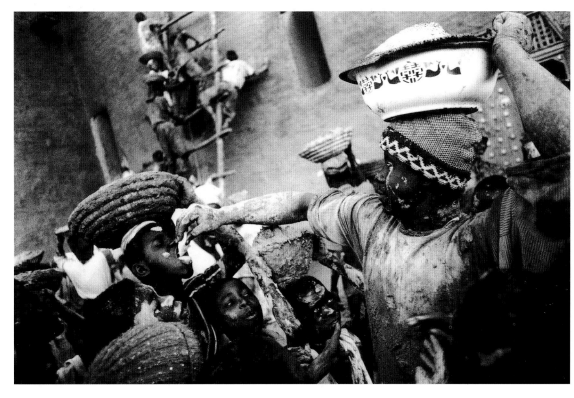

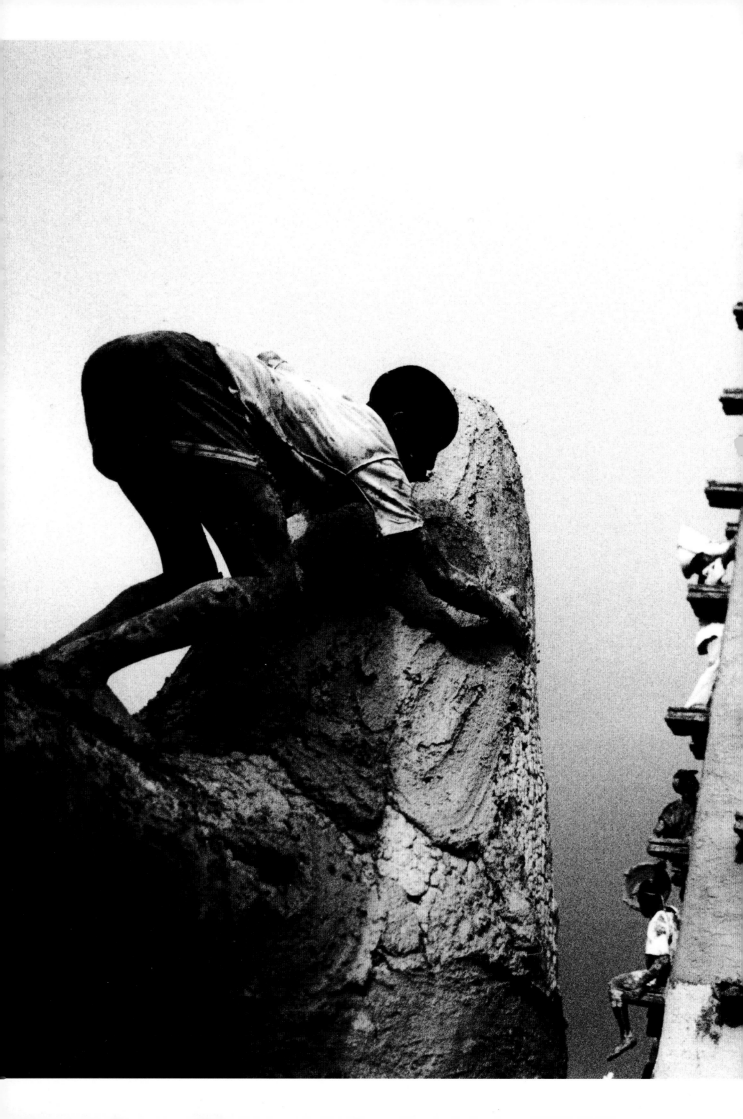

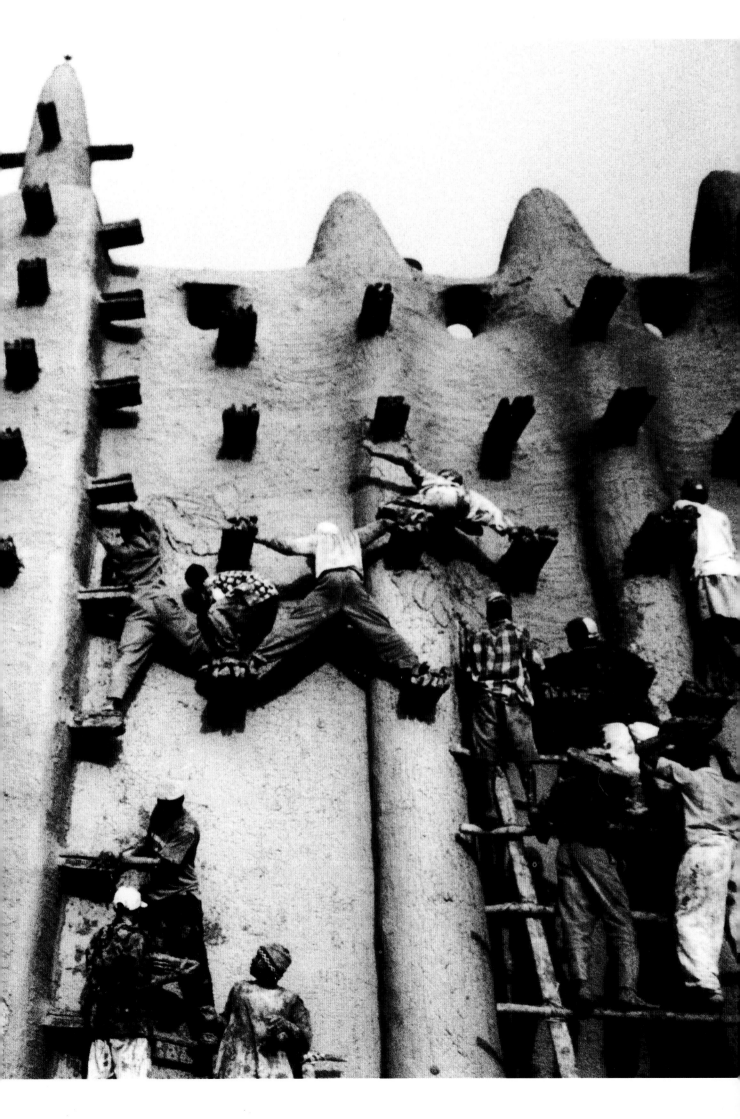

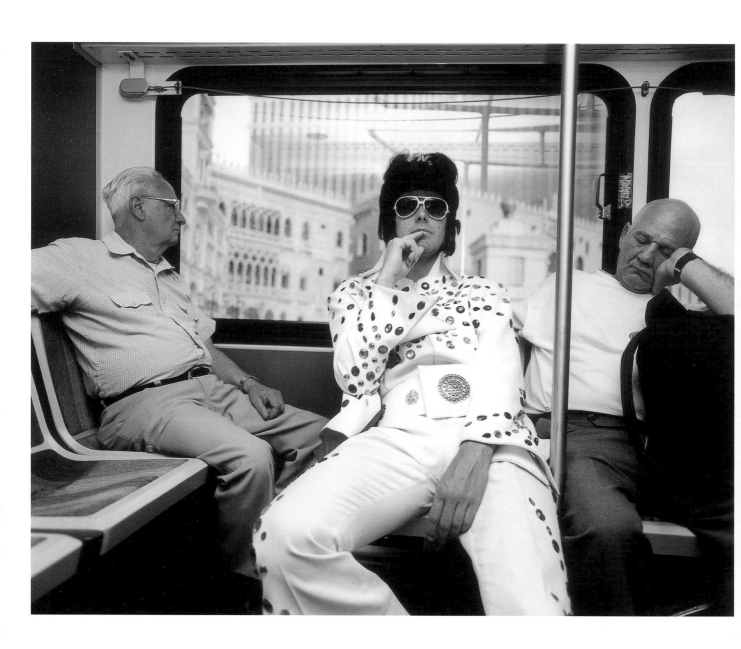

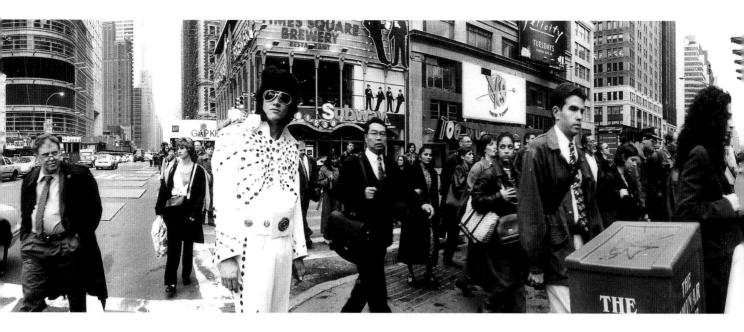

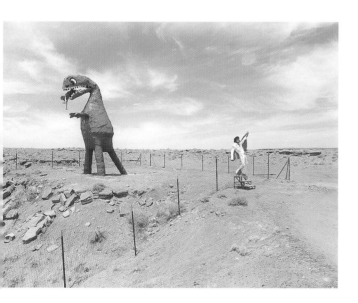

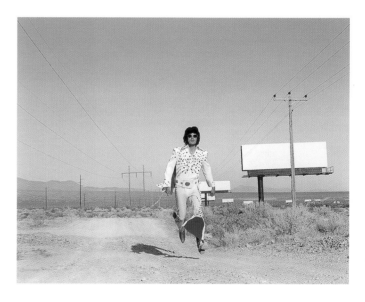

· Stephan Vanfleteren & Robert Huber
Belgium/Switzerland for Lookat Photos

3RD PRIZE STORIES

As 'Elvis & Presley' the photographers spent three weeks crossing the USA. Along the way they photographed each other, with Presley (Vanfleteren) pictured in black-and-white and Elvis (Huber) in color. Clockwise from top left: On Staten Island ferry; at the intersection of Broadway and 42nd Street, New York; in Pahrump, Nevada; dinosaurs near Holbrook, Arizona; and on public transport in Los Angeles.

· Harald Henden
Norway, Verdens Gang/Black Star

1ST PRIZE SINGLES

A man and a child embrace in Murray Camp, Freetown, in Sierra Leone. The camp is supported by Médecins Sans Frontières and functions specifically to help amputees. Thousands of civilians have had their limbs cut off by rebel fighters in the course of Sierra Leone's civil war. The camp helps teach victims how to fit artificial limbs and how to be as independent as possible.

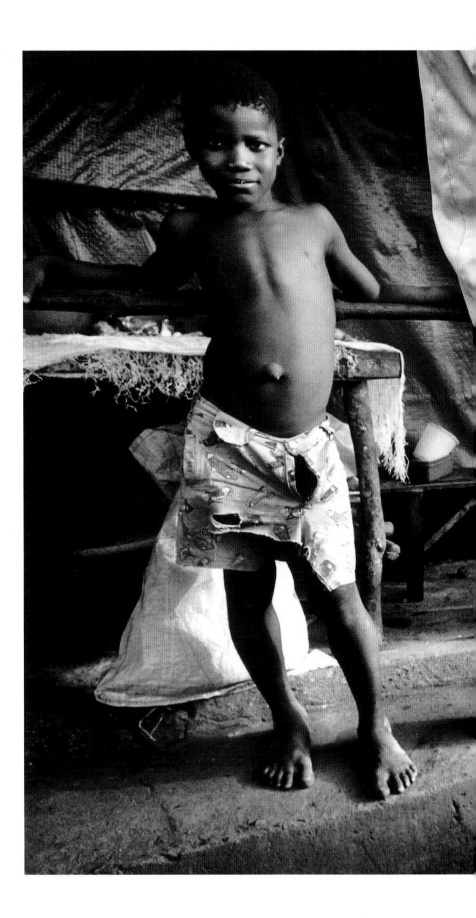

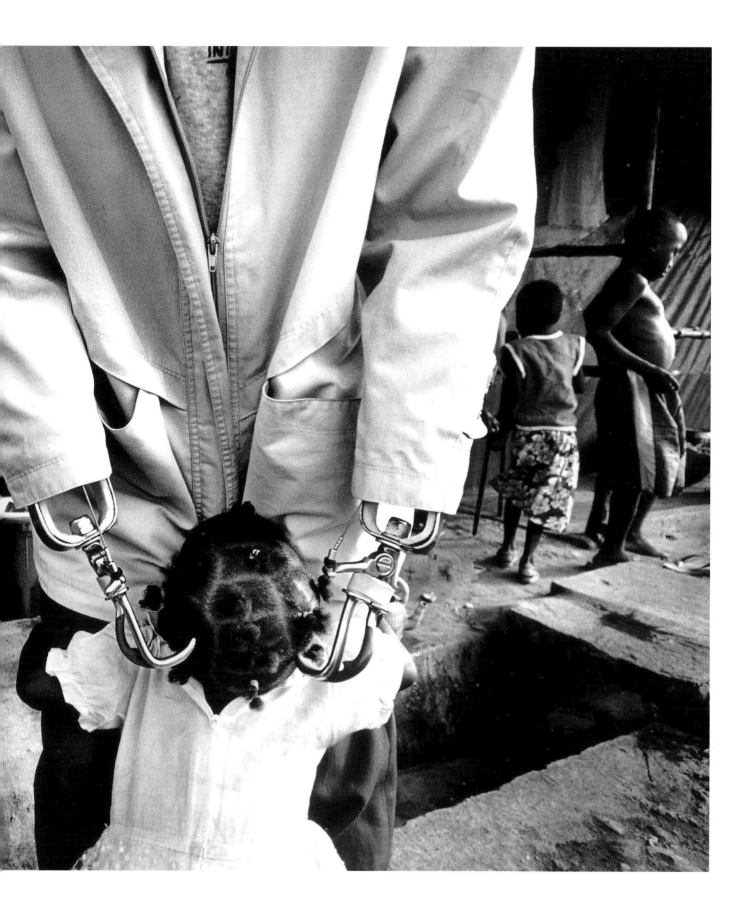

· David White
UK, Katz Pictures

2ND PRIZE SINGLES

Trainee cosmonaut Yuri Lonchakov gets ready to climb into his space suit at the Gagarin Cosmonaut Training Center, popularly known as Star City, just outside Moscow. The undersuit he is wearing has a complex network of water pipes sewn into it that will help regulate his body temperature when he is in space.

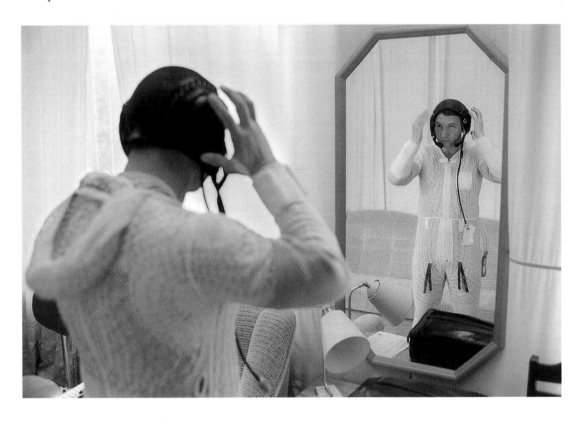

· Oliver Meckes & Nicole Ottawa
Germany, for Biomedpark

3RD PRIZE SINGLES

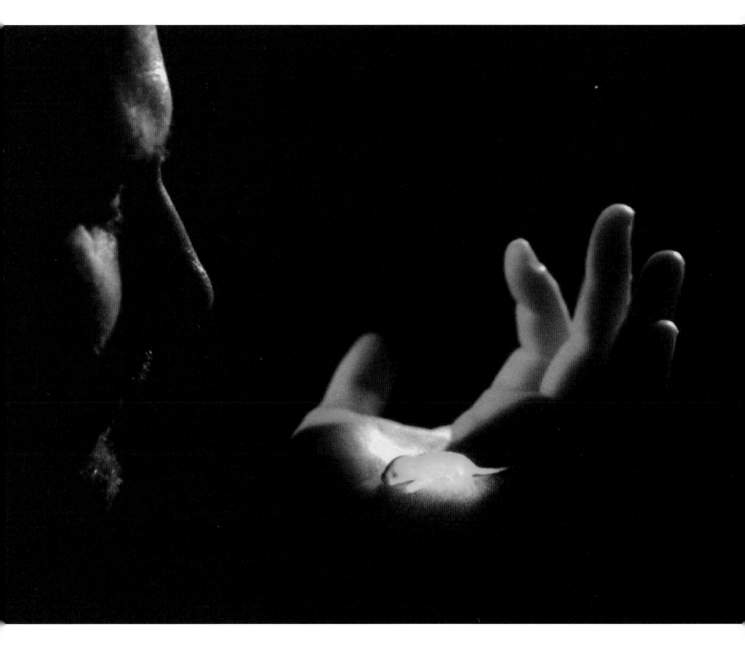

Scientist Jürgen Bachl observes a genetically manipulated mouse. The four-day-old rodent glows green under specially filtered light. Researchers had injected a green-florescent-protein gene (GFP) from a deep-sea jellyfish into fertilized mouse egg cells. The GFP spreads through all cells and tissue of the embryo. Scientists hope to use this discovery to further research into cell differentiation and tumor growth.

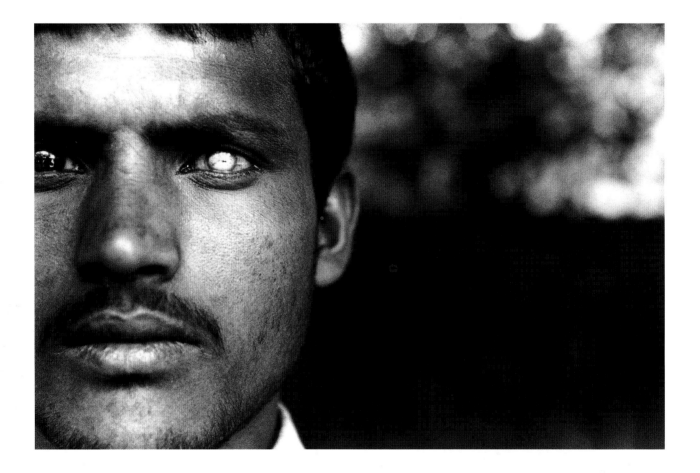

· Michael Amendolia
Australia, Network Photographers

1ST PRIZE STORIES

Intense ultra-violet light at high altitudes in Nepal causes cloudy cataracts and eventual blindness. Over 70 per cent of blind people in Nepal suffer from cataracts but the condition is easily treatable. Eye Camps have been set up in remote parts of the country to alleviate the problem, and in the capital Kathmandu an eye bank co-ordinates cornea donation. Right: A cornea is cut from the eye of a deceased donor. Facing page: An ophthalmic nurse from the eye bank extracts corneas on the steps of the Pashupatinah temple in Kathmandu before a cremation. (story continues)

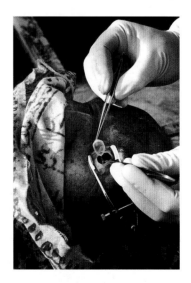

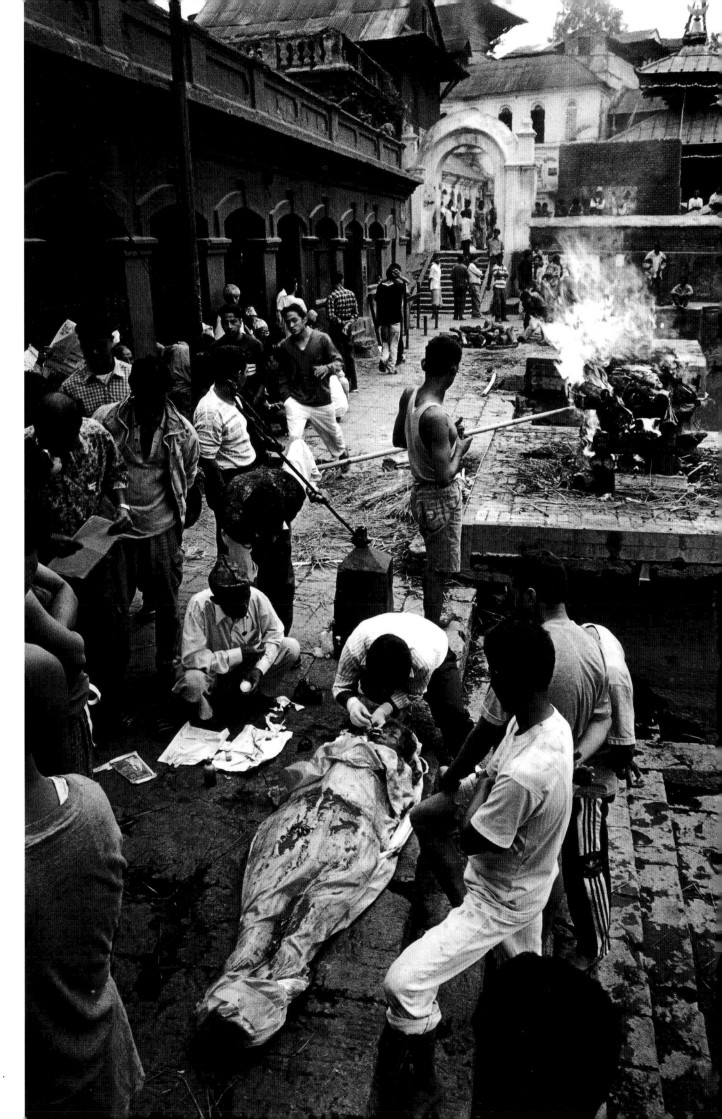

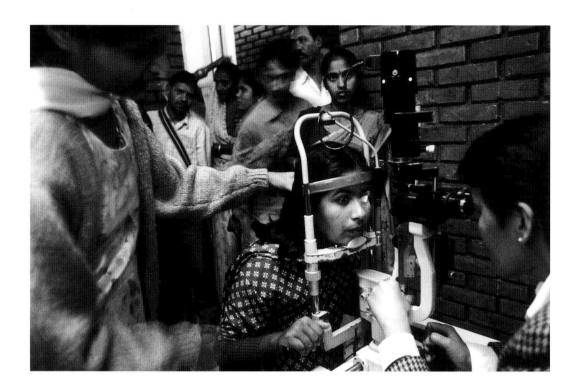

(continued) The Tilganga Eye Centre is just 500 meters from the temple. Top: Dr Reeta Gurung examines the eyes of 15-year-old Goma Mainali prior to a transplant. Below: Goma walks through Kathmandu traffic after a post-operative check-up.

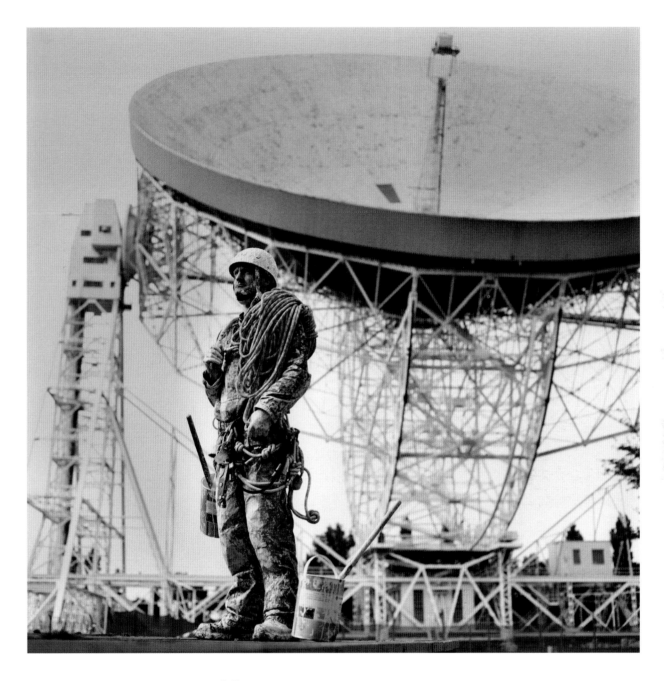

· Simon Norfolk
UK, for The Independent Magazine

2ND PRIZE STORIES

Radio telescopes are some of the most sensitive scientific instruments known to man, yet they are also among the largest. The Lovell Telescope at Jodrell Bank Obsevatory in northern England is the oldest such telescope in the world, and the place where radio astronomy was invented. Some 3,500 tonnes of steel support a dish 76 meters in diameter, making an instrument that is more powerful than the famous Hubble telescope. (story continues)

(continued) Without the annual application of 5,200 liters of weatherproof paint, the telescope on the exposed Cheshire Plain would rust away. Scaffolding cannot be used, as the telescope remains operative at night after daytime maintenance work. Instead, specially trained painters use ropes and harnesses to do the job.

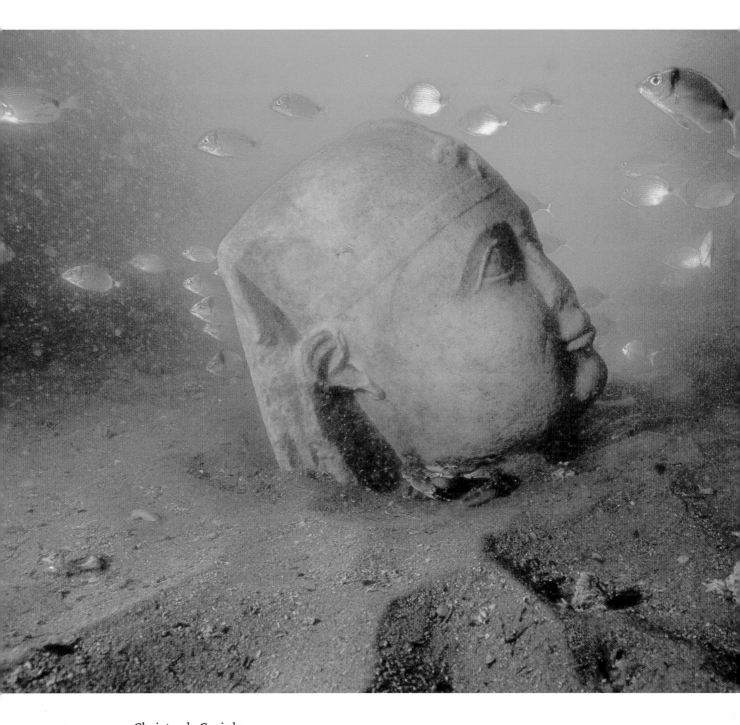

· Christoph Gerigk
*Germany, Franck Goddio/Hilti
Foundation/Discovery Channel*

3RD PRIZE STORIES

Over 2,000 years ago the port of Herakleion, at the mouth of the River Nile, was the maritime gate-
way to Egypt. Now the city lies beneath the waters of the Bay of Abu Qîr of the Egyptian north coast.
It is not yet known whether what caused Herakleion to sink was a cataclysmic or a gradual subsidence.
The lost city was uncovered by Frank Goddio, founder of the European Institute of Underwater
Archeology. Above: A Pharaonic head of the XXVth dynasty found at the site of the suburb of
Canopus. Facing page, top: A diver measures the feet of a colossal red granite statue. Below: A diver
surfaces with the head of Serapis, a sun god, dating from the Roman period.

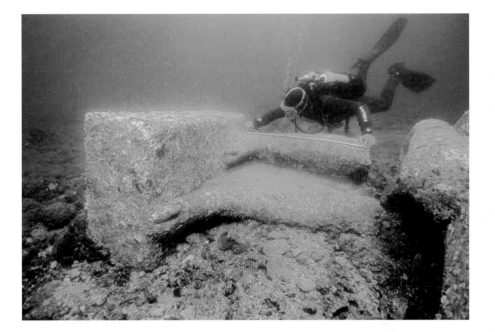

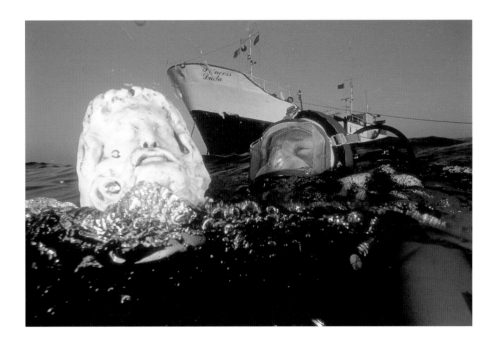

Sports

· Bill Frakes & David Callow
USA, Sports Illustrated

1ST PRIZE SINGLES

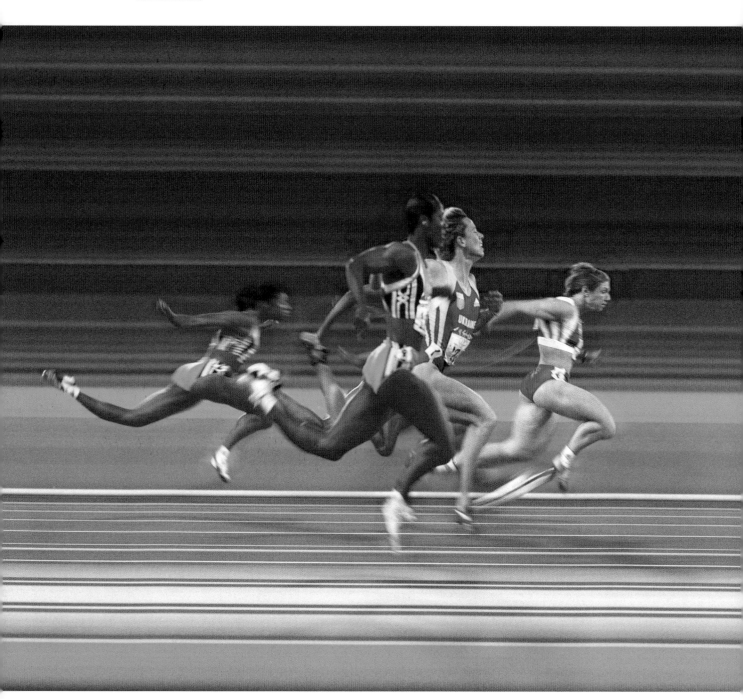

American athlete Marion Jones wins the 100-metre dash at the Sydney Olympics. The world's fastest woman completed the race in 10.75 seconds with a victory margin of 0.37 seconds, the second largest in Olympic history. Jones had said that she would win five gold medals at the Sydney Games. She didn't reach her goal, but with three golds and two bronzes she did better than any female track athlete ever at a single Olympics.

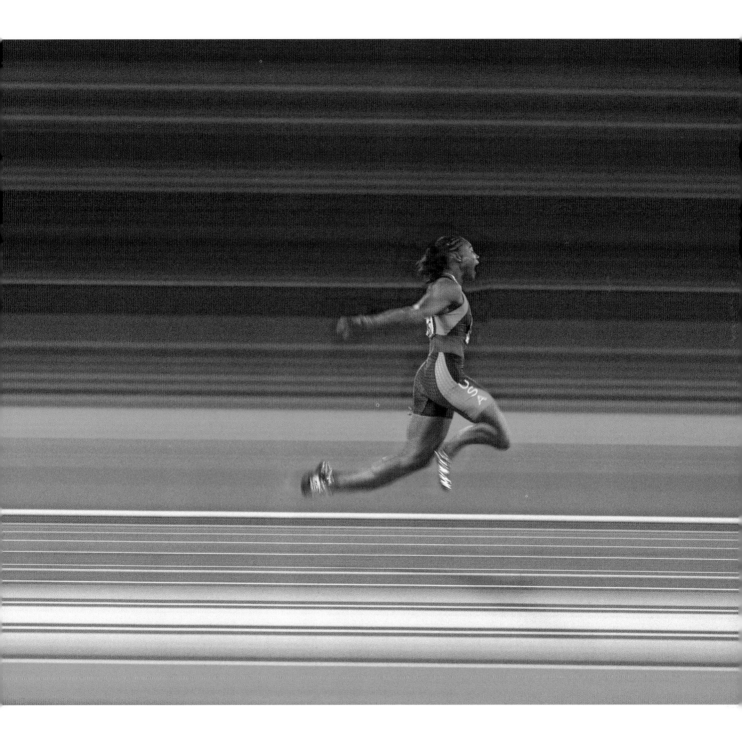

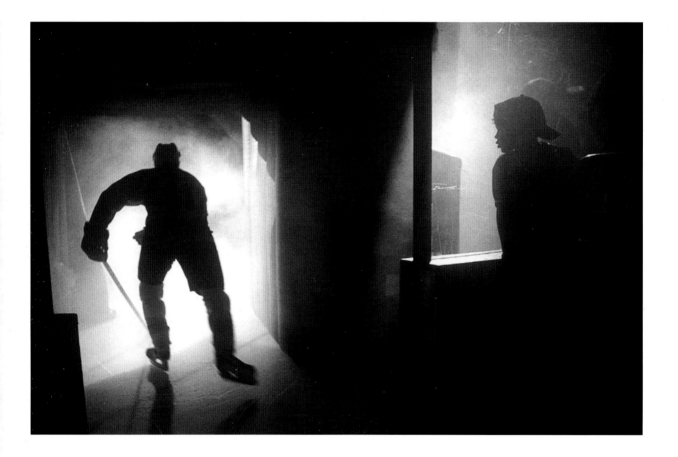

· Dale Omori
USA, The Plain Dealer

2ND PRIZE SINGLES

A young fan gets an up-close look at a Cleveland Lumberjacks ice-hockey player in the opening stages of a playoff game in Cleveland, USA. The minor league team originated in the lumberjacking town of Muskegon, Michigan, but kept their nickname when they relocated to Cleveland in 1992.

· Chris de Bode
The Netherlands, Hollandse Hoogte
for Nieuwe Revu

3RD PRIZE SINGLES

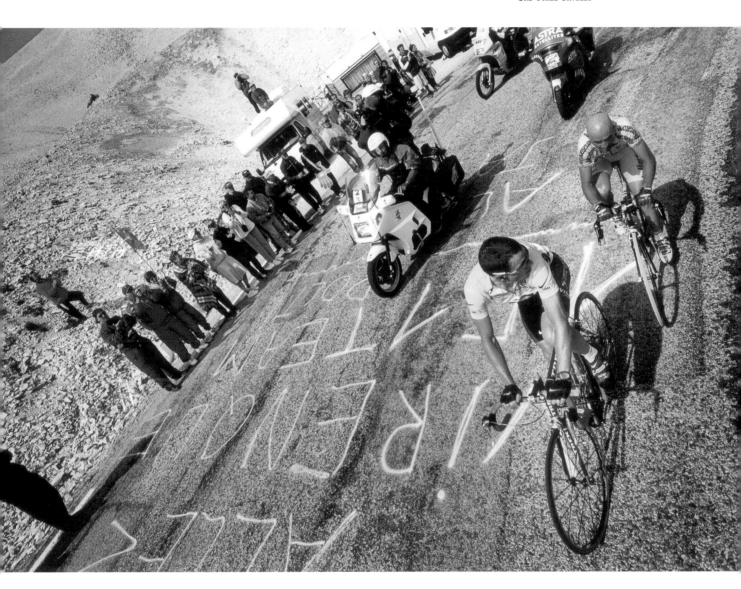

Lance Armstrong glances back at fellow rider Marco Pantani at the summit of Mont Ventoux, during the Tour de France cycle race. Mont Ventoux rises 1,619 meters in 21 kilometers, and is known as one of the most grueling parts of the Tour. Later it was suggested that Armstrong had allowed the Italian, who fans hail as the strongest climber in the world, to win this stage of the contest. Armstrong went on to become the overall winner.

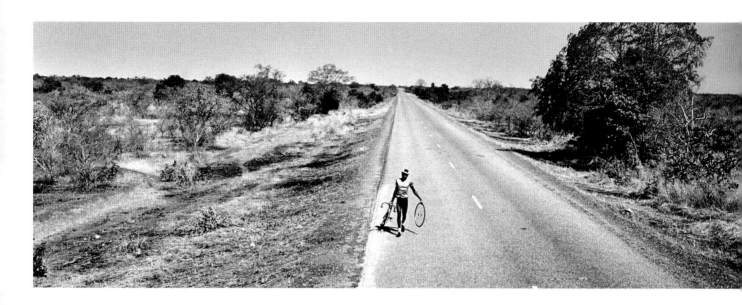

· Chris Keulen

The Netherlands, Hollandse Hoogte for Trouw

1ST PRIZE STORIES

The Tour du Faso is one of Africa's most important cycle races. The route runs from a small village in southwest Burkina Faso for over 1,300 kilometers through countryside that basks in temperatures of up to 40 degrees Celsius. This year 66 cyclists from Africa and Europe took part. Above: With no reserve bicycle, Nigerian participant Ibrahim Alzouma must walk after getting a puncture. Dutch cyclist Wout Conijn applies sunblock. Facing page: Cycling legend Eddy Merckx watches the finish as guest of honor. (story continues)

(continued) The race is second in popularity only to soccer in Burkina Faso. Below: Burkinabé cheer as fellow countryman Mahamadi Sawadogo comes in second during one of the early stages. Facing page, top: An Italian cyclist's futuristic helmet attracts spectator attention. Below: Local favorite Hamado Pafadnam at the end of the penultimate stage.

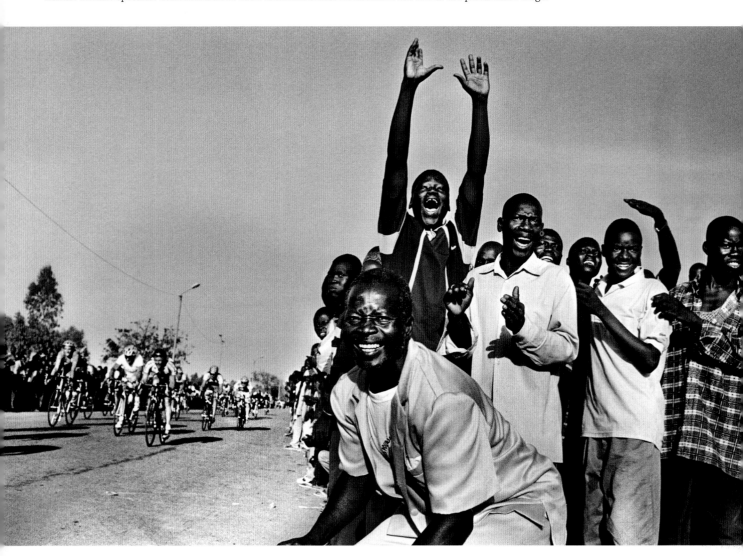

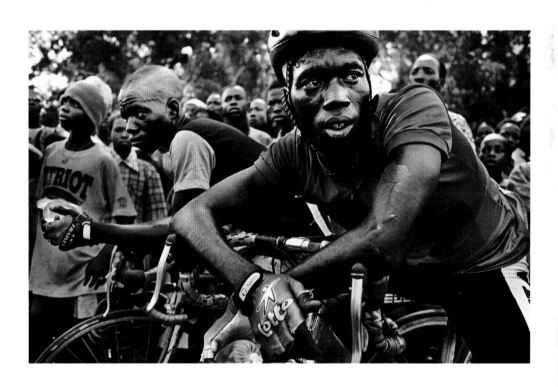

· Seamus Murphy
Ireland, Corbis Saba, USA for
Independent Magazine, UK

2ND PRIZE STORIES

Athletes of the Sierra Leone
Olympic squad work to qualify for
the Sydney Games. Sierra Leone
first attended the Olympics in
1968, but is yet to win any
medals. Right: Fishermen draw
their nets tight so that Quintin
Hindwejivah Saliakonneh can
work on his high jump. (story
continues)

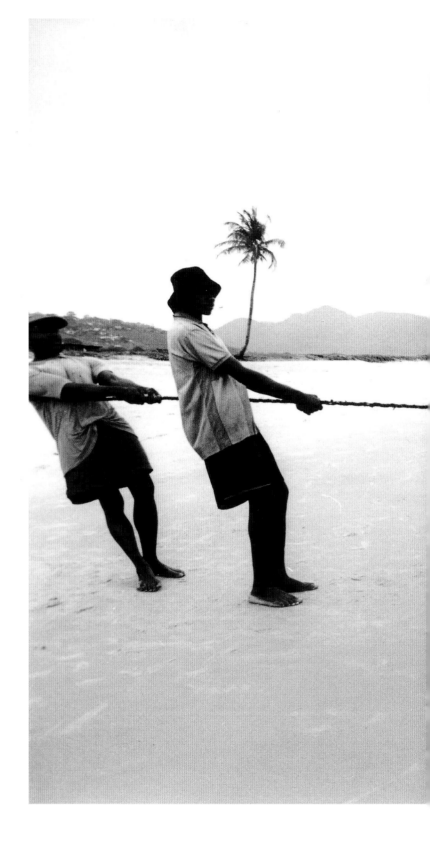

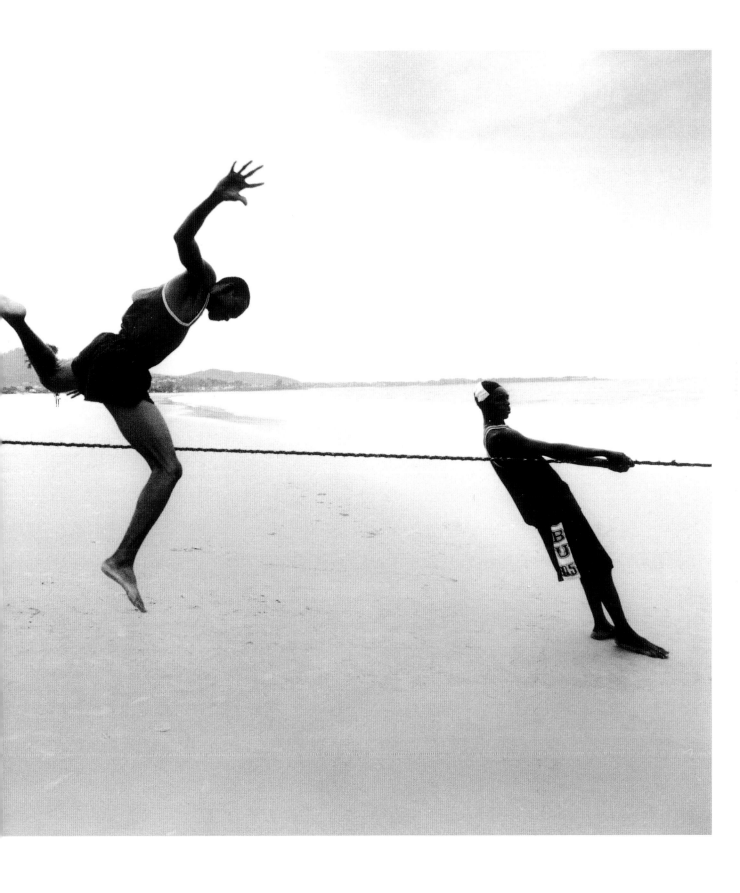

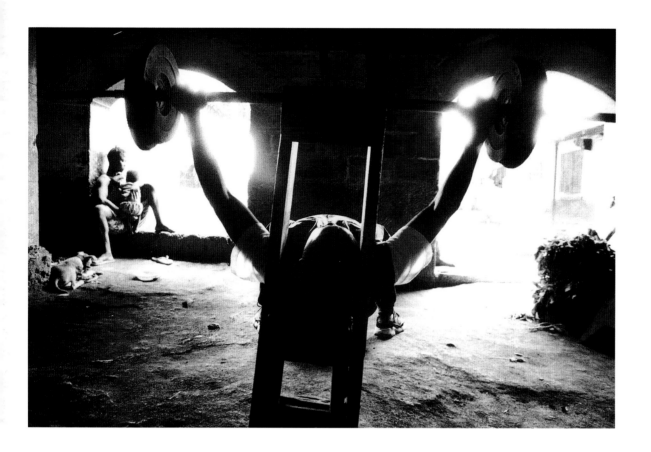

(continued) Many of the hopefuls trained and slept in the national stadium in Freetown, with only one cold-water tap and no electricity. Above: Mohammed S. Sesay uses makeshift weights at home in Freetown. Facing page, top: An athlete runs up the terraces of the national stadium. Below, left: Mariatu Conteh practices long jump.

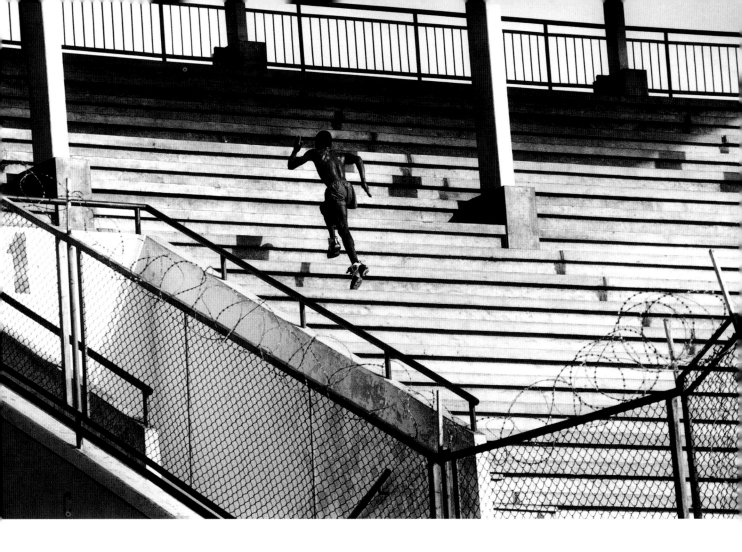

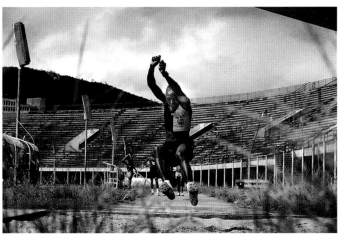

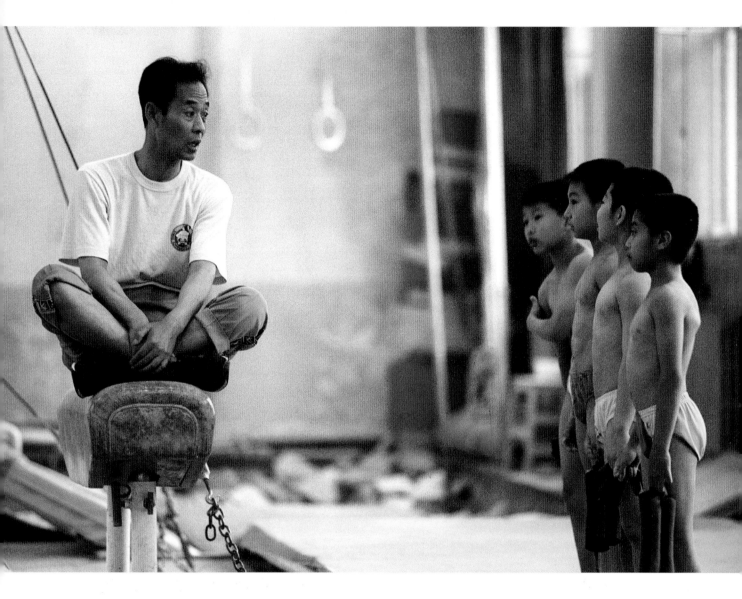

· Greg Baker
New Zealand, Associated Press

3RD PRIZE STORIES

The state-sponsored Shichahai sports school in Beijing selects and coaches young athletes to become future Olympians. Training is rigorous. Medical screening and X-rays keep track of the children's physical development, and discipline is taught at an early age. The gymnastics regime is one of the most demanding. Days begin at 7.00 am and end at 9.30 pm, with academic work in the morning and gymnastics in the afternoons.

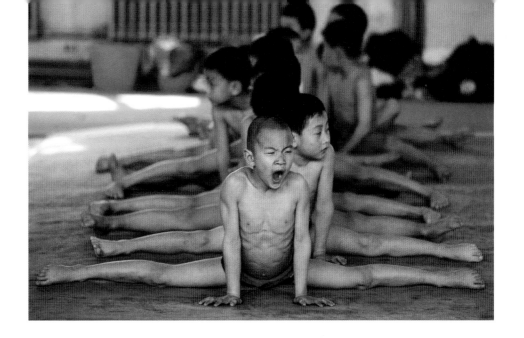

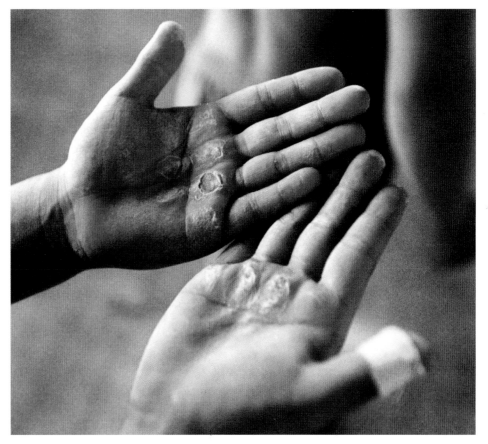

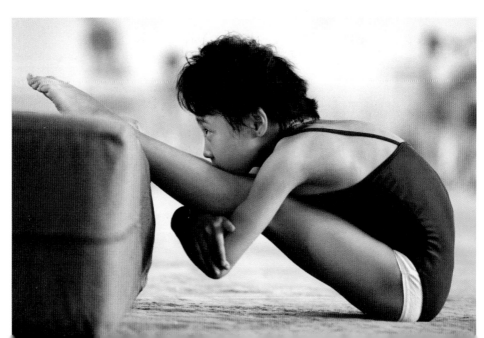

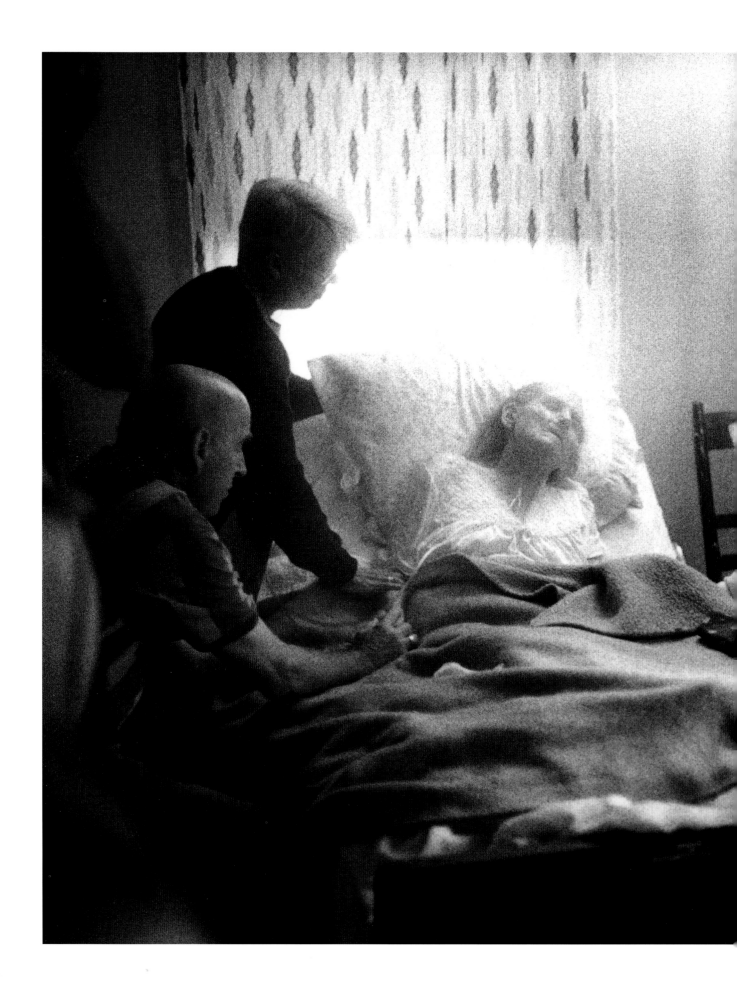

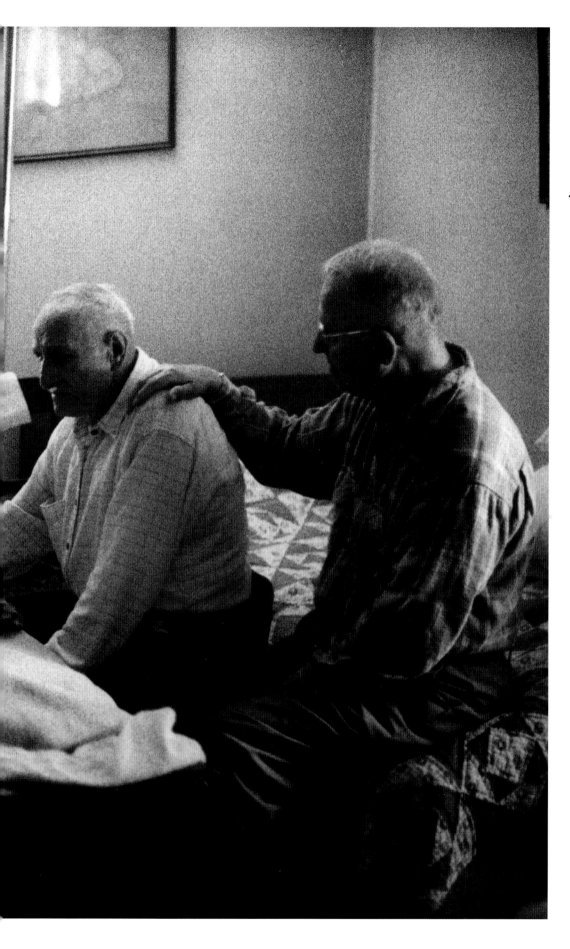

· Ed Kashi
USA

2ND PRIZE SINGLES

Maxine Peters dies at the age
of 90 in her West Virginia
farmhouse, after a long battle
with Alzheimer's and
Parkinson's disease. She is
attended by her husband
Arden and Warren DeWitt, a
close friend who shares the
house and helps care for the
elderly couple. Her son and
daughter-in-law have come
from Los Angeles. Maxine
was a patient of the Hospice
Care Corporation, which
helps people to die at home.
Emphasis is put on comfort
not remedy, on pain manage-
ment rather than medical
prolongation of life.

· Julien Daniel
France, L'Œil Public

3RD PRIZE SINGLES

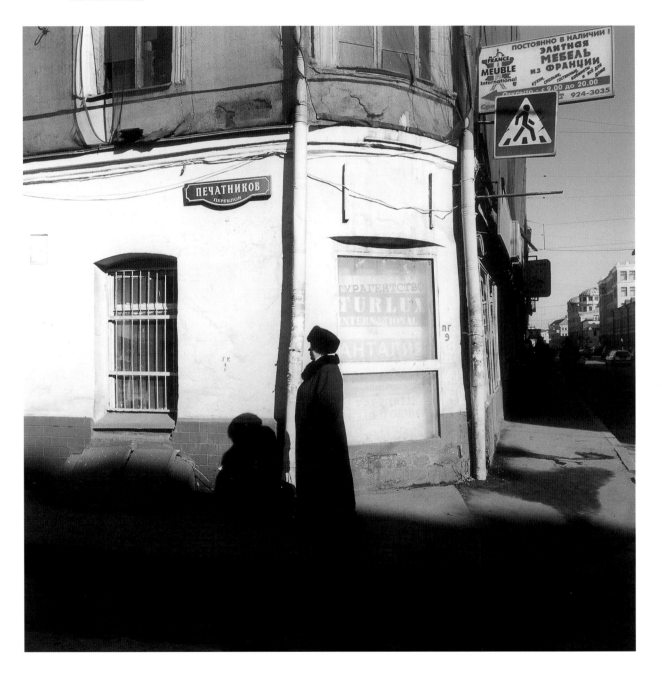

The Lubianka district in central Moscow in late March.

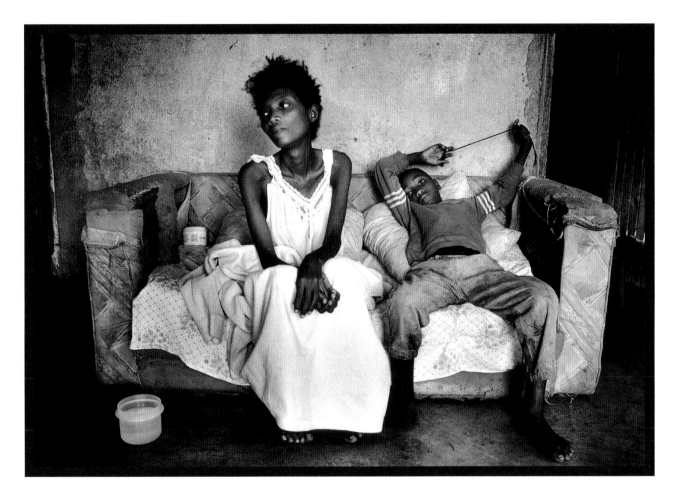

· Gideon Mendel
South Africa, Network Photographers, UK for
Fortune, USA

HONORABLE MENTION SINGLES

Samkelisiwe Mquananaze sits with her son at her mother's home in Ngwelezana Township, near Empangeni in South Africa. Samkelisiwe was open about her HIV status in a society that still stigmatizes people living with HIV or Aids. She said that by being frank about her condition she could help educate her community and save others. Samkelisiwe died a month after the photograph was taken.

· Jodi Bieber
South Africa, Network Photographers, UK for Pro Helvetia/Arts Council of Switzerland

1ST PRIZE STORIES

Illegal immigrants to South Africa are rounded up and sent back to Mozambique. Since the first South African democratic elections in 1994, there has been a marked increase in people from elsewhere in Africa making their way into the country. Around 180,000 illegal immigrants are deported annually. In February, police mounted Operation Crackdown to reduce crime levels and detain illegal migrants. Above: Police apprehend and search a man in Hillbrow, Johannesburg, a quarter that is home to many illegal immigrants. Facing page, top: Once arrested, illegals were sent to Lindela, a repatriation camp outside Johannesburg. Below, left: Paperwork is cleared and records computerized before deportation. Right: A police guard watches over deportees beside a repatriation train. (story continues)

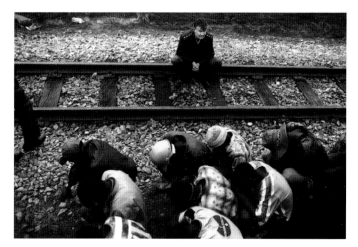

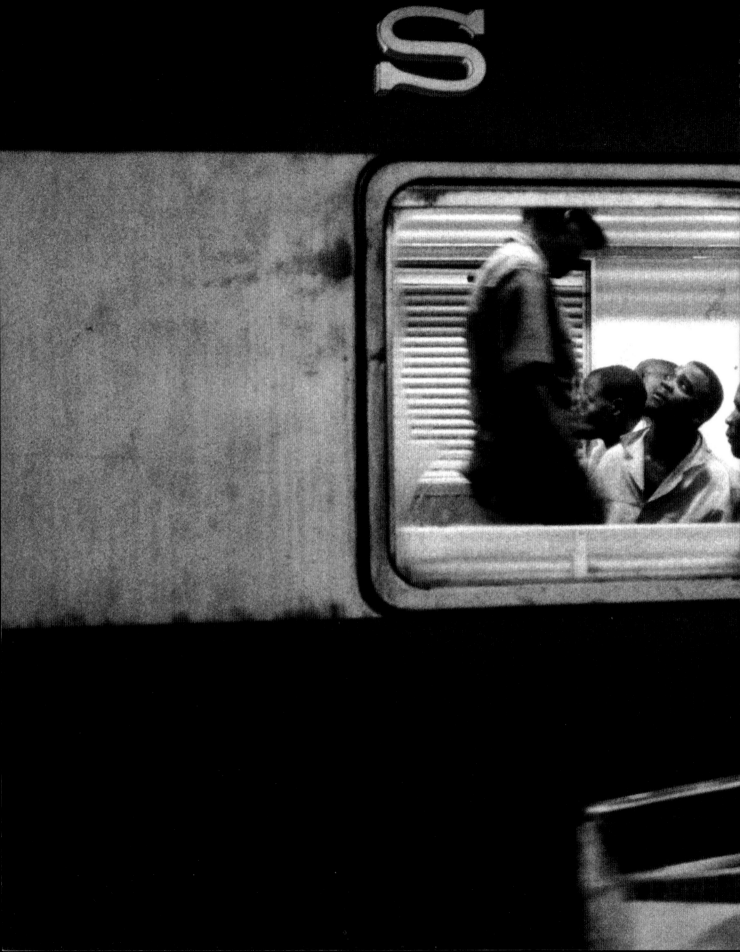

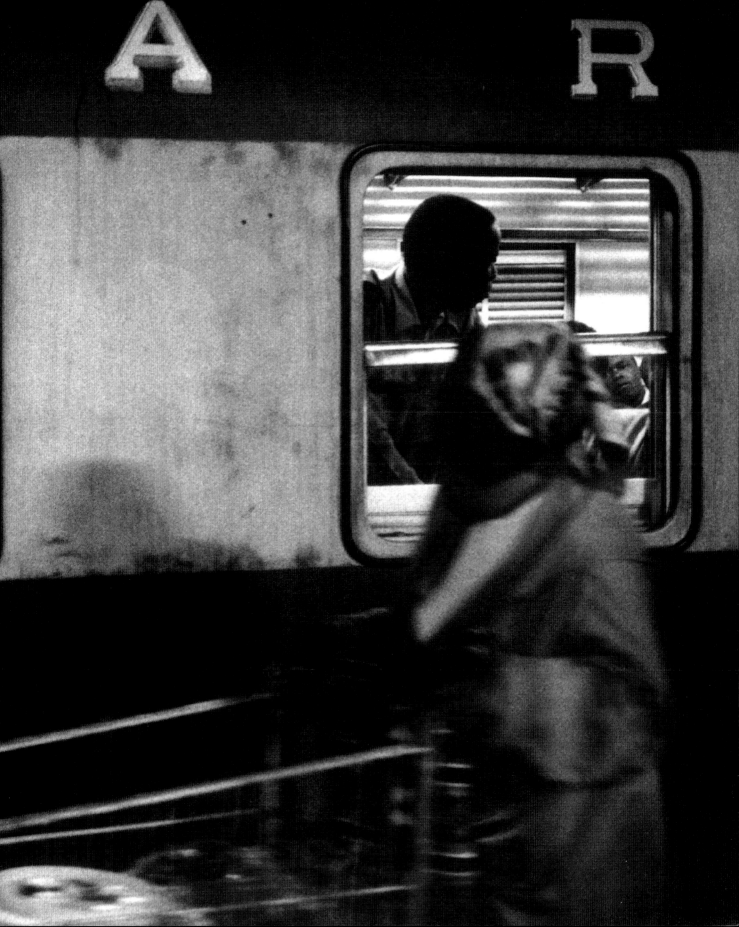

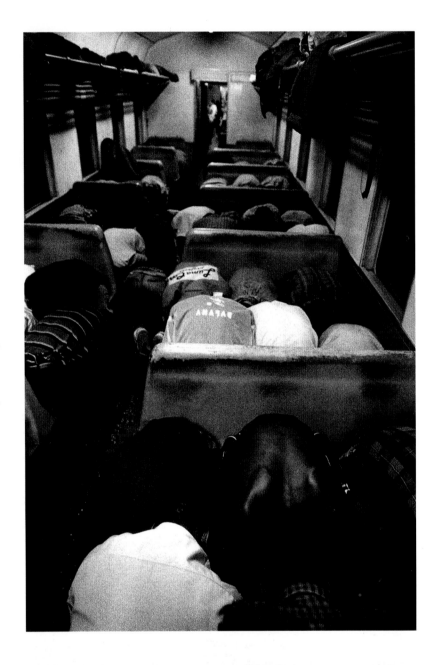

(continued) Immigrants have claimed that officials are corrupt, and that it is possible to purchase freedom. Previous spread: Trains leave Lindela every Wednesday to repatriate people to Zimbabwe and Mozambique. This page, top: When the train stops at stations, returnees have to put their heads between their knees so that they can be better controlled.

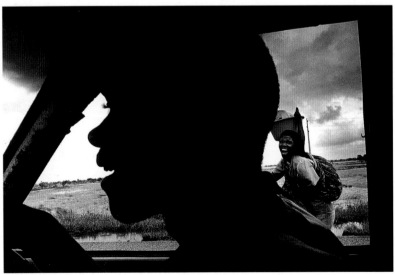

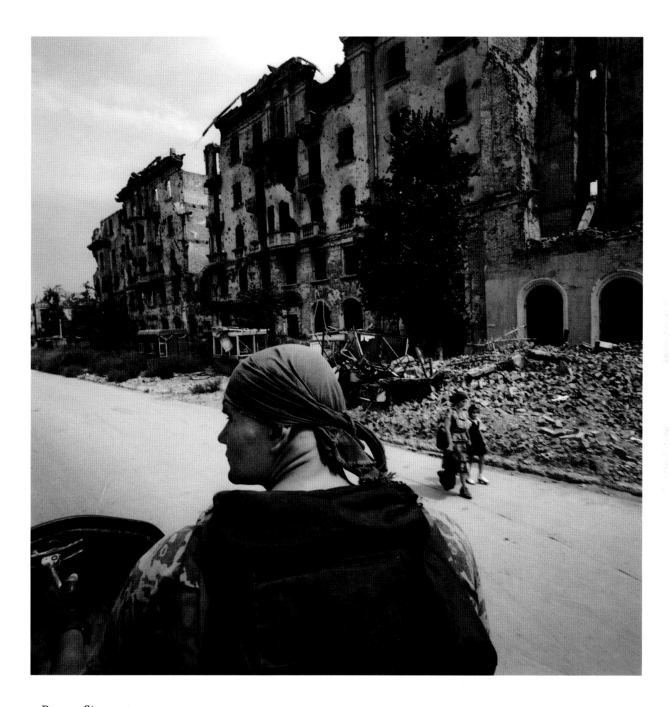

· Bruno Stevens
Belgium, for Paris Match, France

2ND PRIZE STORIES

By August Grozny was a phantom city. Conditions were miserable and the population
had halved. Food was hard to come by. The remaining residents, mostly women and
children, attempted a return to ordinary life with no gas, electricity or running water.
Russian soldiers kept up constant surveillance by day, but some rebel fighters had
returned and moved through the city at night. Above: A Russian soldier patrols the
streets. (story continues)

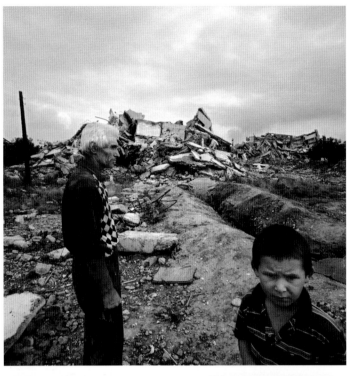
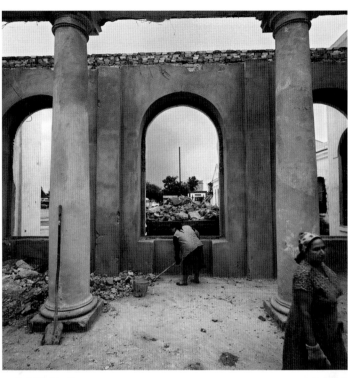
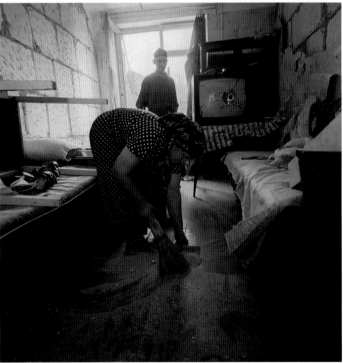
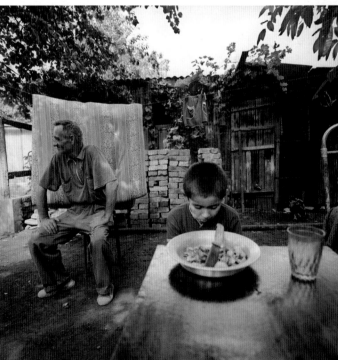

(continued) Distribution systems had collapsed, and finding food required disproportionate effort. People made risky trips to nearby villages and the neighboring republic of Ingushetia for provisions, and as winter approached the situation became critical. This page, clockwise from top: Sultan and his grandson Saslan examine the remains of the 12-storey building where they used to live. The train station was one of only three official buildings that the Russians started to rebuild. Five-year-old Rassul and his uncle make the most of their meager resources. A family returns home after nine months in a refugee camp in Ingushetia. Facing page: Women return to their villages on the outskirts of Grozny after visiting the city market.

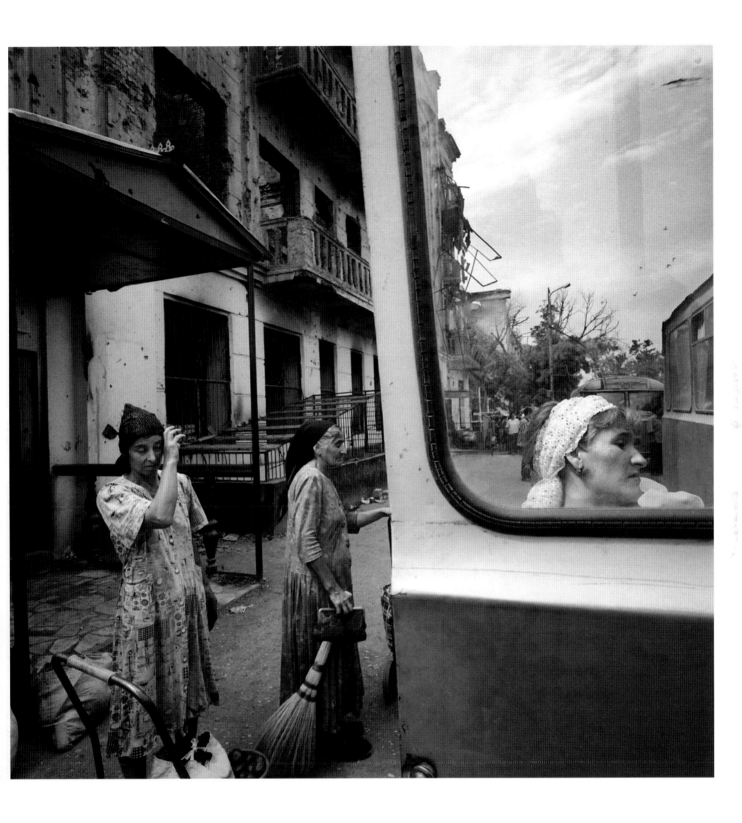

· Haseon Park
Republic of Korea, for Geo Korea

3RD PRIZE STORIES

In the Tibetan funeral tradition of Tianzang (Sky Funeral), also called Niaozang (Bird Funeral), the dead are fed to vultures. Tibetans believe that the soul passes from the body after death to be reborn, so the body can be used to benefit other living things. In the 1960s and 1970s Chinese authorities banned the practice, but it regained limited acceptance in the 1980s. In the tiny village of La Rong, high in the mountains of Sichuan, there are few trees for firewood and the ground is stony, so Tianzang is a natural alternative to burial or cremation. (story continues)

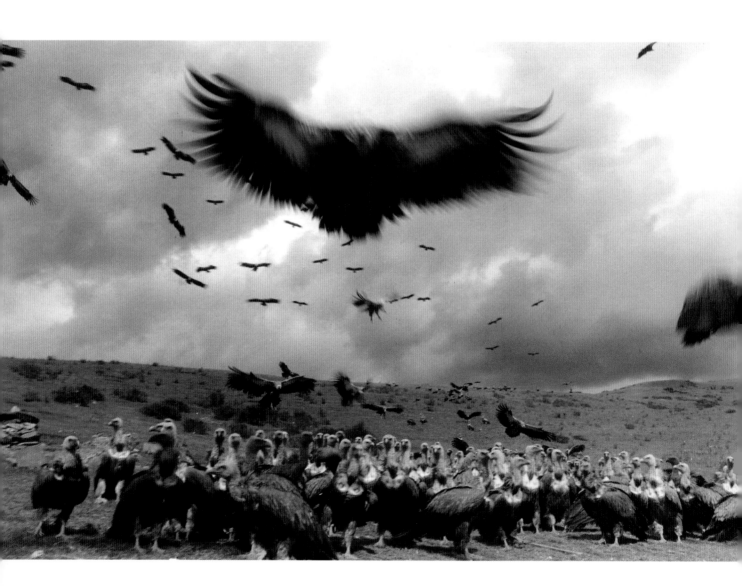

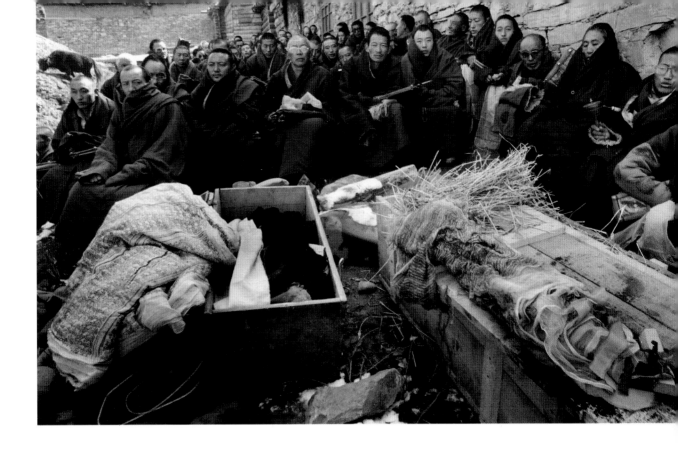

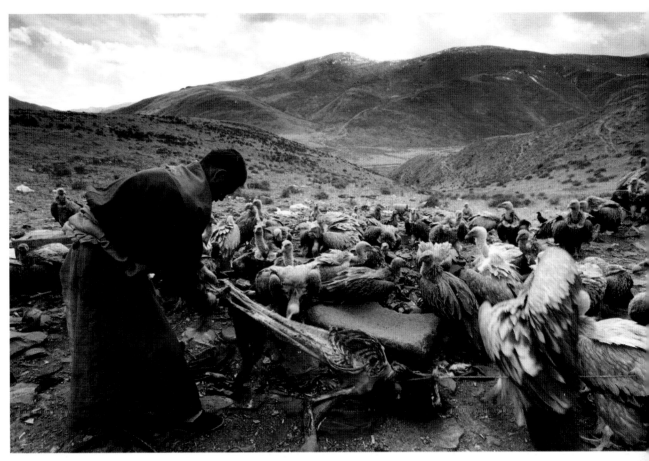

(continued) Outsiders are seldom welcome at the ceremony. Three days after death the corpse is placed in a fetal position in a box or sack and carried to the temple for prayers, and then to the Tianzang ground. Top: Priests, family and friends chant for the deceased outside the temple in La Rong. Below: The Tianzang Master has to grind the remains finely with a hammer to make them easier for the vultures to eat. Tibetans believe the soul can be reborn in a better place only if the body is completely devoured.

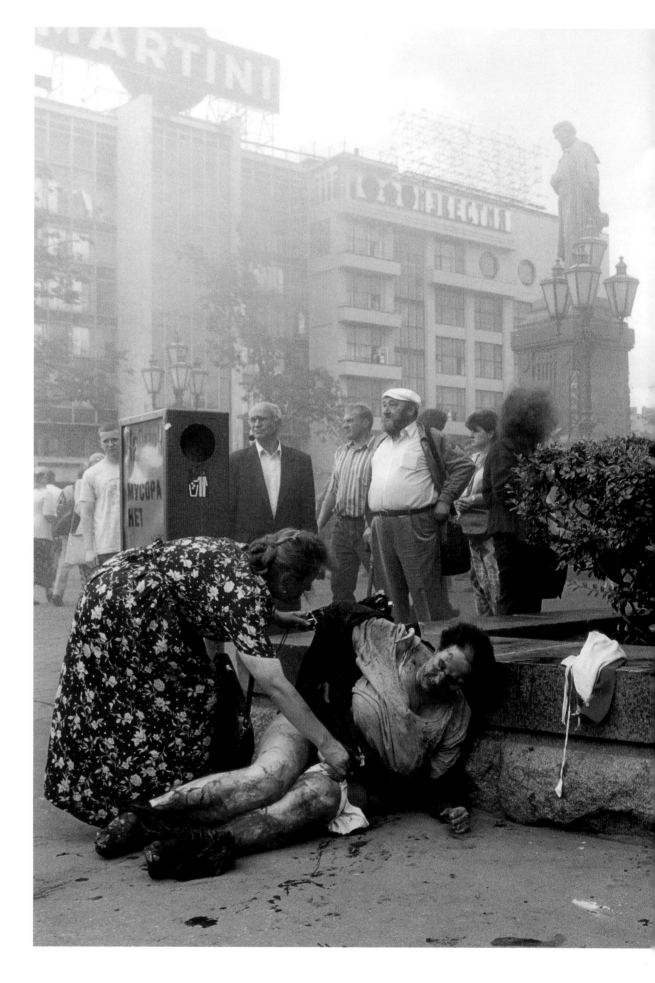

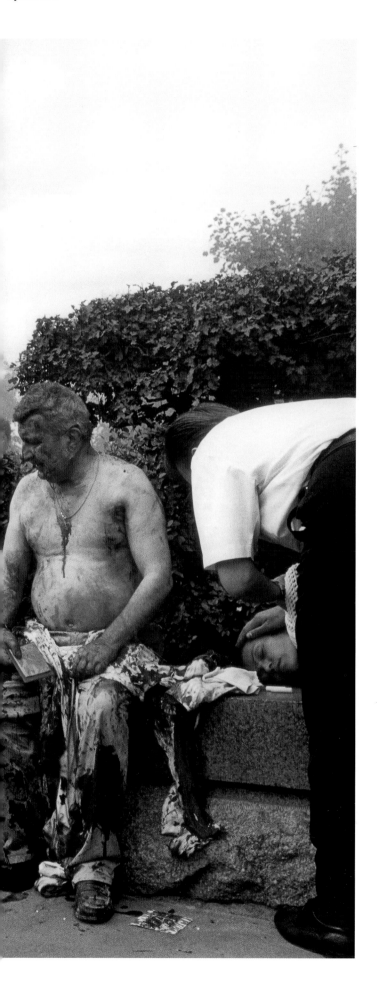

· Yuri Shtukin
Russia, Izvestia

1ST PRIZE SINGLES

A suitcase bomb exploded in a pedestrian underpass near Pushkin Square in central Moscow on August 8, a year after a wave of bombings had rocked the city killing hundreds. It was rush hour and hundreds of commuters and shoppers were using the underpass, which connected with the metro. Panic broke out as smoke filled the passageway. Local authorities initially put the blame for the attack on Chechen separatists, but no evidence was produced and no arrests were made. The final death toll was twelve, with many more people injured.

· Alan Diaz
USA, Associated Press

2ND PRIZE SINGLES

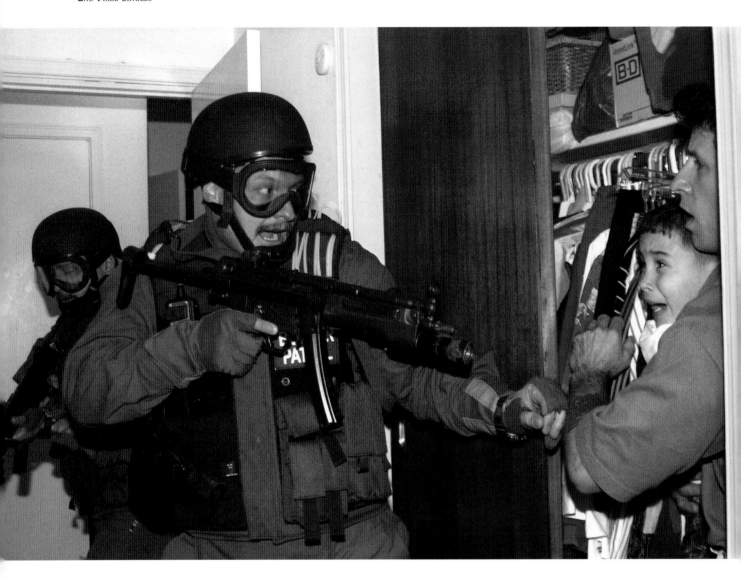

Cuban Elian Gonzalez is seized by US federal agents during a dawn raid on his relatives'
home in Miami's Little Havana district. Elian was found off the coast of Florida in
November 1999, after the boat carrying him from Cuba sank, killing his mother and ten
others. The US Immigration and Naturalization Service ruled that he should return to his
father in Cuba, but a Florida family court granted Elian's great uncle temporary custody
and a legal battle followed. The dispute sparked mass demonstrations and propaganda
campaigns both in Cuba and among anti-Castro Cuban Americans. Elian's father came to
the US in early April, and federal agents took custody of the six-year-old two weeks later.
Further lawsuits prevented them from returning to Cuba until the end of June.

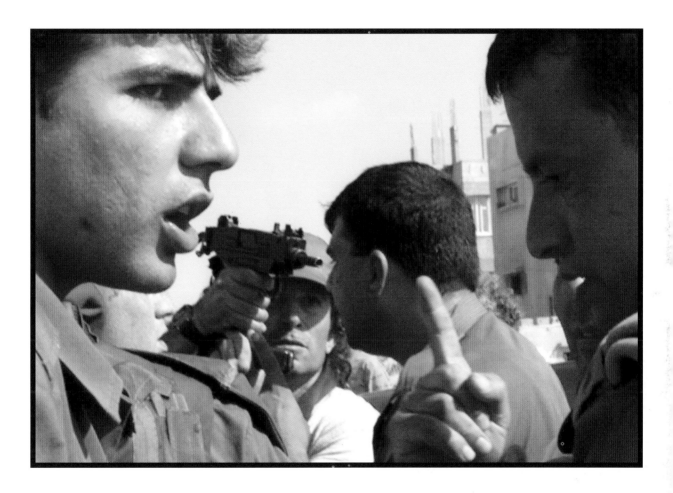

· Suhaib Salem
Palestinian Territories, Reuters

3RD PRIZE SINGLES

An Israeli soldier gesticulates in argument with a Palestinian policeman during an
anti-settlement protest near the Kfar Yam Jewish settlement in southern Gaza Strip in
June. A settler points his gun at a second Palestinian police officer. The standoff was
triggered when around 50 settlers erected a tent on a beach near Kfar Yam. Israeli
troops fired rubber-coated bullets at protestors, but no injuries were reported.

· Thomas Dworzak
Germany, Magnum Photos

1ST PRIZE STORIES

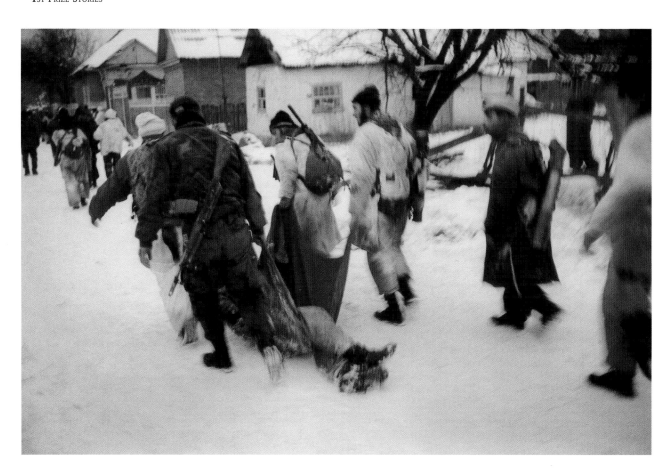

After several months of fighting the Russians, Chechen separatists withdrew from Grozny in February. The fighters used a 'safe corridor' to the west, towards the village of Alkhan-Kala. Russian soldiers did not open fire, but the corridor turned out to be mined. Several hundred were killed or lost limbs. Casualties included a number of the rebel commanders. Above: Chechen rebels drag a fellow fighter into Alkhan-Kala. Facing page, top: Vera is Russian, but lives among Chechens with her Chechen husband's family. Her grandson is playing with a toy gun. Below, left: Rebels try to save a wounded comrade, who died a few hours later. Right: A Chechen man looks for a friend among the dead and injured. (story continues)

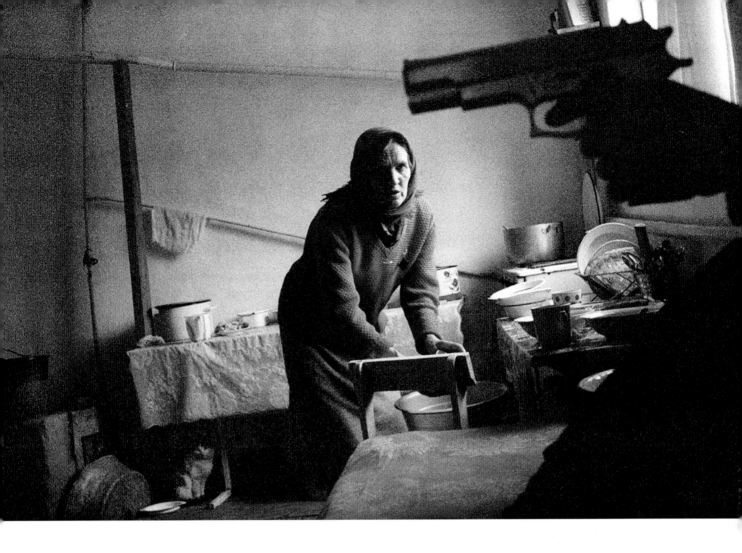

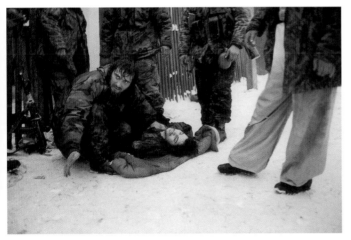

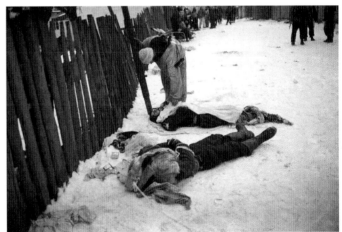

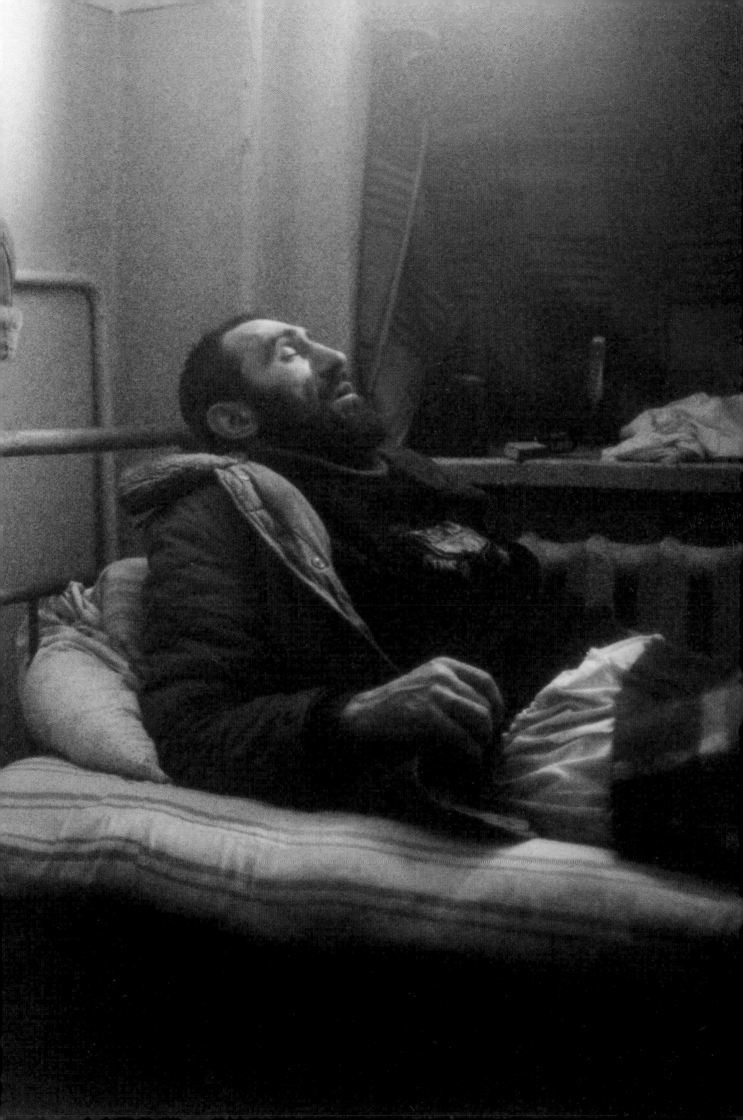

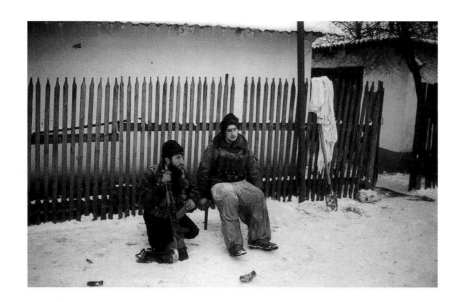

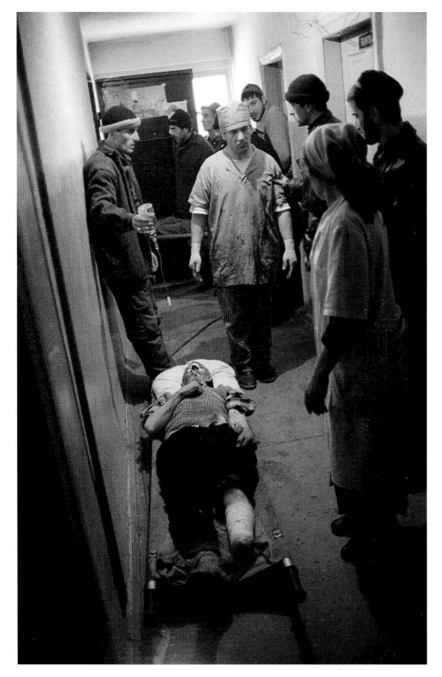

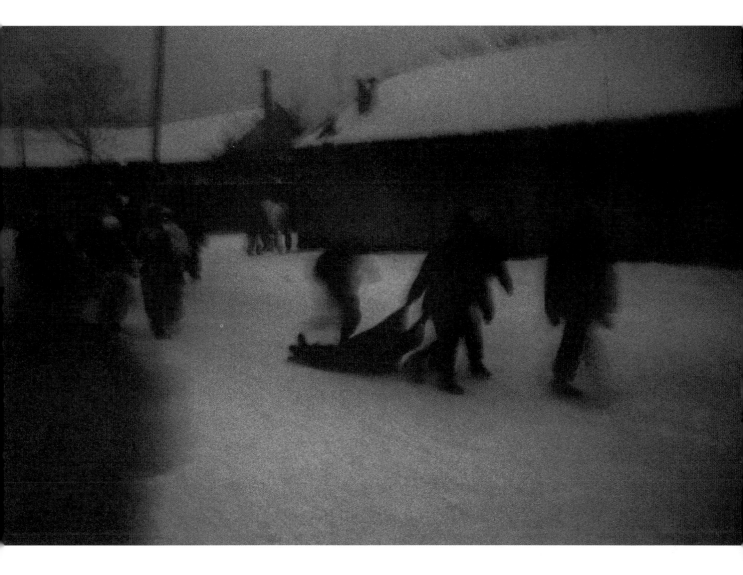

(continued) Alkhan-Kala became overcrowded, and days after the fighters arrived, the Russians attacked the village.
Previous spread: An injured Chechen fighter in hospital in Alkhan-Kala. Facing page, top: Exhausted rebels rest having reached the village. Facing page, below: Hospital staff struggled to cope with the numbers of wounded.

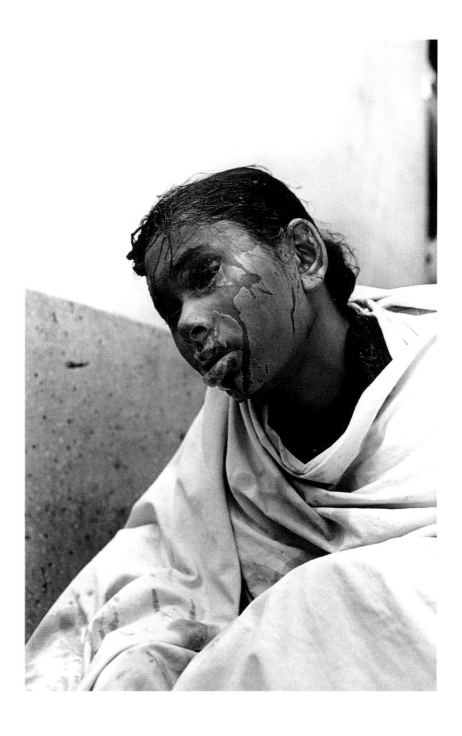

· Shafiqul Alam Kiron
Bangladesh, MAP Photo Agency

2ND Prize Stories

Nasrin Sultana Dulali worked as a nurse in a private clinic in Dhaka. She refused the advances of ward assistant Haider, who was later sacked for misconduct. After work one evening in March, Dulali had acid thrown at her. People alerted by Dulali's screams said they caught Haider red-handed. They tied him to a lamppost, beat him and handed him over to police. Acid attacks, usually against women, are rising in Bangladesh, with well over 100 occurring each year. The success rate in arresting and prosecuting acid throwers is low. Above: Dulali had to wait for two hours before being taken to hospital, where she died 32 hours later. Facing page, middle: Haider was apparently burnt by his own acid when throwing it. He confessed to the photographer, but later denied involvement to the police.

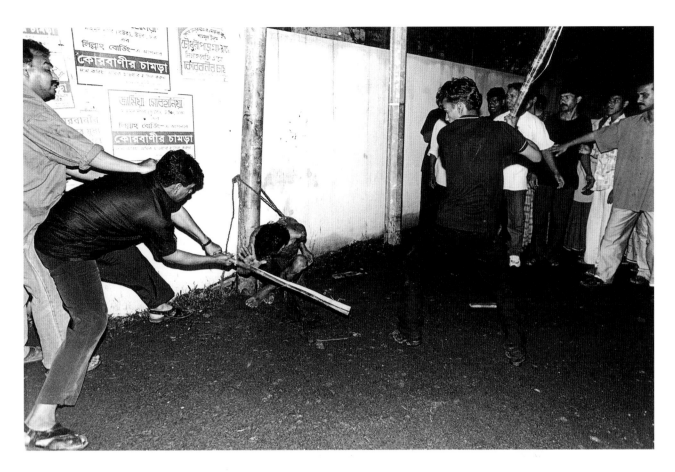

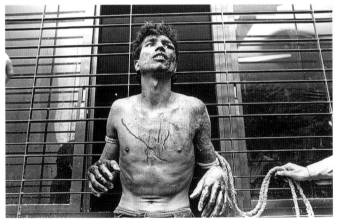

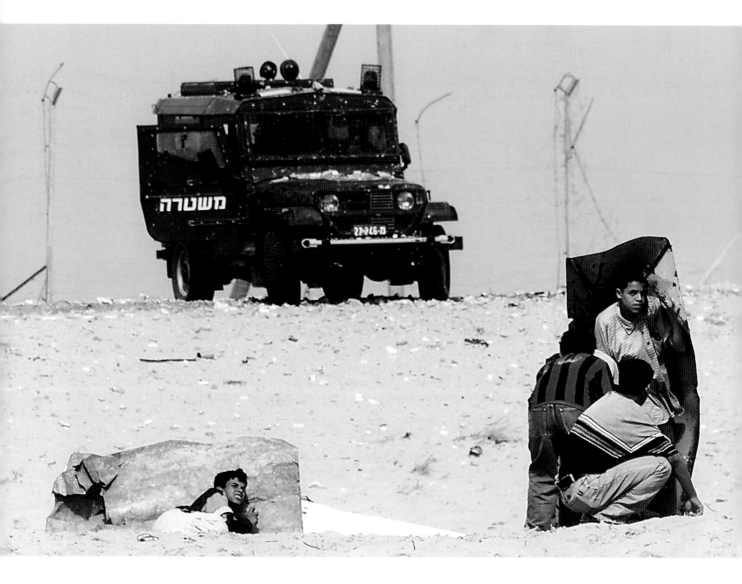

· Thomas Coëx

France, Agence France Presse

3RD PRIZE STORIES

Palestinian youths take cover behind sheets of corrugated iron during clashes with Israeli troops in the Gaza Strip in October. The confrontation took place in the area that separates the Palestinian city of Khan Yunes from the Jewish settlement of Gush Katif. Conflict between Palestinian protestors and Israeli forces had so far left over 140 dead and 4,000 wounded. All but eight of the fatalities had been Palestinian.

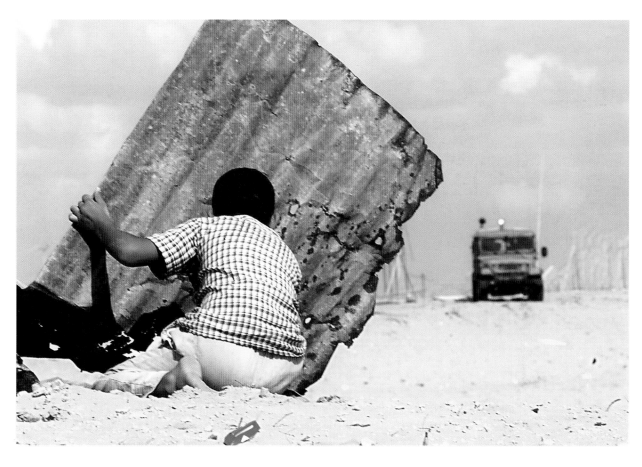

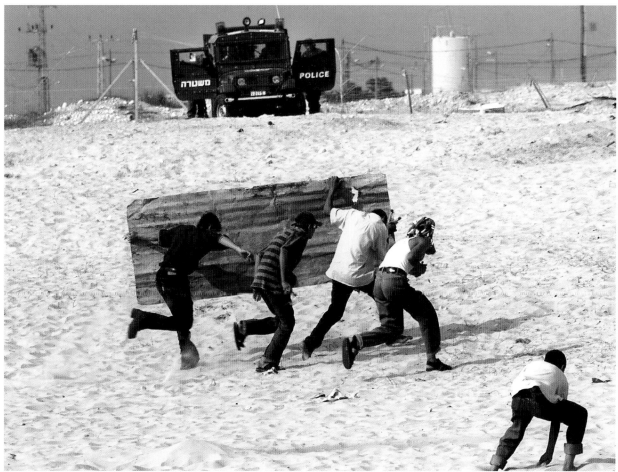

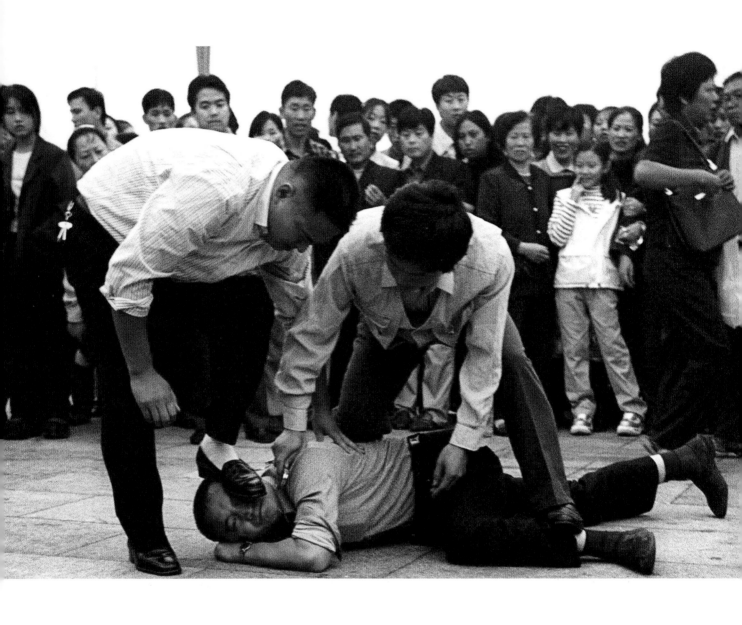

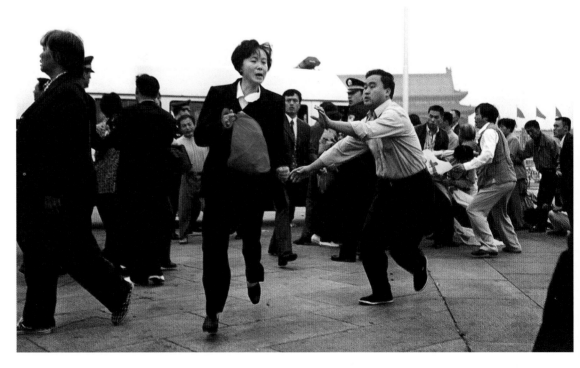

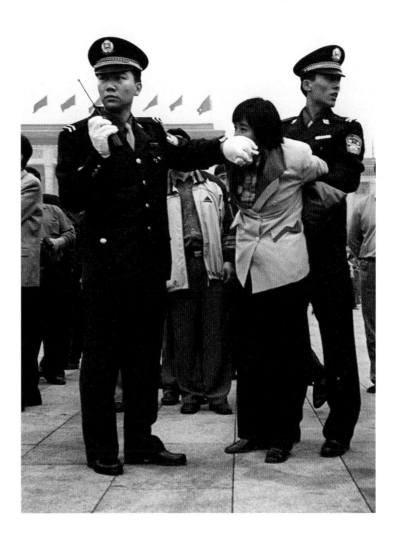

· Chien-min Chung
USA, Associated Press

HONORABLE MENTION STORIES

Chinese police break up a Falun Gong demonstration on Tiananmen Square on 1 October, China's National Day. The Falun Gong movement first attracted international attention in April 1999, when 10,000 silent protestors surrounded the Chinese government compound in Beijing. The group says it is a peaceful spiritual sect with no political motives. But three months after the initial April protest, the government banned the practice of Falun Gong and launched a crackdown on the sect, maintaining it was trying to undermine the state.

Prizewinners

World Press Photo of the Year 2000

Lara Jo Regan, USA, for Life Uncounted Americans: An Immigrant Family from Mexico at Home, Texas

Page 4

The World Press Photo of the Year Award honors the photographer whose photograph, selected from all entries, can be rightfully regarded as the photojournalistic encapsulation of the year: a photograph that represents an issue, situation or event of great journalistic importance and which clearly demonstrates an outstanding level of visual perception and creativity.

World Press Photo Children's Award

Stephan Vanfleteren, Belgium, Lookat Photos, Switzerland for Artsen Zonder Grenzen Nederland Young Landmine Victim, Afghanistan

Page 10

An international children's jury selects the winner of the Children's Award from the entries for the contest. The jury of schoolchildren is composed of winners of national educational contests, organized by leading media in nine countries.

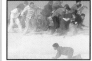

General News Singles

1 Reinhard Krause, Germany, Reuters Palestinians Flee Teargas, Gaza, 20 October

Page 12

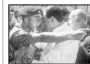

2 Amit Shabi, Israel, for Reuters Israeli Policeman Argues with Palestinian Man, Jerusalem, October

Page 13

3 Dudley M. Brooks, USA, The Washington Post Mass Death of Religious Cult Followers, Uganda, March

Page 14

General News Stories

1 Vladimir Velengurin, Russia, Komsomolskaya Pravda Russian Troops Round Up Suspected Rebels, Chechnya

Page 15

2 Karel Prinsloo, South Africa, Sunday Times/ Associated Press Mozambique Floods

Page 18

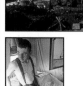

3 Vladimir Vyatkin, Russia, Ria Novosti for Ogonyok Chechnya, March-April

Page 20

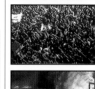

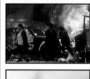

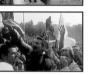

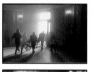

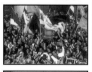

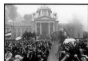

Honorable Mention Noël Quidu, France, Gamma for Newsweek, USA Demonstration Against President Milosevic, Belgrade, October

Page 24

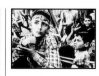

People in the News Singles

1 Antonio Zazueta Olmos, Mexico, for The Observer Palestinian Boys, Gaza, November

Page 27

2 Paul Lowe, UK, Magnum Photos Remains of a 1992 Execution, Bosnia

Page 28

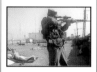

3 Vladimir Velengurin, Russia, Komsomolskay Pravda Russian Soldiers Sunbathe on Rooftop, Grozny, May

Page 30

Honorable Mention Claus Bjørn Larsen, Denmark, Berlingske Tidende Woman Waiting for Food, Mozambique, March

Page 31

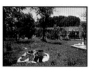

People in the News Stories

1 Matias Costa, Spain, Agence France France Illegal Immigrants Enter Spain

Page 32

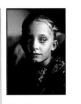
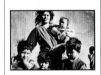

*Dago,
ark
Leone, June
6*

Portraits
Singles

*1 Bill Phelps,
USA, for Fortune*
Young Crigler-
Najjar Syndrome
Patient

Page 41

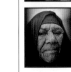

*2 Tim Georgeson,
Australia, Cosmos,
France for World
Vision Australia*
Roma Family from
Kosovo in Refugee
Camp, Montenegro

Page 42

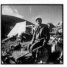

*3 Alessandro Albert
& Paolo Verzone,
Italy, Agenzia
Grazia Neri*
Venus Beach,
Romania

Page 44

*3 Jodi Bieber,
South Africa,
Network Photo-
graphers for The
New York Times
Magazine, USA*
Ebola Crisis in
Uganda, November

Page 38

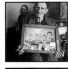

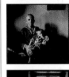
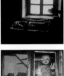

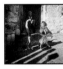
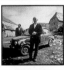
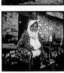

Portraits
Stories

*1 Hien Lam-Duc,
France, Agence Vu*
People of Baghdad

Page 45

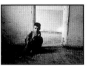
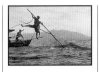
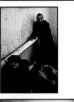

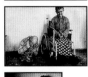
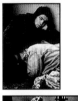

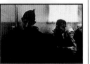

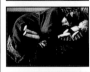

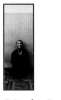

*2 Zijah Gafic,
Bosnia-
Herzegovina*
Last Bosnian Village

Page 48

*3 Stanley Greene,
USA, Agence Vu,
France*
The Forgotten
Refugees of
Chechnya

Page 50

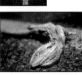

Nature
and the
Environment
Singles

*1 Bo Thomassen,
Denmark*
Traditional
Whaling, Indonesia

Page 54

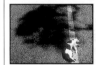

*2 Jacqueline Mia
Foster,
USA*
Relaxing on a Shore
of Industrial Waste,
Russia

Page 56

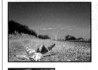

*3 Andres Salinero,
Argentina*
Public Beach, Mar
del Plata

Page 57

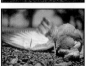

Honorable Mention
Antonio Scorza,
Brazil, Agence
France Presse
Polluted Lagoon, Rio
de Janeiro

Page 58

Nature
and the
Environment
Stories

*1 Trent Parke &
Narelle Autio,
Australia, Oculi
Photos for Sydney
Morning Herald*
Roadkill, Australia

Page 59

Prizewinners

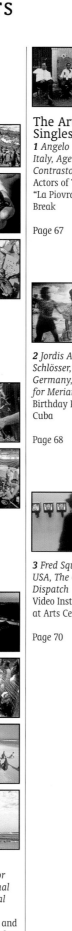

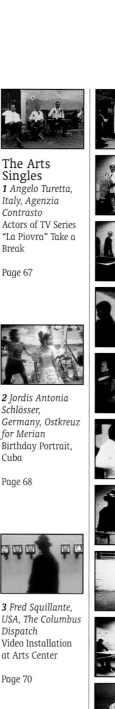

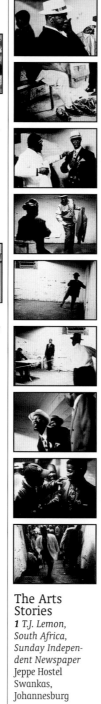

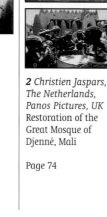

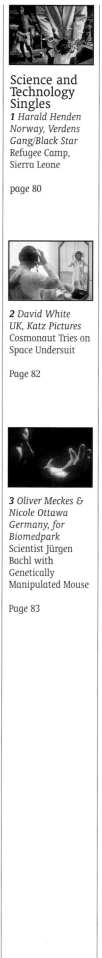

The Arts Singles

1 *Angelo Turetta, Italy, Agenzia Contrasto*
Actors of TV Series "La Piovra" Take a Break

Page 67

2 *Jordis Antonia Schlösser, Germany, Ostkreuz for Merian*
Birthday Portrait, Cuba

Page 68

3 *Fred Squillante, USA, The Columbus Dispatch*
Video Installation at Arts Center

Page 70

The Arts Stories

1 *T.J. Lemon, South Africa, Sunday Independent Newspaper*
Jeppe Hostel Swankas, Johannesburg

Page 71

2 *Christien Jaspars, The Netherlands, Panos Pictures, UK*
Restoration of the Great Mosque of Djenné, Mali

Page 74

3 *Stephan Vanfleteren & Robert Huber, Belgium/Switzerland, for Lookat Photos*
Elvis & Presley

Page 78

Science and Technology Singles

1 *Harald Henden Norway, Verdens Gang/Black Star*
Refugee Camp, Sierra Leone

page 80

2 *David White UK, Katz Pictures*
Cosmonaut Tries on Space Undersuit

Page 82

3 *Oliver Meckes & Nicole Ottawa Germany, for Biomedpark*
Scientist Jürgen Bachl with Genetically Manipulated Mouse

Page 83

Science and Technology Stories

1 *Michael Amendolia, Australia, Net Photographers*
Blindness in N

Page 84

2 *Michel Denis-Huot, France*
Opportunist Baboons, Kenya

Page 62

3 *Jon Hrusa, South Africa, for The International Fund for Animal Welfare*
Penguin Rescue and Rehabilitation After Oil Spill, South Africa

Page 64

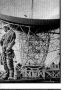
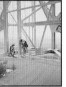
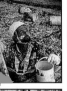
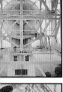

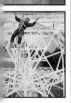

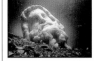

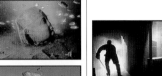

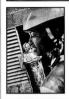

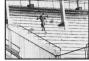

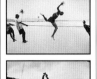
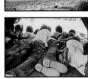
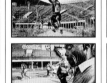

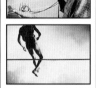
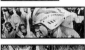
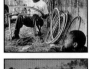

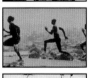
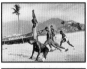
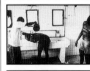
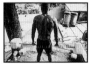

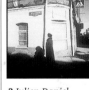

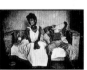
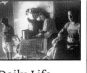

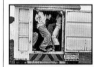
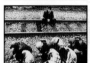

Prizewinners

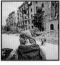

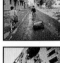
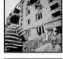
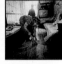
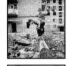
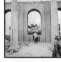
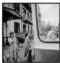
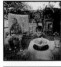
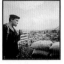

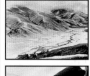
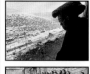
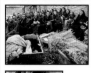
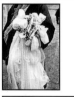
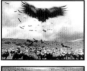
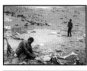
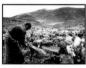
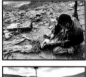
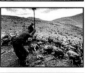
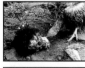

2 *Bruno Stevens,
Belgium, for Paris-
Match, France*
Grozny, August

Page 115

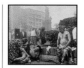
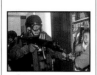

3 *Haseon Park,
Republic of Korea,
for Geo Korea*
Sky Burial in Tibet

Page 118

Spot News
Singles
1 *Yuri Shtukin,
Russia, Izvestia*
Bomb Attack in
Moscow
Underground, 8
August

Page 120

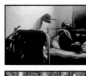

2 *Alan Diaz,
USA, Associated
Press*
Cuban Refugee
Elian Gonzalez
Seized by US
Federal Agents,
Miami, 22 April

Page 122

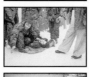

3 *Suhaib Salem,
Palestinian
Territories, Reuters*
Scuffle Between
Israeli and
Palestinian Police,
Gaza, 20 July

Page 123

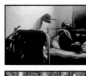
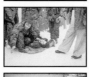

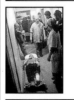

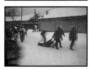

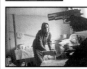

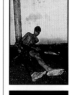
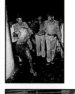
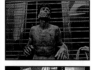

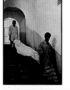
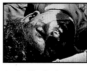

Spot News
Stories
1 *Thomas Dworzak
Germany, Magnum
Photos*
Chechen Fighters
Leave Grozny,

Page 124

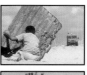
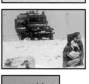
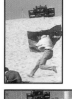
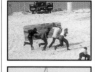
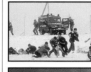
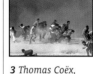

2 *Shafiqul Alam
Kiron,
Bangladesh, MAP
Photo Agency*
Acid Attack, March

Page 130

3 *Thomas Coëx,
France, Agence
France Presse*
Palestinian Youths
Take Shelter from
Israeli Troops, Gaza,
October

Page 132

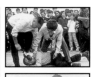
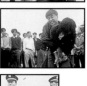
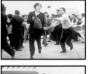

Honorable Mention
*Chien-min Chung,
USA, Associated
Press*
Falun Gong
Demonstration on
Tiananmen Square,
Beijing, 1 October

Page 134

Participants 2001 Contest

In 2001, 3,938 photographers from 121 countries submitted 42,321 entries. The participants are listed according to nationality as stated on the contest entry form. In unclear cases the names are listed under the country of mail address.

AFGHANISTAN
Zalmai Ahad

ALBANIA
Bevis Fusha
Marketin Pici
Namik Selmani

ALGERIA
Hocine
Atmane Idjeraoui
Abd Elaziz Sahraoui

ARGENTINA
Marcelo Aballay
Martin C.E. Acosta
Pablo Aneli
Martin Arias Feijoo
Bernardino Avila
Carlos Daniel Brigo
Ruben Adrian Cabot
Leonardo Hugo Cavallo
Ricardo Eduardo Ceppi
Alejandro Chaskielberg
Leandro Walter Coniglio
Gabriela Fernanda Corbani
Daniel Dapari
Benito Francisco Espindola
Ana Paula Far Pahurra
Julio Giustozzi
Marcos Guillermo Gomez
Pablo Ariel Gomez
Francisco Gonzalez Guillen
Sergio Gabriel Goya
Claudio Marcelo Herdener
Miguel Angel Mendez
Luis Alberto Micou
Julio C. Pantoja
Christopher Pillitz
Santiago Porter
Héctor Rio Hacho
Joaquin Rodriguez
Andres Salinero
Juan Jesús Sandoval
Rosana Schoijett
Rubén J. Sotera
Sebastian Spongia
Gustavo Marcelo Suarez
Luciano Thieberger
Antonio Valdez
Juan Domingo Vera
Verónica Vichi
Leonardo Vincenti
Diego Vinitzca
Alejandro Vivanco
Enrique Wartenberg

ARMENIA
Berge Arabian

AUSTRALIA
Simon Alekna
Gill Allen
Michael Amendolia
Dave Anderson
Jack Atley
Narelle Autio
Mark Baker
Ross Bird
Paul Blackmore
Philip Blenkinsop
Vasil Boglev
Michael Bowers
Darrin Braybrook
Angela Brkic
Philip Brown
Michel Bunn
Vince Caligiuri

David Callow
Gabriele Charotte
Steve Christo
Darren Clark
Warren Clarke
Tim Clayton
Simon Cocksedge
Nick Cubbin
Ian Charles Cugley
Sean Davey
Jenny Duggan
Stephen Dupont
Greg Garay
Timothy Georgeson
Jacky Ghossein
Luke Glossop
Criag Golding
Steve Gosch
David Gray
Paul Harris
Sahlan Hayes
Mathias Heng
Phil Hillyard
Tiet Ho
Adam Hollingworth
Glenn Hunt
Martin Jacka
Gabor Jakab
Tara Johns
Quentin Cameron Jones
Wayne Jones
Dallas Ashton Kilponen
Nicholas Laham
Tanya Lake
Tony Lewis
Jesse Marlow
Jean-Dominique Martin
Regis Martin
Alex Massey
Robert McFarlane
Darren Charles McNamara
Samuel McQuillan
Andrew Meares
Andrew Merry
Paul Miller
Palani Mohan
Nick Moir
Claire Michele Mossop
Helen Nezdropa
Renee Nowytarger
Barry O'Brien
Trent Parke
David Dare Parker
Gregg Porteous
Adam William Pretty
Tom Putt
Pat Scala
Dean Sewell
Russell Shakespeare
Matthew Sleeth
Danielle Smith
Troy Snook
Virginia Star
Kenneth Stevens
Tasso Taraboulsi
Grant Turner
Matt Turner
Donald Turvey
Angelo Velardo
Ian Waldie
Greg Wood
Jonathan Adley Wood
Andy Zakeli

AUSTRIA
Heimo Aga
Astrid Bartl
Robert Fleischanderl
Josef Friedhuber
Christine Grancy
Peter Granser
Christoph Grill
Günter Jost
Franz Kaplan
Erwin Kneidinger
Wolfgang Luif
Peter Mathis
Wolfgang Mayer
Franz Neumayr
Rita Newman
Josef Polleross
Reiner Riedler
Deniz Saylan

Roland Schönbauer
Josef Timar
Andreas Urban
Ludwig Vysocan
Nikolaus Wagner
Günter Wilfinger
Erwin Wurm

AZERBAIJAN
Rufat Abbasov
Elnur Babayev
Rafig Gambarov
Ilgar Jafarov
Ilham Kishiyev
Ogtay Mamedov
Orkhan Mamedov
Naring Mamedov
Hasan Oglu Mirnaib
Zalya Velieva
Ibadov Vugar

BAHAMAS
Andrew Seymour

BANGLADESH
Shafiqul Alam Kiron
Abul Fazul MD. Ashraf
Kajal Hazra
Md Delowar Hossain
Fakrul Islam
Zahidul Islam Khan
Momena Jalil
Shahidullah Kaiser
Nazrul Islam Khan Md.
Rashid Un Nabi
Mizanur Rahman
Pavel Rahman
Mohammadur Rahman
Mohammad Safiuddin
Bashir Ahmed Sujan

BELARUS
Vladimir Bazan

BELGIUM
Vincent Berg
Henri Berlize
Patrick Bollen
Paul Bolsius
Bie Bostrom
Elisabeth Broekaert
Robert Brugge
Marleen Daniels
Marc Deville
Tim Dirven
Thierry Falise
Maria Fialho
Henrik G. de Gyor
Peter Hoof
Gert Jochems
Eddy Kellens
Didier Lebrun
Firmin Maitre
Jacques Marechal
Frederic Materne
Olivier Papegnies
Stephan Peleman
Philip Reynaers
Dominique Simon
Lieve Snellings
Bruno Stevens
Luc Struyf
Dieter Telemans
Gaël Turine
Stephan Vanfleteren
Alex Vanhee
Louis Verbraeken
Eva Vermandel
John Vink
Peter Voecht
Tim Waele

BOLIVIA
Sandra Boulanger
Patricio Crooker
David Mercado Montano
Gaston Ugalde Castro
Martha Vázquaz Yutronic

BOSNIA-HERZEGOVINA
Berzhip Adzaip
Zijah Gafic
Senad Gubelic

Haris Memija
Nedad Ugljesa

BRAZIL
Jorge Akimoto
Araujo Alberto Cesar
Alan Kardec E. Alves
Reginaldo Alves de Castro
Euler Paixão Alves Peixoto
Tasso Alves Pinheiro
Sergio Amaral
Paulo Amorim
J. Anchieta Xavier de Sousa
Luiz Araujo Marques Filho
Elisandro Ascari
Francisco de Assis Sampaio
Ricardo Azoury
Nário Barbosa da Silva
Alexandre Belém
Jamil Bittar
Roberto Bonomi
José Geraldo Borges
Mario Borges Junior
Paolo Cesar Bravos
Manoel Brito
João Luiz Bulcao
Leonardo Caldas Cavalcanti
F. Canindé C. dos Santos
Rubens Cardia
Marcelo Carnaval
Weimer Carvalho Franco
Gianne C. Soares dos Santos
Tatiana Cassia de Deus
Cristiana Castello Branco
Ivaldo Cavalcante Alves
Antonio R. Cazzali
Julio Cesar Bello Cordeiro
Jose Luiz Cordeiro Lopes
N. Hamilton Costa Junior
Joseane Daher
Fernando Dantas
Teresa Dantas de Góes
Leonardo Dias Corrêa
Domingos Rodrigues Peixon
F. Fernandes da Costa Lima
Davi Fernandes da Silva
Denis Ferreira Netto
E.P. Ferreira T. Dos Santos
Márcia Foletto
Ricardo Funari
Dado Galdieri
M.O. Gomes de Andrade
Alexandre Gondim
Francisco Guedes de Lima
Dulce Helfer
José Antonio Leister Perez
Ulisses Job Lima
Levis Litz
André Lobo
Orestes Locatel
Benito Maddalena
Jorge William Marinho
Manoel Marques Neto
Antonio Meneses
Gleice Mere
Pedro de Moraes
Sebastião Moreira
Carlos Alves Moura
Roberto Nemais Junior
Humberto B. Nicoline
Adrovando Claro Oliveira
Ricardo B. Oliveira
Antonio Carlos Paz
Eraldo Peres
José Emilio Perillo
Izan Petterle
Paulo Martins Pinto
Marcos André Pinto
Paula Prandini
Marcelo Prates
Carol Quintanilha
Marcelo Reis
M. R. de Mendonca e Silva
E. Ribeiro de Queiroz
Monica Richter
Zulmair Porfirio Rocha
E. Rodrigues de Freitas
Teotônio José Roque
Marcelo Rudini
Christina Rufatto
Paulo R. Santos Araújo
Antonio Scorza
Alberto Leandro Silva

Raimundo Valentim Soares
Fernando Souza
Francisco Souza
Gilvan Souza Barbosa
Gilberto Tadday
Luís Carlos Tajes
Rosane Talayer de Lima
Kathia Maria Tamanaha
Marco A. Flores Teixeira
André Telles
Otavio Andrade Valle
Luiz Armando Vaz
Gil Vicente de Brito Maia
Renata M. Victor de Araujo
J.T. Vidal Cavalcante
Ovidio Vieira
Roberto Wagner
Mônica Zarattini

BRUNEI
Cheong Huat Seng

BULGARIA
Vladimir Alexeev
Mishael Gueron
Ilian Iliev
Lyubomir Jelyaskov
Dimitar Kyosemarliev
Alexander Manzov
Anelia Nikolova
Georgiev Roumen
Liulin Stamenov
Vladimir Stoianov
Bisser Todorov
Plamen Todorov
Todor Todorov
Ivan Sabev Tzonev
Ivaylo Velev
Vesel Vesselinov

BURKINA
Abdoulaye W. Kabore
Yempabou Ahmed Oudba

BURUNDI
Anton Churochkin

CAMEROON
Dieudonne Abianda
Eustache Djitouo Ngouagna
Raphaël Mbiele Happi

CANADA
Edwin Amsden
Peter Andrews
Bernard Beisinger
Dharmesh S. Bhavsar
Tony Bock
Bernard Brault
Elaine Brière
Geraldine Brophy
Shaughn Butts
Phil Carpenter
Lloyd Cederstrand
Barbara Davidson
Clay Davidson
Didier Debusschere
Don Denton
Hans Deryk
Yuri Dojc
Bruno Dorais
Frazer Dryden
Candace Elliott
Benoît Gariépy
Greg Girard
Matei Glass
Wayne Glowacki
Aaron Harris
Veronica Henri
Gary Hershorn
Philip Hossack
Paul Hourigan
David Hum
Troy Hunter Hunter
Rene Johnston
Todd Korol
Judith Kostilek
Robert Laberge
Marie-Susanne Langille
Julie Langpeter
Roger Lemoyne
Jean Levac
Doug MacLellan

Rick Madonik
Sylvain Mayer
Allen McInnis
Martin Mraz
Jean Nichols
Gary Nylander
Frank O'Connor
Louise Oligny
George Omorean
Jason Payne
Goran Petkovski
Vincenzo Pietropaolo
Peter Power
Joshua Radu
Steve Russell
Natalie Schonfeld
Peter Sibbald
Steve Simon
Guillaume Simoneau
Lana Slezic
Phill Snel
Gregory Southam
Fabrice Strippoli
Homer W. Sykes
Robert Tinker
Larry Towell
Orlo Tveter
Kevin Unger
Scott Van Seggelen
Suva Vrbaski
Ron Ward
George Webber
Bernard Weil
Simon Wilson
Larry Wong
Iva Zimová

CHILE
Miguel Alemparte
Rodrigo Arangua
Orlando Barria Maichil
Christian Byrt Jimenez
Fernando Morales
Tomas Munita Philippi
Miguel Sepulveda Saez
Marco Ugarte
Claudio Vera Ormeño

COLOMBIA
Fabiola Acevedo
Luis Henry Agudelo Cano
Aymer Alvarez
Fredy Amariles Garcia
Humberto Arango Gomez
Oscar Ariza Romero
Felipe Caicedo Chacón
Abel Cardenas Ortegon
Gerardo Chaves Alonso
Rodrigo Cicery Beltran
Milton Diaz Guillermo
William Martinez Beitran
Javier Galeano Naranjo
Jaime Garcia Rios
Camilo George Jimeno
Jose Gomez Mogollon
Maria Gonzalez Gonzalez
Jose Luis Guzman Negrete
Juan Herrera Parra
Alejandro Mendoza Quiroga
Rodrigo Molina Lora
Hector Moreno Valdes
German Murillo Ruiz
Jorge Orozco Galvis
Jorge Paez Fonseca
Jaime Perez Munevar
Filiberto Pinzon Acosta
Tulio H. Pizano Arroyave
Luis Ramirez Ordonez
Martha Reyes Orjuela
Henry Romero
Robinson Saenz Vargas
M. Saldarriaga Quintero
Juan A. Sanchez Ocampo
Roberto Schmidt
Emiro Silva Ruiz
John Wilson Vizcaino Tobar
Hector Fabio Zamora Pabon
Donaldo Zuluaga Velilla

COSTA RICA
Gloria Calderon Bejarano
Jorge Castillo Monestel
Jose Luis Diaz Serrano

Eduardo López Lizano
Marco Monge Rodriguez
Kattia Vargas Araya

CROATIA
Angelo Bozac
Rajle Damir
Vladimir Dugandzic
Kreso Durich
Marko Gracin
Silvano Jezina
Fjodor Klaric
Vlado Kos
Predrag Krstic
Andrea Kulundzic
Veljko Martinovic
Ivica Pejic
Kristina Stedul
Denis Stosic
Balas Tomislav
Srdan Vrancic

CUBA
Hector Fernández Ferrer
Gonzalo Gonzalez Borges
F. Hechavarria Guzman
C. Herrera Ulashkevich
Huo Yan
Jorge Lopez Viera
Humberto G. Mayol Vitón
Ramon Pacheco Salazar
Alejandro Perez Estrada
Luis Quintanal Cabriales

CYPRUS
A. Hadjicharalambous
Petros Karatzias

CZECH REPUBLIC
Radim Beznoska
Josef Bradna
Karel Cudlin
Alena Dvorakova
Eduard Erben
Viktor Fischer
Lenka Hatasová
Jakub Hnevkovsky
Hana Jakrlová
Vaclav Jirsa
Maria Kracíkova
Antonin Kratochvil
Jiri Krenek
Jaroslav Kucera
Michal Novotny
Jiri Pekarek
Milan Petrik
Petra Ruzickova
Vladimir Rys
Jan Schejbal
Robert Sedmik
Roman Sejkot
Josef Sloup
Richard Spur
Josef Strouhal
Tomas Svoboda

DENMARK
Soren Bidstrup
Claus Bonnerup
Marie Louise Brimberg
Kristian Buus
Finn Byrum
Asger Carlsen
Jakob Carlsen
Jan Dago
Casper Dalhoff
Jacob Ehrbahn
Mads Eskesen
Jorgen Flemming
Finn Frandsen
Jan Anders Grarup
Mads Greve
Tine Harden
Ulrik Jantzen
Anna Kari
Lars Krabbe
Henning Kristensen
Joachim Ladefoged
Mogens Laier
Claus Bjørn Larsen
Soren Lauridsen
Tao Lytzen
Nils Meilvang

Sif Meincke
Lars Moeller
Ricky John Molloy
Miklas Njor Nielsen
Hans Otto
Ulrik Pedersen
Lene Esthave Pedersen
Erik Refner
Lars Salomonsen
Soren Skarby
Betina Skovbro
Jan Sommer
Claus Sondberg
Bo Thomassen
Anders Vendelbo
Robert Wengler
Kaspar Wenstrup

ECUADOR
Juan Pablo Barragán
P. Calahorrano Betancourt
Yuri Campana Altuna
Vicente Costales Terán
Stalin Diaz Suarez
Alfredo Lagla Lagla
Alex Robin Lima
Gerardo Mora Drouet
Jorge Penafiel Fajardo
Leen Prado Viteri
Paol Rivas Bravo
Manuel Sosa Boada
Patricio Teran Argüello
Eduardo Teran Urresta

EGYPT
Medhat Abb Almeged
Amr Gamal Abd el Sadek
Khaled El Figi
Mohammed Hanafy Sayed

ERITREA
Russom Fesahaye
Ibrahim Ali Haj Idris
Tesfaldet Kidane
Hana Kiflemariam
Eyob Tecle Ghebremedhin

ESTONIA
Tiit Räis

ETHIOPIA
Alemu Asfaw Manni
Fasika Ermias Mammo
Kinfemichael Habtemariam
Tenteme Abebe Kidist
Tesfa Lakew
Tewodros Tilahun

FINLAND
Petteri Kokkonen
Jussi Nukari
Jyrki Parantainen
Hernan Patino
Petri Puromies
Erkki Raskinen
Eetu Sillanpää
Ilkka Uimonen
Markku Ulander

FRANCE
Bruno Abile
Guilhem Alandry
Navitel Amazone
Jean-Marc Armani
Patrick Artinian
Maher Attar
Bénédicte Ausset
Patrick Aventurier
Bruno Bade
Helene Bamberger
Eric Baudet
Pascal Baudry
Eric Bauer
Patrick Baz
Arnaud Beinat
Remi Benali
Desjeux Bernard
Valérie Berta
Alain Bétry
Olivier Blaise
Romain Blanquart
Olivier Boels
Christian Boisseaux-Chical

Samuel Bollendorff
Franck Boucourt
Jean-Marc Bouju
Denis Boulanger
Denis Bourges
Eric Bouvet
Gabriel Bouys
Alain Buu
Christophe Calais
Serge Cantó
Stephane Cardinale
Sarah Caron
Jean-François Castell
Patrick Chapuis
Julien Chatelin
Patrick Chauvel
Simon Christoph
Thomas Coëx
Jean Pierre Collin
Stephane Compoint
Jerome Conquy
Carl Cordonnier
Nicolas Cornet
Olivier Corsan
Jean-Louis Courtinat
Antoine D'Agata
Julien Daniel
Ljubisa Danilovic
Georges Dayan
Regis Delacote
Jerome Delafosse
Luc Delahaye
Jerome Delay
Magali Delporte
Jacques Demarthon
Michel Denis-Huot
Lionel Derimais
Bernard Descamps
Philippe Desmazes
Xavier Desmier
Miquel Dewever
T. Doan Na Champassak
Marie Dorigny
Claudine Doury
Marc Dozier
Christophe Dubois
Alexis Duclos
Emmanuel Dunand
Philippe Dupre
Philippe Dupuich
Andre Durand
Philippe Eranian
Alain Ernoult
Patricio Estay
Bruno Fablet
Albert Facelly
Bruno Fava
Patrick Favier
Franck Fife
Laurence Fleury
Patrick Forestier
Yves Forestier
Romain Franklin
Raphaël Gaillarde
Michel Gangne
Beatrice Gea
Christoph Gin
Frédéric Girou
Pierre Gleizes
Georges Gobet
Philippe Gontier
José Grain
Philippe Grangereau
Pascal Grimaud
Diane Grimonet
Jacques Grison
Olivier Grunewald
Laurent Guerin
Jack Guez
François Guillot
Pascal Guyot
Antoine Gyori
Philippe Haÿs
Julien Hékimian
Daniel Herard
Sylvie Huet
Dimitri Iundt
Mat Jacob
Frederic Jacquemot
Olivier Jobard
Patrick Kovarik
Jean Philippe Ksiazek
Bernard Lachau

Brigitte Lacombe
Vincent Laforet
Hien Lam-Duc
Patrick Landmann
Jacques Langevin
Sylvain Larnicol
Francis Latreille
Christophe Le Petit
Cyril Le Tourneur d'Ison
Christophe Lepetit
François Lochon
Tony Lopez
Philippe Lopparelli
Jean-Marc Lubrano
Manoocher
Stephane Mantey
Jean-Michel Mart
Bertrand Meunier
Roland Michaud
Sabrina Michaud
Luc Moleux
Laurent Monlaü
Eve Morcrette
Jean-Luc Moreau-Deleris
Olivier Morin
Jean-Pierre Muller
Hop Nguyen
Gilles Nicolet
Alain Noguès
Emmanuel Ortiz
Emmanuel Pain
Richard Pak
Joel Palmie
François Paolini
Hertzog Patrick
Guillaume Pazat
Francois Perri
Philippe Pico
Emmanuel Pinganaud
Gerard Planchenault
Jean-Pierre Porcher
Eric Prinvault
Noël Quidu
Gérard Rancinan
Marine Réan
Laurent Rebours
Lucille Reyboz
Reza
Patrick Robert
Raymond Roig
Xavier Rossi
Patrick Roux
Stephane Ruet
Cyril Ruoso
Jean Yves Ruszniewski
Joël Saget
Bruno Sananès
Alexandre Sargos
Frédéric Sautereau
David Sauveur
Sylvain Savolainen
Laurent Sazy
Gregory Scicluna
Franck Seguin
Ahmet Sel
Antoine Serra
Jérome Sessini
Jean-Michel Sicot
Jean-Manuel Simoes
Klavdij Sluban
Alain Soldeville
Laurent Starzynska
Dominique Szczepanski
Theo
Olivier Thebaud
Pascal Tournaire
Jean-Michel Turpin
Gérard Uferas
Gerard Vandystadt
Christian Vioujard
Lorenzo Virgili
Dung Vo Trung Dung
Laurant Weyl

GEORGIA
Alexandre Kvatashidze

GERMANY
Dirk Adolphs
Carola Alge
Theo Allofs
Eva Alpers-Gromoll
Michael S. Anacker

Klaus Andrews
Nicole Angstenberger
Patrick Barth
Theodor Barth
Dirk Bauer
Marion Beckhäuser
Brigit Beizelt
Kirsten Benoufa
Wonge Bergmann
Gunnar Berning
Klaus Beth
Birgit Bitterman
Dieter Blum
Christoph Boeckheler
Stefan Boness
Alexander Boom
Wolfgang Borm
Jörg Böthling
Wolf Böwig
Ina-Maria Brämswig
Michael Braun
Jan Braunholz
Hans Jürgen Britsch
Franka Bruns
Martina Buchholz
Matthias Creutziger
Sven Creutzmann
Anthony Crossley
Peter Dammann
Tomas Dashuber
Thomas Duffé
Thomas Dworzak
Winfried Eberhardt
Stephan Elleringmann
Detlev Endruhn
Stephan Erfurt
Thomas Ernsting
Volker Essler
Julia Fassbender
Martin Fejér
Nicolas Felder
Klaus Fengler
Jockel Finck
Ute Fischer
Wiebke K. Fölsch
Klaus Franke
Henner Frankenfeld
Sascha Fromm
Daniel Fuchs
Albrecht Fuchs
Thorsten Futh
Christoph Gerigk
Gaby Gerster
Bodo Goeke
Josef F. Göhri
Igor Gorovenko
Thomas Grabka
Wolfgang Groth
Oliver Grottke
Kirsten Haarmann
Gabriel Habermann
Kerstin Hacker
Michael Hagedorn
Gerhard Heidorn
Wim Helm
Arnd Hemmersbach
Michael Herold
Andreas Herzau
Katharina Hesse
Markus C. Hildebrand
Karl-Josef Hildenbrand
Joachim Hirschfeld
Marcus Höhn
Milan Horacek
Helge Huland
Monika Jäger
Karlheinz Jardner
Burkhard Juettner
Christian Jungeblodt
Marcus Kaufhold
Reinhard Kemmether
Volker Kess
Markus Kettel
David Klammer
Robert Kliem
Brigitta Klotz
Gunter Klötzer
Georg Knoll
Herbert Knosowski
Hans-Jürgen Koch
Heidi Koch
Vincent Kohlbecher
Sven-Oliver Korb

Tom Körber
Ulrich Kox
Reinhard Krause
Gebhard Krewitt
Dirk Krüll
Michael Kunkel
Bernhard Kunze
Andrea Künzig
Christa Lachenmaier
Karl Lang
Martin Langer
Gudrun Laufer-Vetter
Markus Leser
Torsten Leukert
Russell Liebman
Lorne Carl Liesenfeld
Dorothea Loftus
André Luetzen
Hans Manteuffel
Oliver Meckes
Anja Meyer
Marc Meyerbröker
Bodo Müller
Elke Niedringhaus-Haasper
Ralf Niemzig
Rolf Nobel
Axel Nordmeier
Roland Obst
Nicole Ottawa
Christoph Otto
Jens Palme
Michael Penner
Laci Perenyi
Thomas Pflaum
Sebastian Pfütze
Stefan Pielow
Oliver Plath
Boris Potschka
Marko Priske
Michael Probst
Frank Pusch
Christophe Püschner
Karsten-Thilo Raab
Thomas Rabsch
Rainer Raeder
Andreas Reeg
Uli Reinhardt
Sabine Reitmaier
Jiri Rezac
Astrid Riecken
Karin Rocholl
Boris Roessler
Peter Rogowsky
Daniel Roland
Bernd Roselieb
Daniel Rosenthal
Sabrina Rothe
Tina Ruisinger
Ottfried Sannemann
Sabine Sauer
Hans Sautter
Bernd Schäfer
Rüdiger Schall
Peter Schatz
Michael Schindel
Frank Schirmer
Jordis Schlösser
Barbel Schmidt
Bernhard Schmitt
Harald Schmitt
Walter Schmitz
Martin Schoeller
Edgar Schoepal
Steffen Schrägle
Markus Schreiber
Frank Schröter
Bernd Schuller
Marc Oliver Schulz
Horst Jürgen Schunk
Stephan Schütze
Hartmut Schwarzbach
Oliver Sehorsch
Stephan Siedler
Leon Singh
Peter Sondermann
Renado Spalthoff
Martin Specht
Babette Sponheuer
Günter Standl
Marc Steinmetz
Stefanie Sudek
Andreas W. Thelen
Peter Thomann

Harald Tittel
Oliver Tjaden
Michael Trippel
Dieter Tuschen
Friedemann Vetter
Marcus Vogel
Helmut Wachter
Frank P. Wartenberg
Anja Weber
Markus Weiss
Petra Welzel
Michael Wesely
Georg Wex
Kai Wiedenhöfer
Claudia Yvonne Wiens
Mathias Wild
Christian Wyrwa
Dirk Zimmer
Samuel Zuder

GHANA
Forstin Adjei Doku

GREECE
Yannis Behrakis
Alexander Beltes
Peter Giannakoyris
Markos George Hionos
Yannis Kabouris
Yiorgos Karahalis
Petros Kipouros
Yiannis Kolesidis
Yannis Kontos
Thomas Lappas
Stelios Matsagos
Yiorgos Nikiteas
Athanasios Papadopoulos
Lefteris Pitarakis
Aristidis Siannis
Thanasis Stavrakis
Sophie Tsabara
Gonis Vasilis
John Vellis

GUATEMALA
Luis Garcia
Daniel Hernández-Salazar
Ricardo Ramirez Arriola

HONG KONG, S.A.R. OF CHINA
Chan Kam-Fai
Pornchai Kittiwongsakul
Jewel Samad

HUNGARY
Eva Arnold
Attila Balázs
László Balogh
Andras Bankuti
Ivan Benda
Imre Benkö
David Bozsaky
Gyula Czimbal
Zsolt Demecs
Bela Doka
Szabolcs Dudas
Imre Földi
Csaba Forrásy
Balázs Gardi
Sopronyi Gyula
Attila Kisbenedek
Tibor Kocsis
Szilárd Koszticsák
Attila Kovács
Bence Kovács
Tamas Kovacs
Vegh Laszlo
Ferenc Markovics
Zoltan Molnar
Gyoergy Nemeth
Zsolt Pataky
Katalin Sandor
Andrea Schmidt
Lajos Soós
Barnabas Szabó
Sándor H. Szabó
Péter Szalmás
Lilla Szász
Miklos Teknos
Illyés Tibor
Domaniczky Tivadar
Viktor Veres

Akos Verö
Peter Zádor

ICELAND
Einar Falur Ingolfsson

INDIA
Ajay Aggarwal
Sanjay Ahlawat
Amit
Bindu Arora
Atul
S. Balakrishnan Babu
Asish Bal
Madhavan Balan
Sanat Bandi
Tarapada Banerjee
Shyamal Basu
Samir Basu
Shome Basu
Sandesh Bhandare
Amit Bhargava
Rajesh Kumar Bhasin
Kamana Bhaskar Rao
Kedar Vilas Bhat
Gopal Bhattacharjee
Jayanta Bhattacharyya
Mukund Bhunte
Bijoy Kumar Jain
G. Binu Lal
Gautam Bose
Nand Kishore Budhodi
Hersh W. Chadha
Chandra Balan
Bhaskaran Chandrakumar
Sandipan Chatterjee
Suvendu Chatterjee
Johnson V. Chirayath
Bikas Das
Pradip Das
Saurabh Das
Shantanu Das
Sucheta Das
Suman Datta
Rajib De
Deepak
Pallikunnel Raghavan
Devadas
Minakshi Dey
P. Dileepkumar
Subandhu Dube
Gajanan Dudhalkar
Jaganathanan Durai Raj
Victor George
Subhendu Ghosh
Gauri Gill
Alok Bandhu Guha
Santosh Harhare
Dipak Hazra
Fawzan Husain
Sunil Inframe
Iyer
Rajeev Jain
C.K. Jayakrishnan
Vibi Job
Samar S. Jodha
Rana Kamal
Gopi Kannadasan
Rajan Karimoola
Kuttibabu A. Beekayyar
Rajan Kuttur
Atul Loke
Dilip Lokre
T. Madhuraj
Prahlad Mahato
Natasha M. Martis
Dilip Mehta
Aloke Mitra
Kailash Mittal
Mohan
Moni Sankar Das
Bhaskar Mukherjee
Dines Mukherjee
Indranil Mukherjee
Joy Mukhopadhyay
Prashanth Mukundan
Babu Murali Krishnan
James Sundar Murthy
Tauseef Mustafa
Ashok Nath Dey
Kedar Nene
Nanu Neware
Chauhan Nilesh Singh

J. Niravath Prabhakaran
Sudharak Olwe
P.V. James
Das Pabitra
Ganesh Parida
Gautam Patole
S. Paul
Mustafa Peediakkal
Vasant Prabhu
Kumar Pradeep
Bhagya Prakash
Neeraj Priyadarshi
Shakeel Qureshy
Appampalli Radhakrishna
Aijaz Rahi
Abdul Rahman
Rajappan Rajesh
Rajneesh Parihan
Solomon Raphel
Shailesh Raval
Kushal Ray
Rudrakshan
Jayanta Saha
Rakesh Sahai
Alapati Sarath Kumar
Partha Protim Sarkar
Suman Sarkar
Somsubhro Sarkar
Sasikayur
Dominic Sebastian
Bijoy Sengupta
Anupam Shah Hemendra
Pandey Shailendra
Gour Sharma
Pankaj Sharma
Shirish Shete
Shihab
V.S. Shine
Ajoy Sil
Prakash Singh
Virendra Singh
Rajib Singha
Ramesh Soni
Arun Sreedhar
Subrahmanyam
Manish Swarup
Rajan M. Thomas
Bino Thomas
Arun Jacob Thomas
Solomon Thomas
Rajan Vadakkemuriyil
Sanjeev Verma
Joseph Vincent
Babu Vipinchandran
Keshav Vitla
Himanshu Vyas
Ali Zakir

INDONESIA
Ade Dani Setiawan
Surya Adi Lesmana
Andi Anshari
Bambang A Fadjar
Oka Barta Daud
Sinar Goro Belawan
Ali Budiman
Indarto Budiono
Bernard Chaniago
A Damardanto Yudhaputra
Achmad Yessa Dimyati
Purnama Djunedi
Maha Eka Swasta
Ardiles Ekadarma Rante
Riza Fathoni
Elano Gantiano
Heri Gunawan
Abraham Hamzah Subekti
David Hermandy
Ika Rahmawati Hilal
Fernandez Hutagalung
Achmad Ibrahim
Sandi Irawan
Hubert Januar
R. Waluyo Jati
Sugito Jayadi
Kemal Jufri
Paul Kadarisman
Rully Kesuma
Ralph Kholid
Andi Kurniawan Lubis
Aris Liem
Ali Lutfi
Mak Pak Kim

Zarqoni Maksum
Harto-Solichin Margo
Donny Metri
Audy Mirza Alwi
Aris Munandar
Ramli Mustafa
Nogo Agusto Alimin
Pang Hway Sheng
Ivan Nardi Patmadiwiria
Paulus Patmawitana
Erik Prasetya
Andry Prasetyo
Hermanus Prihatna
Arbain Rambey
Sutrisna Ramli, E. Fiap
Seno Resdianto
Fadjar Roosdianto
Awaluddin Rusdiansyah
Saptono
Yamtono Sardi
Stephanus Setiawan
Julian Sihombing
Hotli Simanjuntak
Ferdy Siregar
Poriaman Sitanggang
Woko Wiryono Sriyanto
Sugede S. Sudarto
Cholif Sudjatmiko
Edi Suhaedi
Arief Suhardiman Sutardjo
Sungkono
Sunyoto
Setiyo Supratcoyo
Agus Susanto
Eri Susanto
Wibudiwan Tirta Brata
Nuraini Tjitra Widya
A. Pratomo Tommy
Nonot Suryo Utomo
Pandji Vasco da Gama
Widjanarko
Djohan Wijaya
Tjitra Winarno
Effy Wiojono Putro
Christianto Yohanes
Ujang Zaelani

IRAQ
Sameer Taha Ahmad
Zuhair Kadhim Al Soudani
Amad J. Kareman
Saleh Muhsin Al-Samawi
Ibrahim S. Nadir

IRELAND
Patrick Bolger
Desmond Boylan
Phil Carrick
Colman Doyle
Michael Dunlea
Tom Honan
Steve Humphreys
Matt Kavanagh
Eric Luke
Dara Mac Dónaill
Philip Magee
Frank Miller
Seamus Murphy
Jack P. Nutan
Bryan O'Brien
Padraig O'Flannabhira
Kenneth O'Halloran
Jim O'Kelly
David Sleator
Dermot Tatlow
Eamon Ward

ISLAMIC REP. OF IRAN
Ali Ali
H. Amdjadi-Moghaddam
Faramarz Amele Bordbar
Homayoun Amir Yeganeh
Saleh Asghary
Ali Reza Attariani
Ebrahim Bahrami
Taghi Bakhshi Rad
Modaressi Banafshe
Majid Dozdabi Movahed
Mahdi Fathi
Amir Reza Fatorehchi
Ali Ghalamsiyah
Somayeh Hadji
Sharif Hamed

Yousef Lavi Hamid
Persila Hamidi
Pamchal Hamidi
Hashem Javadzadeh
Kamran Jebreili
Ali Reza Karimi Saremi
M. Keshavarz Keyvani
Majid Khamseh Nia
Ahmad Khirabady
Mohammad Khodadadash
Behrad Khodaee
Majid Mardanian
Hadi Mehdizadeh
Hamid Mohammad Nazar
Hossein Neshat Mobini
Tehrani
Morteza Nikoobazle
Motlagh
Morteza Pournejat
Mohammad Ali Qariqi
Payam Rouhani
Karim Sahib
Ali Salahsour
Mohsen Sanei Yarndi
Ali Seraj
Arash Sharifi
Hamid Reza Shirsafi
Khan Ali Siami
Imanpour Siyamak
Homeira Soleymani
Sheikh Mahmoudi Soroush
Pooyan Tabatabaei
Mojtaba Takin
Behrang Tirgary
Baharnaz Vahidi
Hassan Vasheghani
Farahani
Alfred Yaghobzadeh

ISRAEL
Esteban Alterman
Daniela Java Balanovsky
Rina Castelnuovo
Gil Cohen-Magen
Yori Costa
Nir Elias
Eddie Gerald
Hanoch Grizitzki
Jaime R. Halegua
Liza Hamlyn
Eitan Hess-Ashkenzai
Nir Kafri
Ziv Koren
Yoav Lemmer
Yoray Liberman
Ilan Mizrahi
Daoud Mizrahi
Lior Yoav Mizrahi
Nadav Neuhaus
Dan Peled
Ariel Schalit
Roni Schützer
Ahikam Seri
Amit Shabi
Nati Shohat
David Silverman
Ariel Tagar
Eyal Warshavsky
Yossi Zamir
Ronen Zvulun

ITALY
Francesco Acerbis
Alessandro Albert
Marco Albonico
Aurora Alfio
Stefano Amantini
Douglas Anareeti
Marco Anelli
Manna Annunziata
Glampiero Assumma
Neri Bagnai
Luigi Baldelli
Mario Biancardi
Teresa Bianchi
Giuseppe Bizzarri
Paolo Bona
Tommaso Bonaventura
Massimo Borchi
Alberto Bortoluzzi
Enrico Bossan
Leonardo Brogioni
Maristella Campolunghi

Giuseppe Chiucchiú
Lorenzo Cicconi Massi
Giacomo Cinquepalmi
Mario Cipollini
Lauria Ciro
Francesco Cito
Pier Paolo Cito
Francesco Cocco
Claudio Colombo
Antonino Condorelli
Gianni Congiu
Matteo Corneretto
Giorgio Cosulich de Pecine
Guido Cozzi
Mauro D'Agati
Enrico Dagnino
Daniele Dainelli
Fabrice Dallanese
Marco Di Lauro
Giovanni Diffidenti
Barile Domenico
Alfonso E. Dossi De Gregoris
Rita Falk
Francesco Fantini
Fabio Fiorani
Massimiliano Fornari
Mauro Galligani
Fausto Giaccone
Giovanni Giansanti
Cristiano Giglioli
Alberto Giuliani
Silvio Giuliani
Francesco Giusti
Giovanni Gregorio
Germano Gritti
Nicola Lamberti
Carlo Lannutti
Marco Longari
Stefano Luigi
Ettore Malanca
Claudio Marcozzi
Luca Marinelli
Domenico Marziali
Enrico Mascheroni
Massimo Mastrorillo
Daniele Mattioli
Giovanni Mereghetti
Mauro Minozzi
Bruno Monaco
Luca Federico Monducci
F. Filippo Monteforte
Marisa Montibeller
Alberto Moretti
Emanuele Mozzetti
Gianfranco Mura
Gianni Muratore
Fabio Muzzi
Luca Nizzoli
Antonello Nusca
Olivieri Oliviero
Maurizio Orlanduccio
Agostino Pacciani
Franco Pagetti
Stefano Paltera
Bruno Pantaloni
Eligio Paoni
Bruno Pavan
Paolo Pellegrin
Maria Pennacchio
Michele Pero
Fabrizio Pesce
Vincenzo Pinto
Alberto Pizzoli
Piero Pomponi
Gianluca Pulcini
Alfio Elio Quattrocchi
Giuliano Radici
Alberto Ramella
Giuseppe Rampolla
Alessandro Ruggeri
Ivo Saglietti
Andrea Samaritani
Patrizia Savarese
Giuseppe Sboarina
Max Schenetti
Stefano Schirato
Massimo Sciacca
Alessandro Scotti
Massimo Sestini
Shobha
Mauro Sioli
Silva
Massimo Siragusa

Mario Spada
Mauro Spanu
Riccardo Squillantini
Stefano Torrione
Angelo Turetta
Marco Vacca
Stefano Veratti
Paolo Verzone
Gerace Vince Paolo
Paolo Orazio Woods
Stefano Zardini
Franco Zecchin
Francesco Zizola
Aldo Zizzo

IVORY COAST
Issouf Sanogo

JAMAICA
Ian Allen
Rudolph Brown
Bryan Cummings
Junior Dowie
Norman Grindley
Michael Sloley
Joseph Wellington

JAPAN
Tetsuya Akiyama
Takao Fujita
Yoichi Hayashi
Itsuo Inouye
Takaaki Iwabu
Katsumi Kasahara
Kazunori Kasahara
Yasunori Kawachi
Chiaki Kawajiri
Yoshi Kitaoka
Masanori Kobayashi
Nakamura Koichi
Taro Konishi
Shusaku Kurozumi
Yohei Maruyama
Hirano Masaki
Kudou Masato
Kiyoshi Mori
Toru Morimoto
Takashi Morizumi
Takuma Nakamura
Ayumi Nakanishi
Tomoaki Nakano
Akihiro Ogomori
Akira Ono
Nobuko Oyabu
Yuichi Shimoda
Ekisei Sonoda
Masami Sugiyama
Chitose Suzuki
Noriyuki Suzuki
Ryuzo Suzuki
Kuni Takahashi
Sekine Takanori
Yuzo Uda
Jun Yasukawa
Yutaka Yonezawa

JORDAN
Hassan Abu-Gallyoun
Iyad Ahmad
Awad Awad
Jamal A. Issa Nasrallah
Mohamed A.A.R. Salamah

KAZAKHSTAN
Viktor Gorbunov
Vladimir Jacubovich
Olga Korenchuk
Vladimir M. Shurgayev
Valery Korenchuk

KENYA
Kweyu Collins
Malachi Owino Muga
Luke Njeru Nyaga
Henry Muriithi Nyage
Steve Okoko
Omondi Onyango
Paul Waweru
Peter Waweru

KYRGYZSTAN
Sagyn Ailchiev
Erkin Boljurov

LATVIA
Grigory Aleksikov
Leon Bessar
Aigars Eglite
Allen Joelson
Andris Kozlovskis
Andrej Shapran
Ritvars Skuja
Zigismunds Zalmanis

LEBANON
Ahmad Al-Zain
Anoir Amro
Ossama Ayoub
Joseph Barrak
Ramzi Haidar
Haisam Moussawi
Haidar Ramzy
Suhaila Sahmarani

LESOTHO
Tiny Sefuthi

LIBYA
Marwan Naamani

LIECHTENSTEIN
Eddy Risch

LITHUANIA
Giedrius Baranauskas
Ramunas Danisevicius
Aleksandr Katkov
Tomas Kauneckas
Kazimieras Linkevicius
Rolandas Parafinavicius
Ramune Pigagaite
Sigitas Stasaitis

LUXEMBOURG
Roland Miny

MACEDONIA
Boris Grdanoski
Zoran Jovanovic

MALAGASY
Seth Armand Maksim

MALAWI
Amos Gumulira
Govati Nyirenda

MALAYSIA
Sawlihim Bakar
Rohani Binti Ibrahim
Chen Soon Ling
Goh Chai Hin
Abdullah Jaafar
Leong Leong Chun Keong
Jeffery Lim Chee Yong
Lin Kian On
Liow Chien Ying
Noor Azman Zainudin
Alan Teh Pek Ling
Sang Tan
Shum Fook Weng
Tajudin B. Muhd. Yaacob
Tan Seng Huat
Teh Eng Koon
Vincent Thian
Andy Wong Sung Jeng
Yau Choon Hiam

MALTA
Matthew Mirabelli
John Pisani
Darrin Zammit Lupi

MAURITIUS ISLAND
George Michel

MEXICO
Daniel Aguilar Rodriguez
Jorge Alvarez Diaz
Hector Amezcua
Jorge Ardura
Jorge Bermudez Gonzalez
Victor R. Caivano
Ulises Castellanos Herrera
Ray Chavez
Elizabeth Dalziel
Alfredo Estrella Ayala

José Fernandez Cortes
Gonzalo Fuentes Moreno
Ivan Garcia Guzman
Jose Gonzales Moreno
Genaro Gonzalez Berumen
Luis Gonzalez Silva
C. Guadarrama Guzman
José Alfonso Guevara Lopez
Jose Manuel Jimenez
Leopoldo Kram
Jesus Martinez Garcia
Mario Martinez Meza
Victor Mendiola Galván
Gloria Minauro Sanmiguel
Octavio Nava Hernandez
Marco Nava Hernandez
Raul Ortega
Carlos Puma
Rafael Rio Chávez
Oscar Salas Gómez
Juan Ugalde Trejo
Marco Vargas Lopez
Jose Luis Villegas
Antonio Zazueta Olmos

MOLDAVIA
Vitalya Yakovlev

MOROCCO
Hamid Ben Thami
Ahmed Boussarhane
Mustapha Ennaimi
Brahim Lachgar

NEPAL
Ghale Bahadur Dongol
Suwal Birendra
Mukunda Kumar Bogati
Khyaju Ganga Prasad
Aroj Gopal Gurubacharya
Bajracharya Kaushal Ratna
Kiran Panday
Madan Panday
Shrestha Purushottam
Kiju Rabindra
Kishor Rajbhandari
Chandra Shekhar Karki
Karmacharya Shree Man
Prasant Shrestha

THE NETHERLANDS
Jan Banning
Shirley Barenholz
Jet Belgraver
Guido Benschop
Marcel G.J. Bergh
Yvonne Bijl
Peter Blok
Chris Bode
Remco Bohle
Paul Breuker
Joost Broek
Alexander Broere
Bram Budel
Erik Christenhusz
Rachel Corner
Roger Cremers
Peter Dejong
Janjaap Dekker
Ad van Denderen
Rob Doolaard
Leo Erken
Cornell Evers
Philippe Gelooven
Brian George
Lukas Göbel
Martijn Griendt
Marco Groote
Hans Heus
Wim Hofland
Inge Hondebrink
Rob Huibers
Jan IJken
Vincent W. Jannink
Christien Jaspars
Karijn Kakebeeke
Geert Kesteren
Chris Keulen
Arie Kievit
Roel Kimpe
Wim Klerkx
Robert Knoth
Cor Kock

Maryanne Könst
Michael Kooren
Marc Kort
John Lambrichts
Jerry Lampen
Gé Jan Leeuwen
Floris Leeuwenberg
Jaco Lith
Emile Luider
Michel Mees
Lex Meester
Menno Meijer
Harm Meter
Hinda Meter-v.d. Laan
Reinout Mulder
Jeroen Nooter
Willemine Pernette
Paul Pesman
Frans Poptie
Antonio Quintero
Pim Ras
Paul van Riel
Martin Roemers
Gerhard van Roon
Raymond Rutting
Peter Senstius
Monique Stap
Koen Suyk
Ruud Taal
Robin Utrecht
Sander Veeneman
Koen Verheyden
Rolf Versteegh
Jan Veugelers
Wim Vleghaar
Teun Voeten
Robert Vos
Klaas-Jan Weij
Emily Wiessner
Petterik Wiggers
Reinier Willigen

NEW ZEALAND
Greg Baker
Scott Barbour
Jeff Brass
Mark Dwyer
Peter Elbeshausen
Carolyn Elliott
Andrew Gorrie
Mark Graham
Michael Hall
Scott Hammond
David Hancock
Maarten Holl
Jimmy Joe
Shayne Kavanagh
Robert Marriott
Peter Meecham
Brett Phibbs
Peter James Quinn
Phil Reid
Kenny Rodger
Martin Ruyter
John Selkirk
Craig Simcox
William West
Staton Winter

NIGERIA
Sikiru Adeoye
Ademola Abayomi Akinlabi
Sam Olusegun Alade
M. Kadaralahu Areola
Akinola Ariyo
Taofeek Babajide
Ozowuama Benard
Kingston O. Daniel
George Esiri
Oludare Francis Fasube
Mike Iroanya
Matthew Odeyiola
Ray Onwuemegbulem
Adedeji Sunday Olufemi

NORWAY
Odd R. Andersen
Oddleiv Apneseth
Lise Aserud
Paal Audestad
Jonas Bendiksen
Erik Berglund
Tore Bergsaker

Stein Jarle Bjorge
Pal Christensen
T. Wilgaard Christiansen
Robert Eik
Orjan Ellingvag
Pal Christopher Hansen
Harald Henden
Pal Hermansen
Morten Hvaal
Chris Kyllingmarr
Henning Lillegård
Bo Mathisen
Mimsy Moller
Otto Münchow
Fredrik Naumann
Aleksander Nordahl
Karin Beate Nøsterud
Espen Rasmussen
Rune Saevig

PAKISTAN
Tahir Maalik Khan
Farah Mahbub

PALESTINIAN TERRITORIES
Hossam Abu Allan
Jamal Aruri
Chris Gerald
Rula Halawani
Adel Hana
Ahmed Jadallah
Menahem Kahana
Nasser Nasser
Fayez Nureldine
Suhaib Salem
Randa Shaath
Nasser Shiyoukhi

PANAMA
Eustacio Humphrey
Essdras M. Suarez

PARAGUAY
Hugo Fernández Enciso

PEOPLE'S REP. OF CHINA
An Hejie
Ba Shan
Bai Jianguo
Bai Xueyi
Bian Zhenjin
Cai Jie
Cao Fu Chuan
Cao Wei Song
Jijun Chai
Chen Bao Sheng
Chen Da Yao
Chen Guo Fu
Chen Wen Wei
Chen Xi Shan
Chen Yong
Chen Zhi Wei
Cheng Binghong
Cheng Qi
'Silence' Chenglie Wish
Chenke Jingye
Chia-You Shih
Chiang Yung-Nien
Cui Bo Qian
Cui Gang Cui Ren
Cui Heping
Cui Zhi Shuang
Da Mo Kou Yuan Fu
Dalang Shao
Den Ru-yi
Deng Bo
Dong Lian Shan
Duan Jimin
Fan Haibo
Fan Ying
Fan Zong Lu
Feng Jie
Feng Sheng Liang
Gang Ziang Xuan
Gao Hong Xun
Gao Lin Sheng
Gao Min
Gu Jia
Gu Xiao-Lin
Guan Shu Xian
Guo Chen-qiang
Guo Zhigui

Guorong Jia
Han Yun Min
He DeLiang
He Jing Chen
Hei Feng
Hong Guang Lan
Shi Hong Tao
Hu Jisheng
Hu Qing Ming
Hu Weiming
Hu Xiao Mang
Huang Jingda
Huang Min Xiong
Huang Yiming
Huo Xue Li
Jia Ruiqing
Jiang Ding Zhong
Jiang Fei
Jiang Xian Lu
Jiang Yun Long
Jiang Zhen Qing
Jin Si Liu
Jinsong Zhou
Ju Guangcai
Lai Jin Tang
Lan Feng
Lang Li
Leng Bai
Li Cheng
Li Gang
Li Hanren
Li Hui
Li Jian Quan
Li Jie Jun
Li Jincheng
Li Ming
Li Shaoyi
Li Suren
Li Wending
Li Xiaoning
Lian Xiang Yu
Liang Daming
Liao Chan-yen
Stan Lim
Lin Liu
Lin Ming Bin
Lin Yong Hui
Liu Chang Ming
Liu Chun Feng
Liu Jie
Liu Jie
Liu Jie Min
Liu Ke Geng
Liu Siyuan
Liu Wei
Liu Xiaoyang
Liu Zhen Qing
Long Hai
Lu Bei Feng
Lu Shao He
Lu Su Yang
Lu Zhong Bin
Luguangwei
Ma Hong Jie
Ma Ke
Ma Li-Ming
Mao Shuo
Meng Xingrong
Miao Feng-wu
Ming Zhong
Mingguo Meng
Nan Qiu Yang
Pang Li Ping
Peng Hui
Pingping Zheng
Qi Shangmin
Qi Xiao Long
Qian Houqi
Qian Ming
Qin Da Tang
Qin Sheng Wang
Qin Wengang
Qiu Qing Zhao
Qiu Xiao Wei
Qiu Yan
Quo Yi Jiang
Ran Yusie
Ren Shi Chen
Ren Xihai
Sha Pengcheng
Shi Jianxue
Shi Liang Wang
Stefan Sobotta

Baoli Song
Song Bujun
Sun Yu Hiu
Sun Zhijun
Tang Jian
Teng Ke
Tian Bao Xi
Tong Jiang
Wang Chen
Wang Chongzhi
Wang Fei
Wang Huaigui
Wang Huisheng
Wang Jian Ying
Wang Jicheng
Wang Jie
Wang Juncai
Wang Mianli
Wang Rui Ling
Wang Shunda
Wang Tie Heng
Wang Tong
Wang Tong Xu
Wang Xizeng
Wang Yanzhong
Wang Yao
Wang Yun-Lu
Welyuan Zhang
David Wong Chi-kin
Wu Jialin
Wu Jian Hua
Wu Jin Zhong
Wu Jun
Wu Mao Jia
Wu Qiang
Wu She Ling
Wuniao
Xia Jing Hua
Xiao Lian-cang
Xiao-qun Zheng
Xie Lin
Xie Minggang
Xie Qi
Xinke Wang
Xiong Zheng Hai
Xu Bing
Xu Cheng Ai
Xu Jia Shan
Xu Jian
Xu Jianrong
Xu Lin
Xu Pei Wu
Xu Ruixin
Xu Wu
Xuan Hui
Xue Wei Hong
Yan Bailiang
Yan Guang
Yang Dahai
Yang Fu Sheng
Yang Kejia
Yang Lin Tao
Yang Ming
Yang Shen
Yang Xiao Li
Yang Xiaogang
Yang Xin Yue
Yang Xingfang
Yao Fan
Yao Zhang
Yijun Qian
Yong Chang
Yong Mou-Zhong
Yongquan Jin
Vincent Yu
Yuan Jingzhi
Yuan Xiao Zhen
Zhang Chen Jian
Zhang Feng Yang
Zhang Huibin
Zhang Jusheng
Zhang Nan Xiu
Zhang Wang
Zhang Xiao Mei
Zhang Yan
Zhang Yanhui
Zhang Yi
Zhang Yun Long
Zhang Zhonghe
Zhao Gang
Zhao Haiping
Zhao Jing Dong
Zhao LiJun

Zhao Tongjie
Zhao Wen Sheng
Zhao Ya-Shen
Zheng Guo-qiang
Zheng Rucheng
Zheng Ting
Zheng Xun
Zhengzheng Pang
Zhi Jian
Zhi Xinping
Zhou Chang You
Zhou Guoqiang
Zhou Hai
Zhou Qing Xian
Zhou Zhihong
Zhu Minghui
Zi Liang
Zuo Zhang

PERU
Paolo Aguilar Boschetti
Susana Alcantara Menacho
Martin Alvarado
Mariana Bazo Zavala
Martin Bernetti Vera
Cristóbal Bouroncle
Maria Brun Bonnet
Max Cabello Orcasitas
Nancy Chappell Voysest
José Chuquiure
Cecilia Durand Torres
Hector Emanuel
Elsa Estremadoyro Heller
G. F. Figueroa Tangüis
Mario Flores Zumaeta
Ana Cecilia Gonzales-Vigil
Barbara P. Hernandez
Ana C. Jau Flores
Carlos Lezama Villantoy
Hector Mata
Maria Ines V. Menacho
Mayu Maria Mohanna
Belunde Montalvan
Jaime Razuri
Guiliana Regis Fuentes
Francisco Rodriguez Torres
Verónica Salem Abufom
F. Sanseviero Koffler
Luis Daniel Silva Yoshisato
Jaime Javier Trelles Harcia
Renzo Uccelli Masias
Santiago Paul Vallejo Coral
Justo Pastor Vargas Sota

THE PHILIPPINES
Junn Abriza
Jun Barrameda
Marcelito "Bong" Cabagbag
Edwin P. Calayag
Ramon I. Castillo
Manuel Ceneta
Claro Fausto Cortes
Revoli Cortez
Ian N. Cruz
Antonio E. Despojo
Pepito Frias
Romeo Gacad
Oliver Y. Garcia
Hadrian Hernandez
Victor Kintanar
Marvi Lacar
Samuel Leon
Ruy Martinez
Alfonso L. Mundo
Diana Noche
Marcial, Jr Reyes
Dennis Sabangan
Felicer Santos
Mike Taboy
Amelito Tecson

POLAND
Aleksandra Adryanska
Anna d'Araille
Cezary Aszkietowicz
Anna Bedynska
Piotr Blawicki
Marta Blazejowska
Witold Borkowski
Radoslaw Bugajski
Grzegorz Celejewski
Antoni Chrzastowski
Grzegorz Dabrowski

Sylweriusz Dmochovski
Cezary Dybowski
Janusz Filipczak
Wojtek Franus
Arkadiusz Gola
Waldemar Gorlewski
Christopher Grabowski
Tomasz Griessgraber
Andrzej Piotr Grygiel
Tomasz Gudzowaty
Jerzy Gumowski
Rafat Guz
Michael Gwozwik
Tomasz Gzell
Jacek Herok
Aleksander Holubowicz
Piotr Janowski
Hubert Jasionowski
Maciej Jawornicki
Maciej Jeziorek
Tomasz Jodlowski
Jarostaw Jurkiewicz
Slawomir Kaminski
Piotr Kedzierski
Daniel Klimczak
Pawel Kosinski
Grzegorz Kosmala
Maciej Kosycarz
Robert Kowalewski
Hilary Kowalski
Adam Kozak
Milosz Krajewski
Damian Kramski
Witold Krassowski
Marek Krzakala
Robert Krzanowski
Pawel Krzywicki
Dariusz Kulesza
Jerzy Lapinski
Marek Lapis
Arkadivsz Lawrywianiec
Marek Machay
Andrzej Marczuk
Franciszek Mazur
Mieczystaw Michalak
Andrzej Nasciszewski
Chris Niedenthal
Piotr Niemczynowicz
Krystyna Okulewicz
Eliza Oleksy
Wojciech Olkusnik
Mieczystaw Pawtowicz
Cezary Pecold
Radoslaw Pietruszka
Leszek Pilichowski
Stanislaw Pindera
Aleksander Rabij
Grzegorz Roginski
Olgierd M. Rudak
Marcin Rutkiewicz
Michal Sadowski
Wieslaw Seidler
Maciej Krzysztof Sikorski
Janek Skarzynski
Maciej Skawinski
Jacek Sliwczynski
Adam Slowikowski
Dorota Smoter
Waldemar Sosnowski
Zbigniew Stoklosa
Piotr Sumara
Pawel Supernak
Wojtek Szabelski
Robert Szykowski
Artur Tabor
Pawel Terlikowski
Gregory Torzecki
Lukasz Trzcinski
Wojtek Wieteska
Piotr Wojcik
Lukasz Wolagiewicz
Pavel Woycik
Maria Zbaska
Bartomiej Zborowski
Jerzy Zegarlinski
Marian Zubrzycki

PORTUGAL
Augusto Arango Soares
Ana Maria Baiao Corrgia
José Barradas
Rui Bettencourt Coutinho
Fernando Candido

Rita Carmo
Antonio Manuel Carrapato
Jose Almeida Carvalho
Joao Carvalho Pina
Leonel Castro
A. Cortesão Ferraz de Helo
João Manuel Couto Ribeiro
Antonio José Cunha
Paulo Duarte B.M. Carvalho
Sergio Faustino do Rosario
Jorge Firmino
Eduardo Gageiro
Maria Luiza Gomes Rolim
Helena Henriques
João Mariano
Xavier Martins
Carlos Palma
João Paulo Pimenta
Miguel Proença
Luis Ramos
Daniel Marques Rocha
Nelson Rodrigues Garrido
Vitor M. Oliveira Santos
Bruno Santos
Nuno Cesar Santos Antunes
Fernando Da Silva Saraiva
Jorge Simão
Adriano Simoes Miranda
Pedro Sottomayor
Paulo Cardoso Spranger
Fernando Veludo
Miguel Veterano

PUERTO RICO
Nydia Mabel Tossas Cordero

QATAR
Salim Mohd. Al Marri

REP. OF KOREA
Chae Seung-Woo
Hyoung Chang
Jae-Ho Ham
Jae-hoon Kwak
Ji-Hyun Hahn
Kim Jin Suk
Lee Jong Seong
Kang Min Seok
Kim Yung Soo
Lee Jin-Man
Haseon Park
Soo Hyun Park
Soo-Yong Kuk
Sung-Chan Ham
Jeon Young Han
Young-Pyo Lee
Youngjo Kang

ROMANIA
Adrian Ovidiu Armanca
Constantin Daniel Avram
Dorian-Manuel Delureanu
Halip Doru-Mirel
Vadim Ghirda
Radu Ghitulescu
Tasi Ioan
Vlad Lodoaba
Adrian Luput
Casian Margineantu
Ionut Mitran
Emil Moritz
Marius Nemes
Mircea Opris
Pascal Pamfil
Marian Plaino
Badea Remus Nicolae
Roberto Salceanu
Neculai Terteleac

RUSSIA
Yuri Abramochkin
Andrey Arkchipov
Ildar Asjukow
Dmitri Astakhov
Dmitry Azarov
Yuri Balbyshev
Vitaliy Balmatkov
Vacheslav Baranov
Victor Bazhenov
Dmitry Beliakov
Alexey Beliantchev
Sergei Chirikov
Boris Dolmatovsky

Victor Drachev
Evgeniy Dudin
Valentin Dushin
Boris Filippovich Echin
Andrey Efimov
Mikhail Evstafiev
Vladimir Fedorenko
Lev Fedoseev
Vladimir Filimonov
Vladimir Glazkov
George Gongolevich
Pavel Gorshkov
Yuri Gripas
Alexander Gronsky
Vladimir Gudkov
Sergei Guneyev
Alik Hasanov
Elena Herzog
Serghei Ignatief
Sergei Isakov
Vyachelov Ivanov
Vladimir Jirnov
Yuri Kadobnov
Sergey Kaptilkin
Pavel Kashaev
Boris Kaulin
Yuri Kazakov
Edvard Khakimov
Dmitry Khrupov
Aleksei Khruschev
Arthur Kirakozov
Nickolay Kireyev
Jury Klekovkin
Mikhail W. Klimentiev
Yuri Kochetkov
Roman Koksharov
Alexej Kompanijchenko
Sergei A. Kompanijchenko
Sergei Kovalev
Denis Kozhevnikov
Sergey Kozlov
Igor Kravchenko
Alexey Kunilov
Ivan Kuzmin
Oleg Lastochken
Dmitry Leonov
Alexsander Lisafin
Dmitry Loshagin
Semen Maisterman
Julia Majorova
Victor Martchenko
Vita Masly
Valery Matytsin
Sergey Maximishin
Mikhail Medvedev
Sergei Metelitsa
Mikhail Metzel
Wilhelm Mikhailovsky
Valery Mishakov
Boris Mukhamedzyanov
Alexander Nemenov
Andrei Nickolsky
Oleg Nikishin
Valeri Nistratov
Natalia Onischenko
Alexander Oreshnikov
Larissa Pankratieva
Valentina Pavlova
Alexander Polyakov
Sergei Pyatakov
Alexandre Raube
Natalia Razina
Vitaliy Reshunov
Andrei Rudakov
Dmitry Shalganov
Sergey Shekotov
Andrew Shlykoff
Yuri Shtukin
Vladimir Sichov
Nicolas Simakove
Andrei Sladkov
Pavel Smertin
Alexei Smirnov
Ivan Sokolov
Alexander Stepanenko
Georgiy Stoliarov
Vladimir Stolyarov
Yuri Strelets
Svetlana Sushchen
Vladimir Syomin
Igor Tabakov
Nikolai Tikhomirov
Elena Tikhonova

Alexandr Tkachov
Igor Utkin
Sergei Vasiliev
Vladimir Velengurin
Anatoly Vilyahovsky
Alexei Vladykin
Yuri Vorontsov
Vladimir Vyatkin
Dmitry Vyshemirsky
Michail Zaguliaev
Victor Zagumjonnov
Juri Zaritovsky
Konstantin Zavrazhin
Alexander Zemlianichenko
Anatoli Zhdanow
Igor Zotin
Tatyana Zubkova

SAINT LUCIA
Marius Modeste

SAUDI ARABIA
Zaki Ali Sinan
Baker Dawood Sindi

SIERRA LEONE
Dauphin Randolph

SINGAPORE
Chua Chin Hon
Albert Sim Kim Khoon
Teck Hian Wee
Jose Raymond Thomas

SLOVAKIA
Martin Bandzak
Roman Benicky
Peter Brenkus
Marian Fridrichovsky
Alan Hyza
Martin Kollar
Stefan Strauch
Marek Velcek

SLOVENIA
Bojan Brecelj
Luka Cjuha
Petkovic Darije
Jure Erzen
Dusan Jez
Natalija Juhnov
Borut Krajnc
Andrej Kriz
Tomi Lombar
Marko Turk
Bojan Velikonja

SOUTH AFRICA
Abdul Karriem Adams
Peter Bauermeister
Jodi Bieber
Don Boroughs
Stephen Davimes
Thys Dullaart
Brenton Geach
Louise Gubb
Themba Hadebe
Brian Hendler
John Peter Hogg
Jon Hrusa
Mike Hutchings
Nadine Hutton
Andrew Ingram
Fanie Jason
Jeremy Jowell
Christiaan Kotze
Halden Krog
Alf Kumalo
Barry Lamprecht
T.J. Lemon
Leon Edward Lestrade
Charlé Lombard
Kim Ludbrook
David Lurie
Pia Marangoni
Gideon Mendel
Erik Miller
Mpho Goodwill Mphotho
Mykel Nicolaou
Neo Ntsoma
Hein Plessis
Karel Prinsloo
Karin Retief

Mujahid Safodien
David Sandison
Caroline Suzman
Guy Tillim
Johann Tonder
Schalck Van Zuydam
Johannes Vogel
Roy Wigley
Graeme Williams
Giselle Wulfsohn
Debbie Yazbek
John Alleyne Yeld
Naashon Zalk
Siyabulela Obed Zilwa

SPAIN
Julen Alonso Laborde
Diego Alquerache
Jesús Antoñanzas Ibañez
Antonio Arabesco
Javier Arcenillas
Kepa Arizala
Pedro Armestre
Cristian Baitg Schreiweis
Pablo Balbontin Arenas
Sandra Balsells
Juan Carlos Barbera Marco
Javier Bauluz
Eduardo Bayona Estradera
Enrique Luis Beltran Terol
Clemente Bernad
Anna Boye de la Presa
Manuel Bruque Jiménez
Paloma Bueno Brinkmann
Xavier Calabuig Lluch
Nacho Calonge Minguez
José Camacho Fernandez
Fernando Camino Martin
Carrasco Ragel
Carlos Carrión Buchó
Agustín Catalán Martínez
Ignacio Cerezo Otega
Xavier Cervera Vallve
Santiago Cogolludo Vallejo
Cristóbal Corredor Navarro
Matias Costa
Daniel Culla
Juan Díaz Castromil
Jon Dimmis
Tatiana Donoso Matthews
Paco Feria Villegas
Andres Fernandez Pintos
Pere Ferre Caballero
David Gala
Cristina Gallego Candel
Antón Garcia
Ima Garmendia
Anouk Garrigues Blanc
Ander Gillenea
Miguel Gomez Muniz
Pasqual Gorriz
Isaac Hernández
Jose Ignacio Hernandez
Frank Kalero
Santy López
José López Soto
Rafael Lopez-Monne
Enric F. Marti
Fernando Moleres Alava
Gregorio Montanos G.
Eva Morales
Julio Muñoz
Anna Oliver
Enrique Olmo Gonzalez
F. Javier Parra Artime
Yolanda Pelaez Fernandez
Eudaldo Picas Vinas
Mikel Ponce Aparico
Ramon Puga Lareo
Andreu Reverter Sancho
Carlos Rubio Pedraza
Abel Ruiz de Leon
Marcelli Sàenz
Moises Saman Goñi
Paco Santamaria
Toni Santiso
Tino Soriano
Nelson Souto Oviedo
Juan Tébar Carrera
Javier Temiente Lago
Raul Torres Molinero
Enrique Truchuelo Ramirez
Francis Tsang

Luis Vega
Rosa Veiga Alonso
Roser Vilallonga Tena
Fernando Villar Sellés
Xulio Villarino Aguiar

SRI LANKA
A. Sanjeewanie Bothejuo
Kumara Edirisooriya
A. Sunilshantha Fernando
B. Nalin Wickramage
A. Nayanananda R.
S.A. Pradeep Samarasinghe
T. Kumara Ratnayake
T. Rukshan Bandurathna
C. Sajeewanie Wijethunga
Anushad Sampath Wedage
K. Sembukutti A.
Suseema Sudantini B.A.
K. Kombala Vithanage
Sriyantha Walpola
Kamani Wathsala

SUDAN
Issam Ahmed Abdelhafiez
Ahmed El-Amin Bakhiet
Salman Mutwakil
Md. Nur El-din Abdalla

SWEDEN
Leif A. Andersson
Torbjörn Andersson
Roland Bengtsson
Johan Berglund
Sophie Brandstrom
Lars Dareberg
Stefan Ed
Ake Ericson
Jan Fleischmann
Jessica Gow
Paul Hansen
Krister Hansson
Arne Hyckenberg
Ann Johansson
Peter Kjelleras
Henry Leutwyler
Larseric Lindén
Chris Maluszynski
Jack Mikrut
Sven Nackstrand
Anette Nantell
Ola Nilsson
Brita Nordholm
Tord Olsson
Per-Anders Pettersson
Per-Anders Rosenkvist
Lisa Selin
Hakan Sjöström
Göran Stenberg
Per-Olof Stoltz
Roger A. Turesson
Jan Wiridén
Nils K.-G. Zahedi Fougstedt

SWITZERLAND
Marco Anna
Patrick Armbruster
Manuel Bauer
Peter Baumann
Marc Berger
Christian Bonzon
Markus Bühler
Ladislav Drezdowicz
Mariella Furrer
Enrico Gastaldello
Peter Gerber
Marcel Grubenmann
Tobias Hitsch
Robert Huber
Sandra Hüsser
Jean-Marie Jolidon
Jean Pierre Jost
Tom Kawara
Thomas Kern
LeNeff
Michele Limina
Roger Lohrer
Marcel Malherbe
Claudio Mamin
Andreas Meier
Adrian Mueller
Tomas Muscionico
Trix Niederau

Sabine Papilloud
Marc Renaud
Stefan Rohner
Werner Rolli
Didier Ruef
Hannes Schmid
Andreas Schwaiger
Daniel Schwartz
Monique Stauder
Sandra Dominika Sutter
Hansüli Trachsel
Thomas Ulrich
Olivier Vogelsang
Xavier Voirol
Anne-Lise Vullioud
Tomas Wüthrich
Michaël Zumstein

SYRIA
Zoukaa Al Kahhal
Najem Al-Nayef
Nouh-Ammar Hammami
Mahdi Jafar
Fadi Masri Zada

TAIWAN
Chien-Chi Chang
Chen Chauyin
Chen Chen Kung-Ku
Chia-Jung Chang
Mark Chien
Chien-Chung Su
Chin-Chou Hu
Ching-Ching Wang
Chiung-Huei Huang
Dah-Perng Hang
Hsieh Chia-Chang
Hsieh San-Tai
Tang Hsing-Han
Huang Min-Chien
Jen-Yi Tsai
Jung-Fong Chien
Simon Kwong
Li-Hua Lan
Lin Daw-Ming
Ma Li-Chun
Peng-Chieh Huang
Po-Jen Deng
Shen Chao-Liang
Tsong Sheng Lin
Wei-Sheng Huang
Wen-Cheng Wong
Wen-Tsai Yang
Yi-Pin Wu
Yi-Shu Huang

TANZANIA
Mohamed A. Mambo

THAILAND
Sarot Meksophawannakul
Jetjaras Na Ranong
Olivier Pin Fat
Seri Pouagsalee
Chirasak Tolertmongkol
Rungroj Yongrit

TUNISIA
Karim Ben Khelifa

TURKEY
Arif Akdogan
Sinan Anadol
Fikret Ay
Haluk Cobanoglu
Hakan Denker
Bikem Ekberzade
Murat Germen
Özer Kanburoglu
Engin Karderin
Gunes Kocatepe
Adil Özsüer
Kerem Saltuk
Erhan Sevenler
Ahmet Tarik Tinazay
Aziz Uzun

UGANDA
Henry Bongyereirwe
Enock Kakande
John W.K. Oryema

UKRAINE
Stefan Alekyan
Alexandr Babenko
Alexandr Burkovsky
Mykhaylo Chernichkin
Rodion Chernov
Sergei Datsenko
Vladimir Dyachenko
Gleb Garanich
Alexander Gordievich
Sergey Gukasow
Andrey Kanishchev
Vadim Kozlovsky
Vladimir Lapushniak
Valeriy Levischenko
Goutschar Ljuduila
Efrem Lukatsky
Ivan Melnik
Oxana Nedilnichenko
Vladimir Osmushko
Illya Penyayev
Eugeniy Savilov
Alex Shumeyko
Sergei Supinsky
Sergey Svetlitsky
Vladimir Yusko

UNITED ARAB EMIRATES
Safia Ibrahim Mohammed

UNITED KINGDOM
David Ahmed
Bryan Alexander
Timothy Allen
Nigel Amies
Julian Anderson
John Angerson
Matthew Ashton
Dan Atkin
Stewart Russel Attwood
Jocelyn Bain Hogg
Richard Baker
Roger Bamber
Steve Barney
Jonathan Bartholomew
Barry Batchelor
Ian Berry
Vince Bevan
Mark Bickerdike
Martin Birchall
Dave Black
Marcus Bleasdale
Peter Bolter
Jon Bond
Shaun Botterill
Steve Bould
James Bounenvialle
Russell Boyce
Charles Breton
Clive Brunskill
Jon Buckle
Jonathan Buckmaster
Susan Burrell
Gary Calton
Richard Cannon
Brian Cassey
David Charnley
Wattie Cheung
Russell Cheyne
Edmund Clark
Paul Clements
Andy Cleverley
Nick Cobbing
Michael Cole
Steve Coleman
Bob Collier
Steve Connors
Richard Cooke
Christian D. Cooksey
Philip Coomes
Rob Cooper
Andy Couldridge
Christopher Cox
Steve Cox
Michael Craig
Tom Craig
John Cunningham
Benjamin Curtis
Eleanor Curtis
Simon Dack
Nick Danziger
Andrew Davies
Karen Davies

Adam Davy
Neil Denham
Nigel Dickinson
Alban Donohoe
John Downing
Colin Edwards
Mike Egerton
Neil Egerton
Neville Elder
Jonathan Elderfield
Stuart Emmerson
David Evans
Mark Evans
Sophia Evans
Barbara Evripidou
Paul Faith
Sam Faulkner
Adrian Fisk
Steve J. Forrest
Martin Foskett
Stuart Freedman
Fu Chun Wai
Christopher Furlong
George Georgiou
John Giles
Christopher Gleave
Martin Godwin
Michael Goldwater
Mark R. Graham
David Graves
Johnny Green
Simon Grosset
Andy Hall
Robert Hallam
Neil Hanna
Timothy Harley-Easthope
Malcolm Hart
Mark Henley
Paul Herrmann
Tim Hetherington
Jack Hill
James Hill
Tommy Hindley
Adam Hinton
Stephen Hird
David Hoffman
Dave Hogan
Jim Holden
David Hollins
Kevin Holt
Suzanne Hubbard
John Hulme
Graeme Hunter
Jeremy Hunter
Roger Hutchings
Chris Ison
Tom Jenkins
Victor Jesus
Justin Jin
Edward Jones
Peter Jordan
Suresh Karadia
Findlay Kember
Nicola Kurtz
Rob Lacey
Colin Lane
Kalpesh Lathigra
Stephen Lawrence
Jed Leicester
David Levenson
Jon Levy
Nicky Lewin
Frank Loughlin
Paul Lowe
Simon Mark Lunt
Natasha Lyster
Peter MacDiarmid
Alex MacNaughton
Mike Maloney
Paul Marriott
Tony Marshall
Bob Martin
Dale Martin
Richard Martin
Dylan Martinez
Ed Maynard
Eamonn McCabe
Marie McCallan
Gerry McCann
Eric McCowat
John McIntyre
Colin Mearns
Toby Melville

145 ·

Dod Miller
Sacha William Miller
Rizwan Mirza
Steve Mitchell
David Modell
Yui Mok
J. Doug Moody
Jeff Moore
Mike Moore
Steve Morgan
Jeffrey Morgan
Pauline Neild
Zed Nelson
Simon Norfolk
Tony O'Brien
Richard Okon
Jonathan Olley
Charles M. Ommanney
Jeff Overs
Ali Kazim Ozluer
Colin Pantall
Rob Penn
Marcus Perkins
Robert Perry
Paul Pickard
Tom Pilston
Mark Pinder
Sophie Powell
Will Pryce
David Purdie
Andy Rain
Nick Rain
Scott Ramsey
John Reardon
Elizabeth Reynolds
Phillip Riley
Simon Roberts
Ian Robinson
Karen Robinson
Stuart Robinson
David Rose
Ian Rutherford
Mark Seager
John Sibley
Julian Simmonds
Neal Simpson
Alex Smailes
Ben Smith
Christopher Steele-Perkins
Michael Stephens
David Stewart-Smith
Tom Stoddart
Justin Sutcliffe
Sean Sutton
Jeremy Sutton-Hibbert
Ian Teh
Edmond Terakopian
Gordon Terris
Andrew Testa
Siôn Touhig
David Trainer
Nick Treharne
Neil Turner
Muir Vidler
Neelakshi Vidyalankara
Ahmad Viqar
Howard H. Walker
Michael Walter
Nigel Watmough
Peter L. Watson
Felicia Webb
Horace Wetton
Amiran White
Clifford White
David White
Richard Whitehead
Keith Whitmore
Kirsty Wigglesworth
Denis Williams
Greg Williams
Andrew Winning
Philip Wolmuth
Antony Wood
Matt Writtle
Sandy Young
Tony Yu Kwok Lam

URUGUAY
Leo Barizzoni Martinez
E.H. Borrelli Piendibene
Julio Etchart
Enrique Kierszenbaum
Ernesto Lehn Angelides

USA
Sharon Abbady
Henny Ray Abrams
Doug Abuelo
Kimberlee Acquaro
Steven W. Adams
Mark Adams
Lori Adamski-Peek
Michael Adaskaveg
Lynsey Addario
Noah Addis
Michael Ainsworth
Alfred
Jimi Allen
Stephen L. Alvarez
Lyn Alweis
Chris Anderson
Eika Aoshima
Samantha Appleton
Charlie Archambault
Juana Arias
Guy Aroch
Glenn Asakawa
Timothy Aubry
Jeffrey Austin
William C. Auth
Tony Avelar
Gordon Baer
Brian Bahr
Karen Ballard
James Balog
Jeffrey W. Barbee
Candace B. Barbot
Rebecca Barger-Tuvim
Michael Barkin
Joan Barneh Lee
Don Bartletti
Edward Baumeister
John Bazemore
John Beale
Patricia Beck
Robert Beck
Natalie Behring
Jeff Beiermann
H. Darr Beiser
Al Bello
Bruce Bennett
Harry Benson
P.F. Bentley
Larry Benvenuti
Nina Berman
Alan Berner
Susan Biddle
John Bierer
Molly Bingham
Chris Birks
Robert Black
Peter Blakely
John Blanding
David Blumenfeld
Abigail Bobrow
Wesley Bocxe
Gary Bogdon
Karen Borchers
Kathy Borchers
Harry Borden
Peter Andrew Bosch
Rick Bowmer
Tim Boyle
Brian Brainerd
David Brauchli
Wilhelm Brett
William Bretzger
Timothy A. Broekema
Thomas Broening
Paula Bronstein
Dudley Brooks
Kate Brooks
Christopher Brown
Frederic J. Brown
Jennifer Brown
Milbert Orlando Brown
Simon Bruty
Mark Bugnaski
Robert F. Bukaty
Gregory Bull
Jeffrey Bundy
Joe Burbank
Lauren Victoria Burke
Gerard Burkhart
David Burnett
Adam Butler
John Butler II

David Butow
Renée Byer
David Callow
Mary Calvert
Gary Cameron
Roberto Candia H.
Darren Carroll
J. Pat Carter
Paul Carter
John Castillo
Michael Caulfield
Greg Cava
Sean Cayton
Radhika Chalasani
Bruce Chambers
Gus Chan
Chang W. Lee
Richard A. Chapman
Tia Chapman
Dominic Chavez
Stephen Chernin
Chien-min Chung
Barry Chin
K.M. Choudary
André F. Chung
Daniel F. Cima
Lorenzo Ciniglio
Timothy Clary
Bradley E. Clift
Jodi Cobb
Carolyn Cole
Bob Coleman
James O. Collins
Frank Conlon
John H. Cornell
Anthony Correia
Ronald Cortés
Bill Crandall
Sherwin Crasto
Johnny Crawford
Christopher J. Crewell
James Cross
Mark Crosse
Annie Cusack
Rebecca D'Angelo
Paul Dagys
Jim Damaske
Keith Dannemiller
Leigh Daughtridge
Meredith Davenport
Amy Davis
Helen Davis
Robert A. Davis
Patrick Davison
Penny De Los Santos
David Delpoio
Louis DeLuca
Robert Deutsch
Delores Devlin
Charles Dharapak
Stephanie Diani
Alan Diaz
Al Diaz
J. Albert Diaz
Cheryl Diaz Meyer
Jay Dickman
Anthony V. DiGiannurio
Yvette Marie Dostatni
Larry Downing
Eric Draper
David Duprey
Aristide Economopoulos
Debbie Egan-Chin
Davin R.M. Ellicson
Nancy Ellison
Don Emmert
Douglas Engle
John Epperson
Eileen Escarda
Jason Eskenazi
Gary Fabiano
Timothy Fadek
Steven Falk
Patrick Farrell
William Farrington
Christopher Faytok
Deborah Feingold
Gloria Ferniz
Donna Ferrato
Jonathan Ferrey
Karl Merton Ferron
Stephen Ferry
John Ficara

Robert Fila
Tina Fineberg
Lisa Finger
Jock Fistick
Mikel Flamm
Emilio Flores
Silvia Flores
Viorel Florescu
Marvin Fong
Jacqueline Mia Foster
Charles Fox
Tom Fox
William Frakes
Danny Wilcox Frazier
Luke Frazza
John Freidah
Jen Friedberg
Gary Friedman
Rich Frishman
Susanna Frohmann
Ana E. Fuentes
Sean Gallup
Jacek Gancarz
Alex Garcia
Eugene Garcia
Juan Garcia M.
Mark Garfinkel
Ben Garvin
Robert Gauthier
Karl Gehring
Sharon Gekoski-Kimmel
Catrina Genovese
Jim Gensheimer
Paul F. Gero
Bruce Gilbert
Kevin Gilbert
Thomas E. Gilpin
Sarah Glover
Arnold Gold
Scott Goldsmith
Leila Gorchev
Katy Grannan
Lizabeth Gray
M. Spencer Green
Stanley Greene
Lauren Greenfield
Peter Gregoire
Norbert Groeben
Deborah A. Grove
Jim Gund
David Guralnick
Erol Gurian
Barry Gutierrez
David Guttenfelder
Carol Guzy
Sanjay Hadkar
Robert Hallinen
Chris Hamilton
Scott Hamrick
Nati Harnik
Chick Harrity
Richard Hartog
David Hartung
Thomas Hartwell
Ron Haviv
Alan Hawes
Jeff Haynes
Scott Heckel
Kurt Hegre
Khiang Hei
Gregory Heisler
Todd Heisler
P.J. Heller
Mark Henle
Jake Herrle
Meredith Hever
Tyler Hicks
Jeanne Hilary
Brian Hill
Erik Hill
Cheryl Himmelstein
Charles Hires
Jeremy Hogan
Jim Hollander
Stan Honda
Chris Hondros
Kevin Horan
Beverly Horne
Paul Hosefros
Scott Houston
Rose Howerter
John Iacono
Lenny Ignelzi

Andrew Innerarity
Walter Iooss
Stuart H. Isett
Vance Jacobs
Stephen Jaffe
Terrence Antonio James
Kenneth Jarecke
Seth Jayson
Kim Johnson
Lynn Johnson
Frank Johnston
Marvin Joseph
Oówlan Jah Kamoze
Joan Kanes
Sylwia Kapuscinski
Ed Kashi
Andrew Kaufman
Courtney Kealy
Edward Keating
Dave Kendall
Brenda Kenneally
Charles Kennedy
David Hume Kennerly
Mike Kepka
Cornelius Keyes
John J. Kim
John Kimmich
Kin Man Hui
Robert King
Jed Kirschbaum
Lui Kit Wong
Paul Kitagaki, Jr
Chris Kleponis
Heinz Kluetmeier
David E. Klutho
Jacqueline Koch
Richard Koci Hernandez
Richard H. Koehler
Craig Kohlruss
Brooks Kraft
Benjamin Krain
Amelia Kunhardt
Tony Kurdzuk
Jack Kurtz
Teru Kuwayama
Kenneth Lambert
Rodney A. Lamkey, Jr.
Wendy Sue Lamm
Nancy Lane
Jerry Lara
Jacqueline Larma
Frederic Larson
Eric Larson
Craig Lassig
Olivier Laude
Michael Laughlin
Neal C. Lauron
Mara Lavitt
Jim Lavrakas
John Lee
Wilfredo Lee
Matthew Lee
Jared Leeds
M. David Leeds
Sarah Leen
Mikhail Lemkhin
Mark Leong
Paula Lerner
Claude Alan Lessig
Marc Lester
Will Lester
Catherine Leuthold
Heidi Levine
Michael S. Levy
Ron Levy
Serge J-F. Levy
Schlomit Levy
Michael Lewis
William Wilson Lewis III
John Leyba
Andrew Lichtenstein
Jennifer Lindberg
Brennan Linsley
Callie Lipkin
Richard Lipski
Steve Liss
Scott Lituchy
David Longstreath
Rick Loomis
Delcia Lopez
Jim Loscalzo
V.J. Lovero
Greg Lovett

Florence Low
Jon Lowenstein
Robin Loznak
Raymond Lustig
Eric Lutzens
Michael Lutzky
Andy Lyons
Melissa Lyttle
Preston Mack
Jim MacMillan
Farrah Maffai
David Maialetti
John Makely
Brad Mangin
Jeff Mankie
Rafig Maqbool
Rich Marchewka
Mary Ellen Mark
Maxim Marmur
Bullit Marquez
Dan Marschka
Dave Martin
Glen Martin
Pablo Martínez Monsiváis
Sarah Martone
Diana Matar
Rainey Matt
Robert Mayer
Darren McCollester
Gerald McCrea
Steve McCurry
John McDonnell
John McDonough
Tammy McGinley
Maryellen McGrath
David G. McIntyre
Robert E. McLeroy
Joseph McNally
Robert McNeely
David McNew
Daniel J. Mears
Steven Medd
Rohn Meijer
Kent E. Meireis
Steve Mellon
Eric Mencher
Joyce Mendelsohn
Peter J. Menzel
Catherine Meredith
Jim Merithew
Jeff Mermelstein
Susan Merrell
Keith C. Meyers
Jim Michalowski
Manny Millan
George W. MillerIII
Peter Miller
Doug Mills
Ari Mintz
Donald Miralle
Leah Missbach
Brian Mockenhaupt
Mark W. Moffett
Genaro Molina
Jim Mone
M. Scott Moon
Jose M. More
Debbi Morello
Moritz
Christopher Morris
Paul Morse
John Mottern
Peter Muhly
Michael Mulvey
Paul Michael Myers
James Nachtwey
Adam Nadel
Joyce Naltchayan
Jon Naso
Donna Natale-Planas
Mike Nelson
Scott Nelson
Gregg Newton
Arleen Ng
Huy Nguyen
Robert Nickelsberg
Steven Ralph Nickerson
Martina Nicolls
Clement Ntaye
John O'Boyle
William O'Leary
Annie O'Neill
Michael O'Neill

Quique Olmo
Dale Omori
Kid Orbeta
Edward A. Ornelas III
Francine E. Orr
Max Ortiz
Charles Osgood
José M. Osorio
Tomas Ovalle
James A. Parcell
Eric Parsons
John Partipilo
Judah Passow
Bryan Patrick
Peggy Peattie
Hilda M. Perez
Michael Perez
Stephen Perez
Lucian Perkins
Mark Peterson
Steve Peterson
Mickey Pfleger
Tai Pfleger
Bill Phelps
Keri Pickett
David Pierini
Spencer Platt
William Benjamin Plowman
Joseph Pluchino
Michael Plunkett
Suzanne Plunkett
Marc Pokempner
Arthur Pollock
Smiley Pool
Wesley Pope
Betty H. Press
Joshua Prezant
John Prieto
Richard Pruitt
Alex Quesada
Lisa Quiñones
Joseph Raedle
Lois Raimondo
John Ranard
John Raoux
Anacleto Rapping
Jim Rassol
Matthew Ratajczak
Laura A. Rauch
Patrick Raycraft
Mona Reeder
Robert Reeder
Tom Reel
Tom Reese
Lara Jo Regan
Richard Renaldi
Tim Revell
Damaso Reyes
Martha Rial
Eugene Richards
Paul Richards
Rick Rickman
Perry C. Riddle
Rachel Ritchie
Herb Ritts
Jeff Roberson
Grace Robinette
Michael Robinson-Chávez
Paul Rodriguez
Bob Rosato
Carrie Rosema
Ricki Rosen
Steven Rosenberg
Bill Ross
Jennifer Rotenizer
Jeffrey L. Rotman
Jeffrey B. Russell
Donald Rypka
James F. Saah
Bob Sacha
Zeljko Safar
Jonathan Safir
Paul Sakuma
Carolina Salguero
Jeffery A. Salter
Amy Sancetta
Tom Sanders
David Sandler
Wally Santana
Anthony Santos
Darrell Sapp
Joel Sartore

April Saul
Jonathan Saunders
Tony Savino
Stephan Savoia
Ken Sawchuck
Reed Saxon
Al Schaben
Erich Schlegel
Iris Schneider
Jake Schoellkopf
Andi Faryl Schreiber
Jane Schreibman
Andrew Scott
Cydney Scott
Jeremy Scott
Carl Seibert
Bob Self
Sam Sharpe
Stephen Shaver
Ezra Shaw
David Shea
J. Michael Short
Taryn Simon
Luis Sinco
Peggy Sirota
Wally Skalij
Aaron Skinner
Tim Sloan
Michael Smith
Brian Snyder
Rob Sollett
Chuck Solomon
Lara Solt
Pete Souza
Ken Spencer
Fred Squillante
Jamie Squire
Shaun Stanley
John Stanmeyer
Susan Stava
Larry Steagall
Bill Steber
Evan Steinhauser
R. Todd Stenhouse
Lezlie Sterling
Susan Sterner
Chad Stevens
Mike Stocker
Leslie Stone
Wendy Stone
Scott Strazzante
Art Streiber
Damian Strohmeyer
Paul Sutherland
Akira Suwa
David Robert Swanson
Laurie Swope
Mario Tama
Stuart Tannehill
Adam Tanner
Patrick Tehan
Joyce Tenneson
Donna Terek
Sara Terry
Shmuel Thaler
Robert P. Thayer
Shawn Thew
Elaine Thompson
George E. Thompson
William E. Thompson
Stuart Keith Thurlkill
Al Tielemans
Lonnie Timmons III
Cynthia Timms
Peter Tobia
Joe Toreno
Jonathan Torgovnik
Brian Totin
Charles Trainor Sr
Robert Trippett
Eric Ture Muhammad
Lane Turner
Tyrone Turner
Jeff Tuttle
Jane Tyska
Walt Unks
Gregory Urquiaga
Victoria Ann Valerio
Nuri Vallbona
William Vasta
Ami Vitale
Sarah Voisin
Tamara Voninski

Dino Vournas
Dusan Vranic
Bill Wade
Kat Wade
Craig Walker
Diana Walker
Stephen Wallace
Anastasia Walsh
Susan Walsh
Brian Walski
William Warren
Lori Waselchuk
Lannis Waters
James Watson
Bruce Weber
Nathaniel Welch
Annie Wells
David H. Wells
Matthew West
Dan White
John White
James Whitlow Delano
Bryan Whitney
Max Whittaker
Patrick Whittemore
Jonathan Wiggs
John Wilcox
Geraldine Wilkins-Kasing'A
Anne Williams
J. Conrad Williams
Michael Williamson
Jonathan Wilson
Mark Wilson
Vasna Wilson
Ian E. Wingfield
Damon Winter
Michael S. Wirtz
Rhona Wise
Patrick Dennis Witty
Mitch Wojnarowicz
Darrell Wong
Alex Wong
David Woo
Richard Wood
Michael Woods
Suné Woods
Taro Yamasaki
Dave Yoder
Mark Zaleski
Barry L. Zecher
Tim Zielenbach

VENEZUELA
Kike Arnal
Carlos Balza Casado
Jesus Baquero Suarez
Rodolfo Benitez Parra
José Joaquin Castro
Raumer Cedeño Perez
Jose Cohen
W. Del Valle Olivo Navarro
Félix Gerardi Garcia
F. A. Henriquez Salcedo
Juan E. Jaeger Campos
Nelson Maya Matheus
Jacinto Oliveros Perez
Carlos Ramirez Hernandez
Nicola Rocco
Fernando Sánchez
Jorge Luis Santos Sira
Alejandro Schermbeek

VIETNAM
Bui Ha
Bui Hung
Chu Quang Phuc
Dang Ngoc Thai
Dao Duy Nguyen
Dao Duy Trung
Dao Minh Tuan
Dao Quang Minh
Dao Tien Dat
Dinh Quoc Liem
Dinh Van Hung
Do Viet Khoa
Doan Anh Huy
Doan Duc Minh
Dong Nguyen
Duy Thang
Ho Sy Minh
Giang Huy Hoang
Hoang Luat
Hoang Quoc Tuan

Hoang Xuan Hau
Hong Nga
Huang Thach Van
Hue Le Dinh
Huynh Ngoc Dan
Huynh Tri Dung
Khanh Lai
Lai Dien Dam
Lan Nguyen Duc
Le An
Le Duy
Le Hong Linh
Le Kep
Le Nguyen
Le Nhat
Le Quang Anh Vinh
Le Thuy Chung
Le Van Hai
Le Vi
Luong Chinh Huu
Luong The Tuan
Luu Quang Pho
Ly Hoang Long
Minh Đỗ Thanh
My Ngo
Ngo Dinh Du
Ngo Lich
Thuc Ngueyn Trung
Quy Hoai Nguyen
Nguyen Dinh Vinh
Nguyen Dong Khanh
Nguyen Duc Bai
Nguyen Duy Anh
Nguyen Huu Loc
Nguyen Hy
Nguyen Khac Huong
Nguyen Ngoc Bao
Nguyen Ngoc Ha
Nguyen Nhung
Nguyen Thai Phien
Nguyen Thanh Dung
Nguyen Thi Thu Hoai
Nguyen Van Dung
Nguyen Van Hanh
Nguyen Van Thu An
Nguyen Van Trung
Nguyen Viet Thao
Pham Anh Tuan
Pham Ba Thinh
Pham Cong Thang
Pham Duc Thang
Pham Lu
Pham Minh Gia'ng
Pham Quang Sang
Pham Thi Thu
Phan Trong Tien
Phung Anh Tuan
Phuong Dung
Quang Huy Vu
Ta Van Chanh
Thu Nguyen Trung
To Giang Ngo Minh Luan
Tran Chi Hieu
Tran Chinh
Tran Cu
Tran Hoai Long
Trân Hu'o'ng
Tran Huu Cuong
Tran Ngoc Thanh
Tran Quoc Binh
Tran Quoc Dung
Tran Tam My
Tran The Long
Tran Thi Hoa
Tran Van Luu
Trong Thanh
Truong Huynh Huong
Tuân Le Ngoc
Vu Anh Tuan
Vu Hai Son
Vu Nhat
Xuan Lieu

YUGOSLAVIA
Ilich Andrija
Zoran Bogic
Ivan Dobricic
Gabi Hala'sz
Aleksandar Kelic
Matija Kokovic
Goran Milasinovic Kragovic
Zoran Milovanovic
Mihály Moldvay

Fific Nikola
Milan Obradovich
Sasa Staukovic
Boris Subasic
Srdjan Sulejmanovic
Goran Tomasevic
Valdrin Xhemaj

ZAMBIA
Tsvangirayi Mukwazhi
Asiah Nebart Mwanza
Emmah Nakapizye
Chatowa Ngambi
Patrick Ngoma
Timothy Nyirenda

ZIMBABWE
David Simon Kofi
Costa Manzini
Lovemore Mhaka
Bester Ndoro
Nick Nyambiya

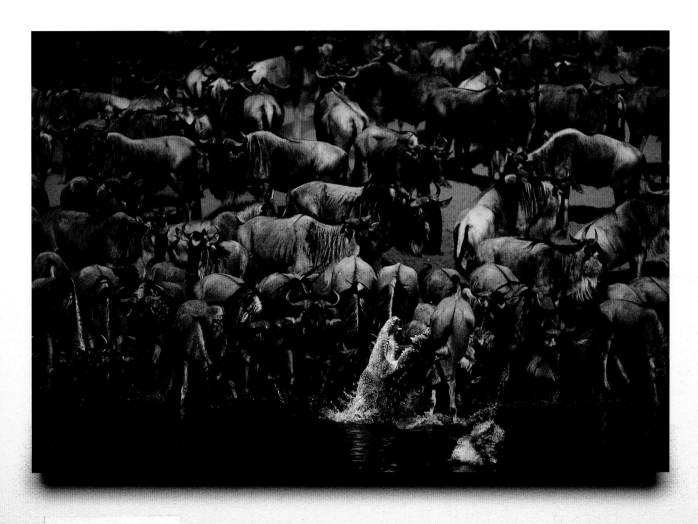

Manoj Shah
Crocodile attacking wildebeest
Serengeti - Mara plains
Tanzania - 1998

EOS IS
PHOTOGRAPHY

Canon
Imaging across networks

Canon Europa N.V. P.O. Box 2262, 1180 EG Amstelveen the Netherlands - www.canon-europa.com

The world's finest books on
photography and photographers from

Thames & Hudson

Bailey **Blumenfeld** Bischof

Bill Brandt Brassaï **Cartier-Bresson**

Walker Evans **Lois Greenfield**

Horst **Hoyningen-Huene**

Jacques-Henri Lartigue **Duane Michals**

Lee Miller **Tim Page** Man Ray

Riboud Daniel Schwartz

Cindy Sherman W. Eugene Smith

For details of our new and forthcoming titles, please write to:

(UK) Thames & Hudson Ltd 181A High Holborn London WC1V 7QX **(USA)** Thames & Hudson Inc. 500 Fifth Avenue New York NY 10110

 Thames & Hudson

EOS D30

EOS is digital

- World's smallest, lightest digital SLR

- 3.25 million pixel large-area sensor

- Compatible with all EF-lenses and
 EOS system accessories

- Built in flash with E-TTL automatic
 light adjustment

- 100-1600 ISO/ASA equivalence

- 3 fps burst rate, up to 8 frames

- 5 data recording settings

- Uses type I or II CF memory card

EOS IS
PHOTOGRAPHY

Canon

Imaging across networks

First published in the United Kingdom
in 2001 by Thames & Hudson Ltd,
181A High Holborn, London WC1V7QX
www.thamesandhudson.com

First published in the United States of
America in 2001 by Thames & Hudson Inc.,
500 Fifth Avenue, New York,
New York 10110
www.thamesandhudsonusa.com

Art director
Teun van der Heijden
Design
Heijdens Karwei
Picture coordinators
Saskia Dommisse
Irina van der Sluys
Interview and captions
Rodney Bolt
Research assistant
Dieter Wouters
Editorial coordinators
Bart Schoonus
Supervising editor
Kari Lundelin

Lithography
Sdu Grafisch Bedrijf bv, The Hague
Paper
Hello Silk 135 g, quality Sappi
machine coated, groundwood-free paper
Cover
Hello Silk 300 g
Proost en Brandt, Diemen
Printing and binding
Sdu Grafisch Bedrijf bv, The Hague
Production supervisor
Rob van Zweden
Sdu Publishers, The Hague

This book has been published under the
auspices of Stichting World Press Photo.

British Library Cataloguing-in-Publication
Data: A catalogue record for this book is
available from the British Library

ISBN 0-500-97598-1

Printed in The Netherlands

Jury 2001
Robert Pledge, France (chair)
president Contact Press Images (New
York/Paris)
Guy Cooper, USA
director of photography Newsweek
Christiane Gehner, Germany
picture editor Der Spiegel
Alexander Joe, Zimbabwe
photographer Agence France Presse
Margot Klingsporn, Germany
director Focus Photo und Presse Agentur
Yuri Kozyrev, Russia
photographer
Miguel Angel Larrea, Chile
director of photography Las Ultimas Noticias
Michele McNally, USA
picture editor Fortune Magazine
Juda Ngwenya, South Africa
photographer Reuters
Brechtje Rood, The Netherlands
picture editor Trouw
Henrik Saxgren, Denmark
photographer
Michael Young, Australia
picture editor Sydney Morning Herald

Children's Jury 2001
Colleen Becket-Davenport, USA
San Francisco Chronicle
Farai Gombedza, Zimbabwe
ZATCYP
Camille Lenoir, France
Images DOC
Li Xiang, People's Republic of China
China Youth Computer Information
Network
Emadur Rahman, Bangladesh
Drik Picture Library
Anne Stikkers, The Netherlands
de Volkskrant/NEMO
Barbro Studsgarth, Denmark
Politiken
Luis Enrique Suarez Valle, Peru
Centro de la Fotografia/El Comercio
Aleksandra Wisniewska, Poland
Gazeta Wyborcza

Office
World Press Photo
Jacob Obrechtstraat 26
1071 KM Amsterdam
The Netherlands

Telephone: +31 (20) 676 6096
Fax: +31 (20) 676 4471

E-mail: office@worldpressphoto.nl
Website:www.worldpressphoto.nl

Managing director: Árpád Gerecsey
Deputy managing director:
Michiel Munneke

Cover picture (detail)
World Press Photo of the Year 2000
Lara Jo Regan, USA, for Life
Uncounted Americans: An Immigrant
Family from Mexico at Home, Texas